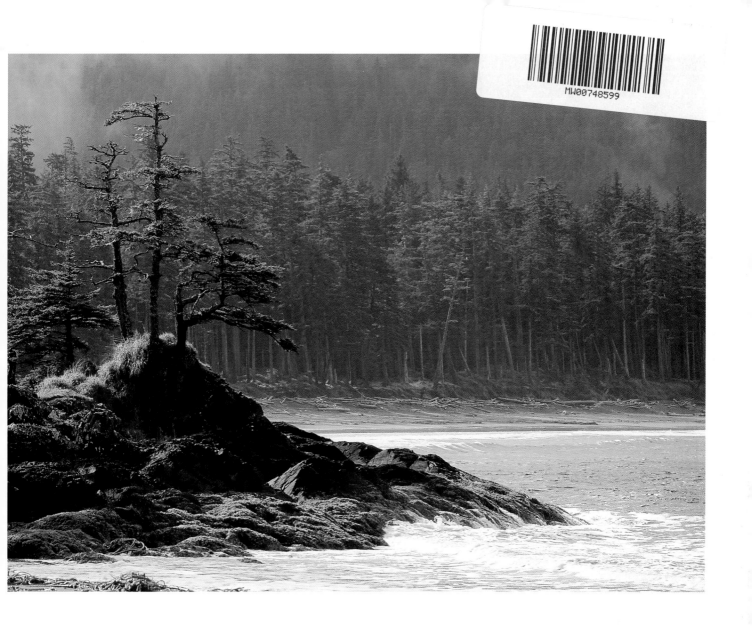

There is a pleasure in the pathless woods,

There is a rapture on the lonely shore,

There is society, where none intrudes,

By the deep Sea, and music in its roar:

I love not Man the less, but Nature more,

From these our interviews, in which I steal

From all I may be, or have been before,

To mingle with the Universe, and feel

What I can ne'er express, yet can not all conceal.

– George Gordon, Lord Byron

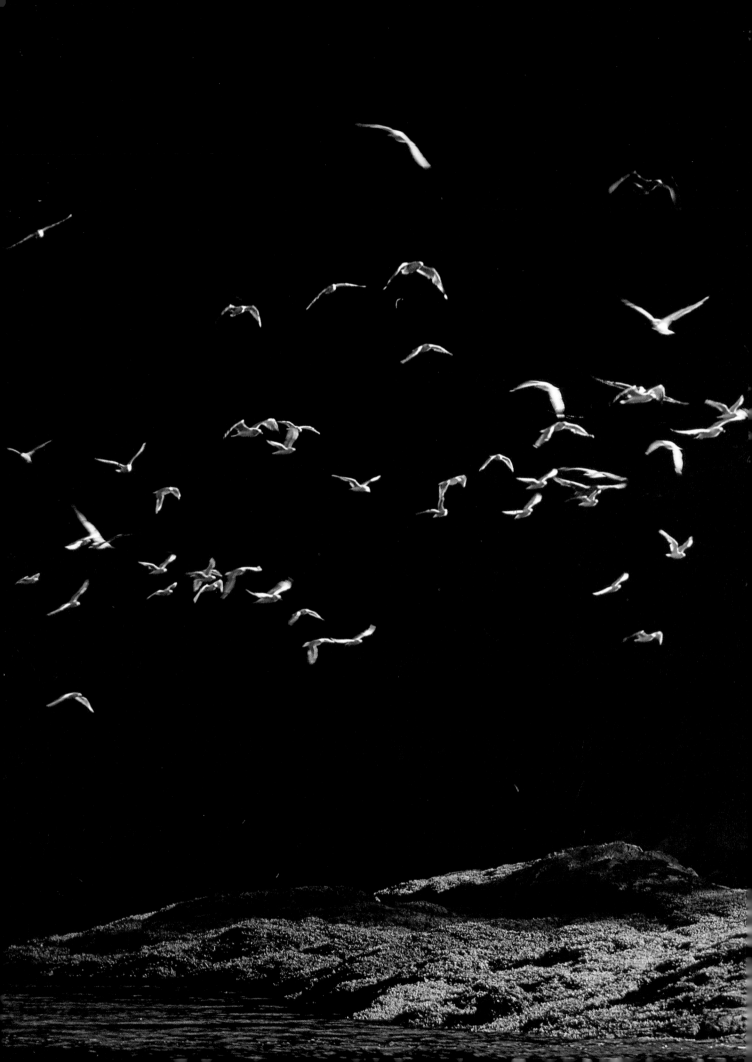

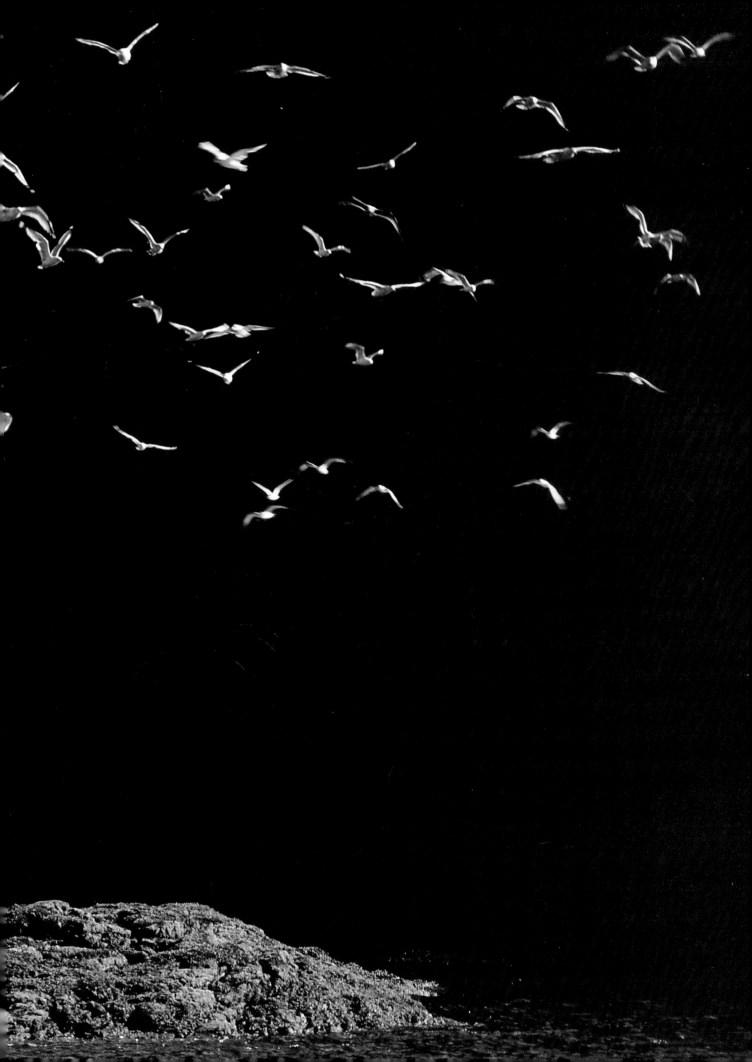

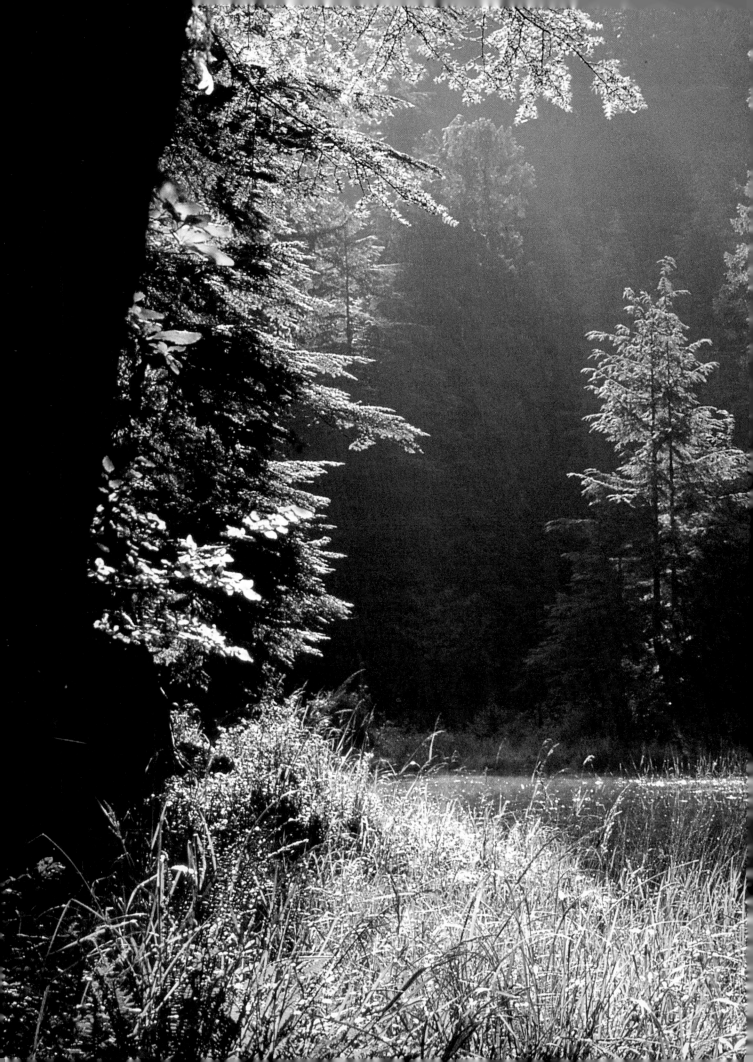

ANCIENT LANDSCAPES
of British Columbia

Text and photographs by
Ian Mackenzie
Foreword by Wade Davis

FLY LEAF: Peril Bay, Duu Guusd, Queen Charlotte Islands.

SECOND PAGE: Seagulls in Laredo Sound.

TITLE PAGE: Princess Royal Island.

THIS PAGE: Near Dennis Creek, White Grizzly Wilderness.

The Publisher: **Lone Pine Publishing**

206, 10426 - 81 Avenue
Edmonton, Alberta
Canada T6E 1X5

202A, 1110 Seymour Street
Vancouver, British Columbia
Canada V6B 3N3

16149 Redmond Way, 180
Redmond, Washington
USA 98052

Canadian Cataloguing in Publication Data

Mackenzie, Ian, 1950-
 Ancient Landscapes of British Columbia

ISBN 1-55105-043-9

 1. British Columbia—Pictorial works. 2. Natural history—
British Columbia—Pictorial works. I. Title.
FC3812.M32 1995 917.121'0022'2 C95-911092-5
F1087.8.M32 1995

Editors: Glenn Rollans, Lynn Zwicky, Nancy Foulds
Design, Production and Layout: Wei Yew, Jean Poulin, Ian Mackenzie
Colour Separations and Pre-press: Pièce de Résistance Ltée.
Printing: Europe Offset, Edmonton
Photography, including Cover: Ian Mackenzie

The publisher gratefully acknowledges the support of Alberta Community Development, the Department of Canadian Heritage and the Canada/Alberta Agreement on the Cultural Industries.

LONE PINE

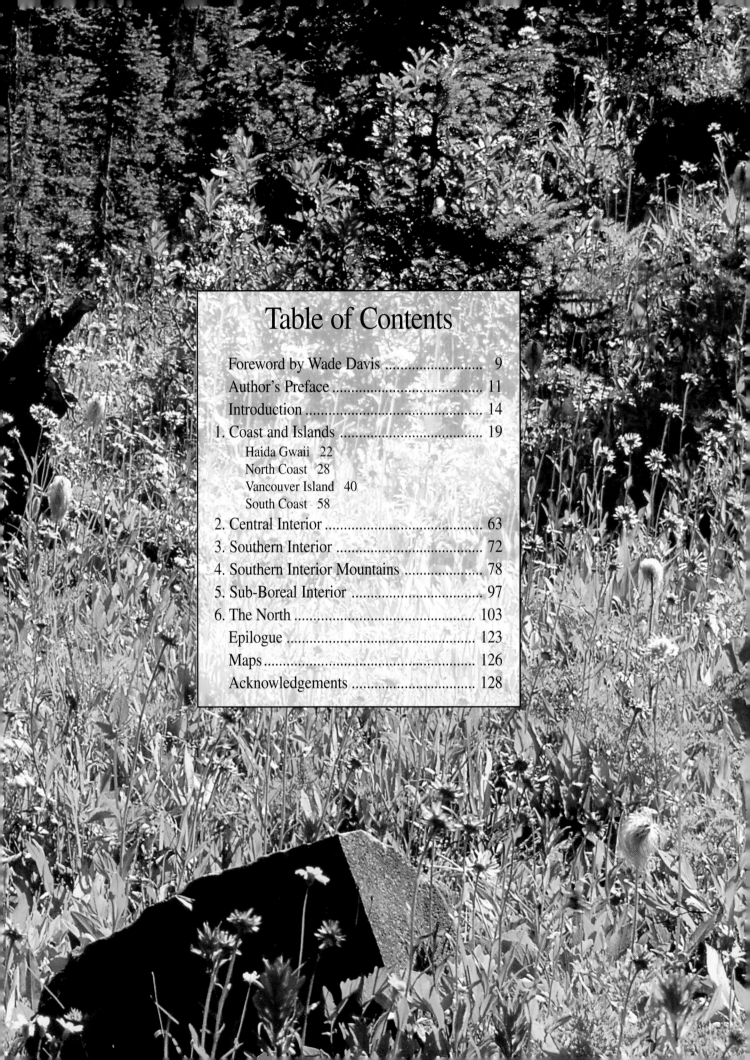

Table of Contents

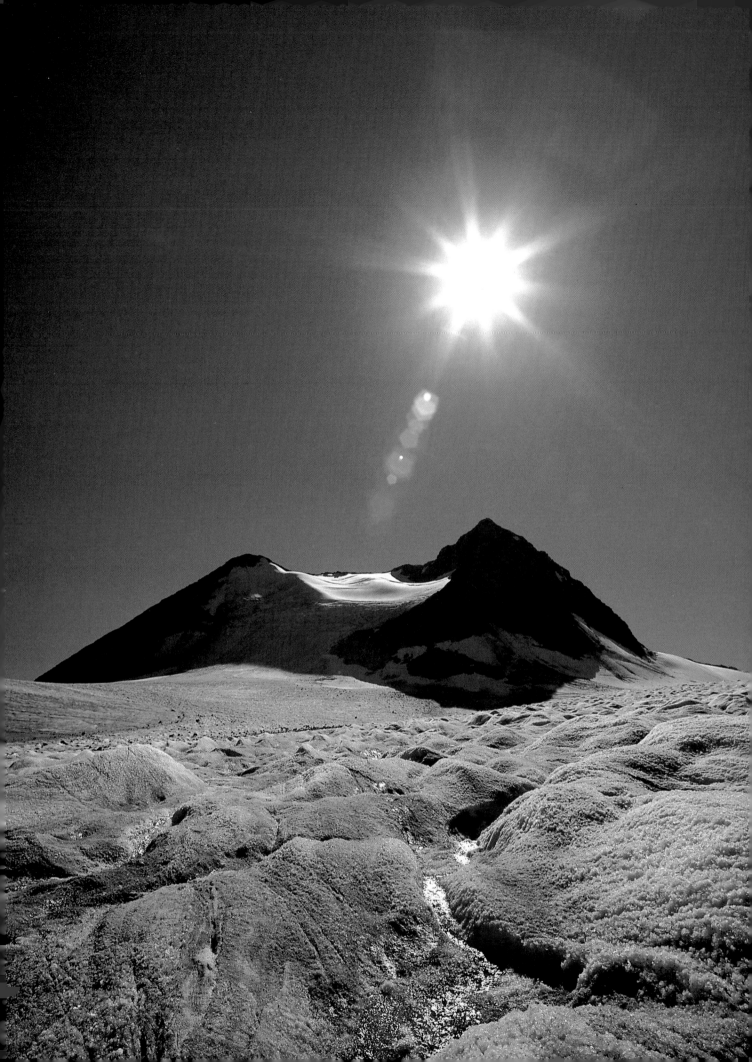

Foreword

The beauty of British Columbia demands to be photographed. Yet, as those of us know whose desks are full of unused and unseen slides that fail utterly to evoke the wonder of this land, it is among the most difficult photographic subjects. Part of the problem lies in the immensity of the landscape. Between a minute alpine blossom and a distant horizon of rock and ice, between a tide pool and a towering fir, there is nothing of a human scale. In this void created by the absence of will wander photographers such as Ian Mackenzie, an artist of light who can see the world in a seed, reveal heaven in a stream, record eternity in a blade of grass bending in the breeze.

This book is a record of six years of his travels, journeys that have taken him on foot and horseback, by canoe and kayak, by air and river, to every remote corner of the province. Working under the most difficult conditions, in every kind of weather, and often alone for weeks at a time, he has been a pilgrim of the wild, a seeker of those quiet moments of illumination when the very spirit of a particular place shines. The ease with which the rest of us snap images of nature must not blind us to the magnitude of his achievement.

For Ian, whom I know well, the process of writing and composing this book has been a coming of age as a person and artist. He began the project as a passionate defender of wilderness; he emerges as one of its most talented and visionary chroniclers. Ansel Adams, who described the camera as "an instrument of love and revelation," said that a great photograph is the "full expression of what one feels about what is being phographed and is, thereby, a true expression of what one feels about life in its entirety." Ian became a photogapher by doing this, his finest work. In the process, the camera became his tool. Through it he now gives meaning to everything around him.

Taking a photograph is, by definition, an aggressive act of non-intervention. I have seen Ian at work, heaving sixty pounds of equipment up a mountain slope, tracking light like a hunter, stalking the ground, elusive as a shadow. I have heard stories of his adventures, encounters with black bear and grizzly, with winter gales and impossible rapids, tales which for modesty's sake find no place in this book. His narrative tells only of the land. The personal vignettes are intended only to impart something of the awe he felt as he sought and composed these images. The photographs themselves are incitements to reverie.

Photography is a twilight art, an art of elegy. The very act of freezing an image in time ensures that it will be touched with pathos, that its memory will be preserved. But for Ian these images are not intended to invoke nostalgia. Nor is this book designed to gather dust. It is not a work of analysis, or a volume of mere appreciation. It is a summons to action. Within its mute testimony is the anger felt by one man for all those who, through neglect or greed, would silence the voices of the wild. The forests, lakes and mountains portrayed so elegantly here are not for Ian mere points on a map, or fuel for a political agenda. They are the loci of divine presence. Drawn to this world of wind and rain, of cedar and hemlock, of meadow and brook, and recreated by his encounters, Ian invites us to honour our home. He calls for a new mystique of the land, a reverence for all that he has sensed and heard and felt in his solitary ramblings. This book is his gift to the people of British Columbia, an antidote to the narrow vision of industrial life, a road map for reworking our senses, and emerging, much as he did, into the wilderness of the spirit.

Wade Davis
Wolf Creek, Ealue Lake

Friendly Glacier,
Tchaikazan Valley.

9

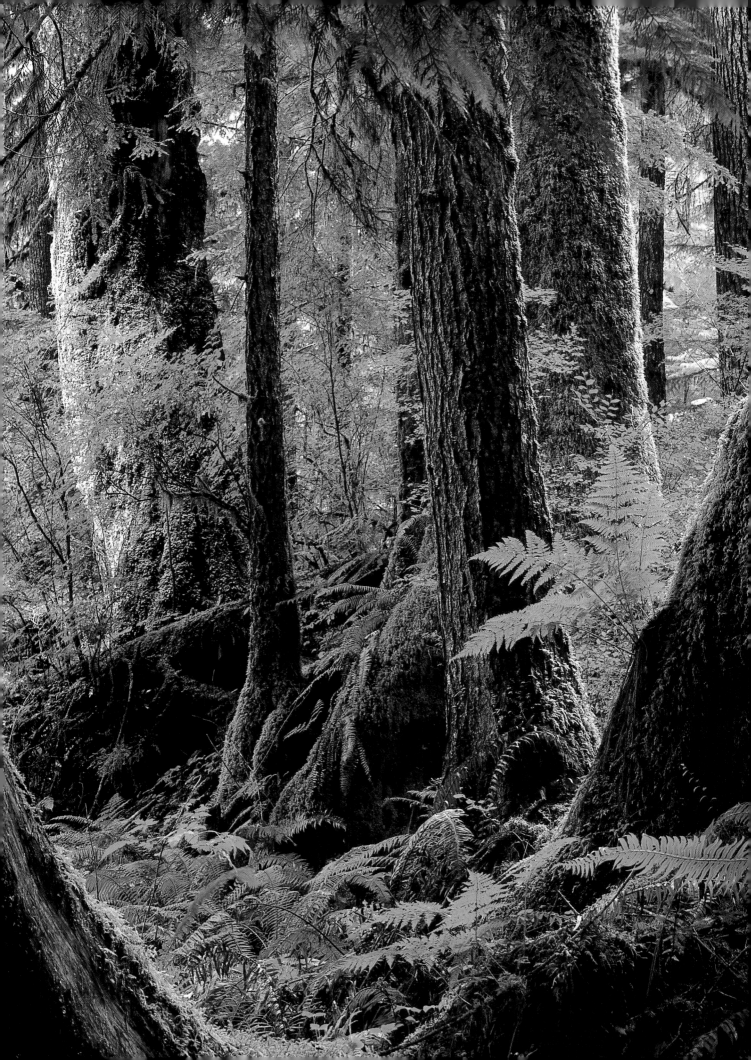

Home

Buried in the depths of each of us lies a spiritual home. It is a place where we first encountered some mystery of life, or felt the kind of awe that only a child can feel. It is a point in our minds where fond memories of youth converge with a landscape.

For hundreds of thousands of years a vision of this special place required no remembering: our ancestors lived and died on the lands of their birth. Today, few of us enjoy this privilege. We have either moved from the place we were born or, staying there, have seen it transformed beyond recognition.

My spiritual home was a small forest on the shores of Quamichan Lake, in the Cowichan Valley, near Duncan, on Vancouver Island. My parents bought a farm there in the 1950s. It was typical of the other farms that ringed the lake: three fields and two "wood lots" covering 40 acres. The forest had been cut about 50 years before, when logging was done by hand, and, unlike today, not all the trees were removed. As a result, the woods had regrown in a natural fashion. Three giant Douglas-firs remained. Each had a peculiarity that had made it unattractive to the loggers: a large burl, a forked top, a crooked trunk. I remember my wonder and delight when, for the first time in my life, I saw trees so large, and recall the fun of joining hands with my brothers to make a human ring around each trunk.

It was not a big forest, but for me it was a world. In the shelter of its trees I found soft moss, coarse bark, sweet berries, ferns glowing in shafts of light, the hum of insects, and the song of birds. It was a refuge from a child's worry and pain.

We had no toys there, nor did we need them. We transformed moss-decked glades into imaginary countries; old rotting logs into caverns and castles; fir cones, twigs and stones into houses, vehicles and animals; and we peopled our fantasies with invisible characters.

We swam in warm waters under poplars along the shore. We cut trails into thickets where we stumbled onto wasps' nests and ran screaming as we were stung. We climbed cedars and reached the realm of the tree tops, where the ground was invisible and the trunks, thin as broom handles, bent alarmingly with our weight.

One warm August night, when I was 15, I crept out of the cabin and felt my way through the moonless woods. I came to the field and my gaze rose past the dark wall of trees up to the ceiling of stars. I was far from cities and the only light came from the cosmos. The Milky Way spanned the horizons.

I had started to learn the constellations from a book; now, for the first time, I saw them in the night sky. Each new recognition triggered a surge of real ecstasy. The Swan, the Eagle, the Dolphin. For the first time in my life I saw the universe.

That was to be my last summer at the lake. Two years earlier we had moved to Vancouver, and my parents were about to sell the farm. For me it was a wrenching transition. I was plunged into the anguish of adolescence and into an urban environment to which I related with difficulty. I never lost the dream of that forest on Quamichan Lake.

I grew up, and became an urban person. I studied and worked, and moved to other cities. I travelled and lived on other continents. I visited the cathedrals of Europe, the temples of Asia, and the slums of many cities. I saw the deserts of Africa, the high plains of the Andes, the rainforests of Asia, the glaciers of Baffin Island, and the coral reefs of the Pacific. Nowhere have I seen anything more wonderful than the forests, fjords and mountains of British Columbia. When I returned here to live, I was drawn not by Vancouver, but by the landscape that surrounds it: a landscape etched onto my soul.

In the summer of 1988, a friend and I went to Vancouver Island to hike in wilderness near Long Beach. Our drive took us through Duncan and I decided to visit our old farm. I had avoided it since our family sold it in 1965. I knew the upper field had been subdivided, and I

OPPOSITE:
The mid-Carmanah Valley.

11

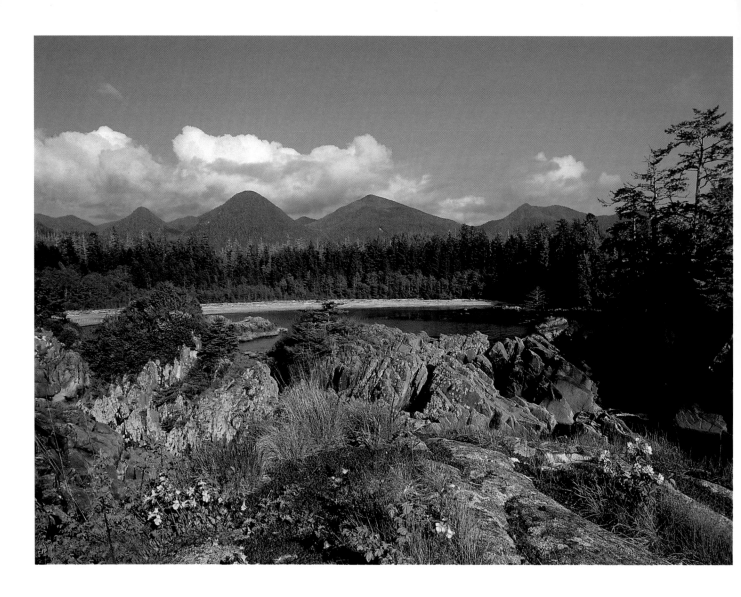

Flores, the island heart of Clayoquot Sound.

did not want the sight of new houses to spoil my memories. With some trepidation I turned down Maple Bay Road and tried to get my bearings.

Ours was not the only farm that had been developed. I drove back and forth several times, and made some wrong turns. At last I entered a group of houses, among which I recognized our old home. I parked the car and we got out and walked down the hill towards the lake. I looked for familiar landmarks. There were none.

The forest had just been destroyed, and the trees lay where they had been felled, their foliage still fresh. I had come too late. I turned my head, and fought to hold my tears.

The last time I had visited Long Beach was in the early 1960s; to reach it, we had to board a tiny ship in Port Alberni. I have a vivid memory of this ship being tossed in a gale, and waves higher than the funnel, and seawater seeping through windows and wetting the seats in the passenger lounge. We stayed then at Wickaninnish Inn, a small lodge facing the ocean. It was early spring, and it rained every day, and the wind and the surf filled me with joy. We were the only guests at the lodge. We walked miles down the beach and along forest trails, and saw neither humans nor buildings.

Today a road leads to Long Beach. With the road came logging. As we drove westward on that summer day in 1988, every bend in the highway brought us new views of mountains that had been stripped and wastelands of charred stumps. A forest a thousand years old had been largely destroyed in a quarter of a human lifetime.

Long Beach is now part of a small national park. Wickaninnish Inn is gone, and its old site holds a parking lot and a visitors' centre. Further north are vast campgrounds, where thousands of city dwellers, hungry for a taste of nature, spend days on the beach and nights near their cars.

Within two days we had found our way to an undisturbed rainforest. It was on Meares Island, just north of Long Beach, across an arm of Clayoquot Sound. On the first day of our hike across the island we walked among giant cedars. We passed a tree as large as a building, part living, part dead, a garden of ferns and huckleberry sprouting high in its trunk. We came eventually to a grove of Sitka spruce and camped among the great moss-cloaked columns.

We had been walking for hours, and had met no people on the forest path. The salal leaves glistened in the falling rain. As we crossed a small creek, I saw an old cedar on the opposite bank. The stream had changed course and exposed the tree's roots.

Centuries ago the tree had sprouted on a midden: it was anchored in a million clamshells, the refuse of a vanished Nuu-chah-nulth village. From below came the gurgle of water, and from above I felt the breath of the forest. I looked up. The branches above me swayed with the muffled laughter of a hundred generations, and the tears of an ancient people dripped from the foliage and mingled with my own.

This forest still stands. I was filled with an emotion I had not felt in a decade: a passion, a certainty, a purposefulness. Until that moment, I had been a hobbyist; from then on, photography would be an occupation. I had found my home.

Cottonwoods,
northern Rockies.

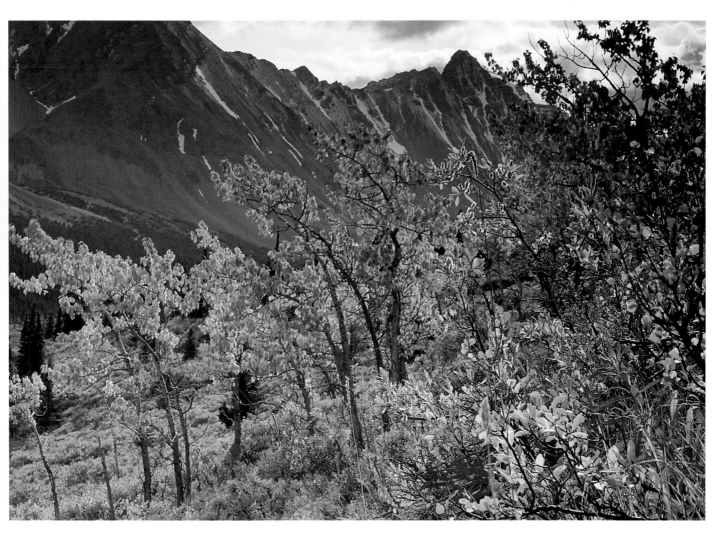

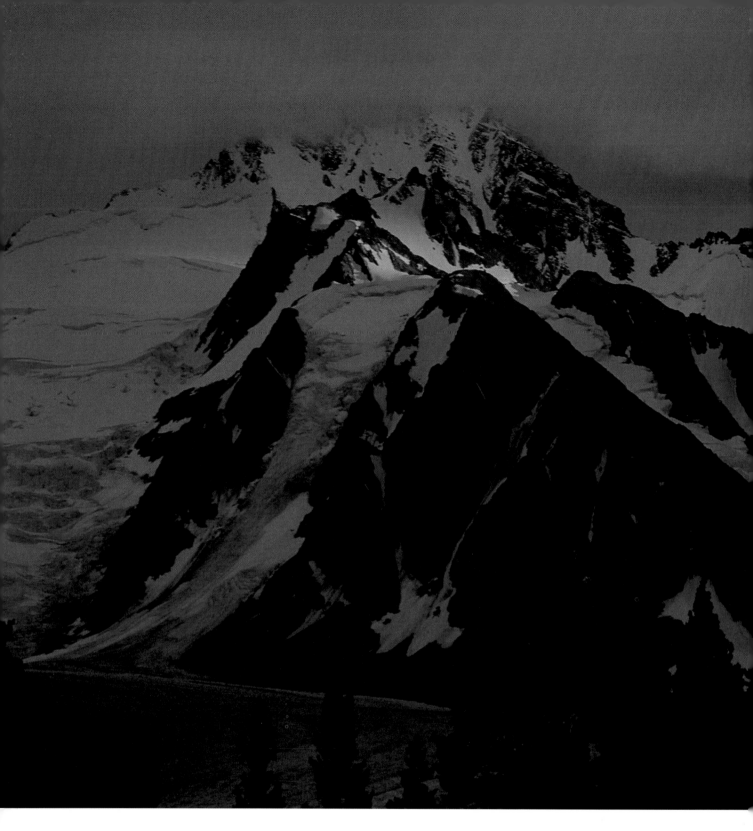

Mount Monmouth at the head of Tchaikazan Valley, Chilcotin region.

Throughout the age of European discovery, the northwest coast of our continent was one of the remotest regions on Earth. The African shore had been mapped for 300 years before George Vancouver first saw the lands that now bear his name. Asian spices had enlivened the cuisine of Iberia for two centuries before Spanish merchants arrived at Nootka Sound to trade cloth and iron for otter skins.

Canada's westernmost province has an ancient history of inaccessibility. Some scientists believe that people arrived in the Americas as long ago as 40 millenia. Such early immigrants could have colonized the southern parts of the continent, but they would not have discovered the land we now call British Columbia. The Pacific Northwest lay buried under a mile of ice.

When the glaciers retreated from British Columbia

14

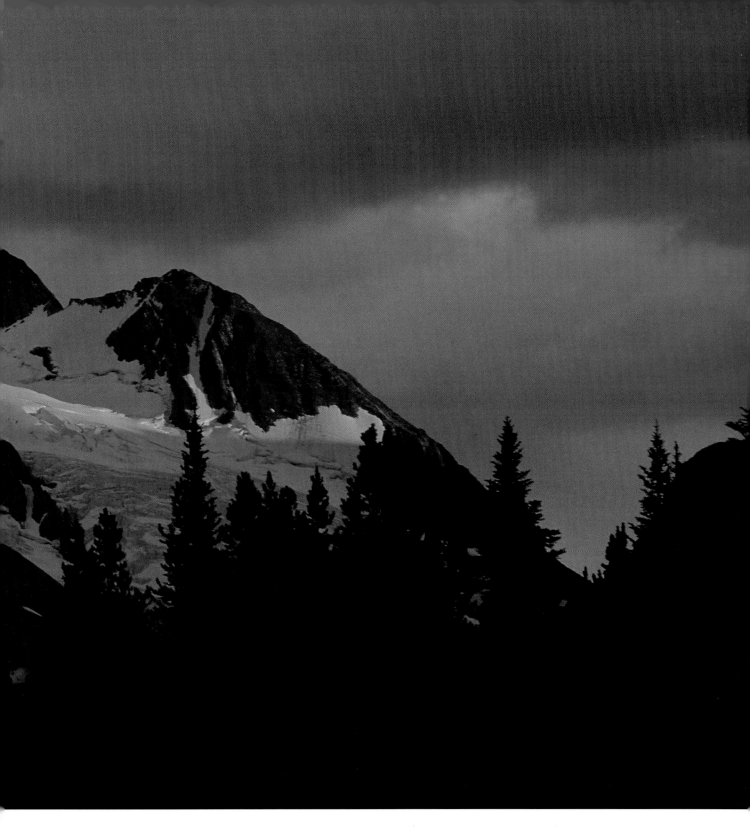

around 12,000 years ago, they exposed a dozen mountain ranges running north to south. The rugged terrain gave rise to a mosaic of climates. Damp ocean air moving east over the ice-scoured landscape supplied some valleys with abundant rain. Other valleys, in rainshadow, became semi-desert. Plant colonies moved northward in the wake of the melting glaciers, and flora and fauna soon reflected the wide variations of altitude and rainfall.

Today, British Columbia is the most ecologically diverse province in Canada.

Human variation parallels the divergences of nature. British Columbia has as much cultural and linguistic diversity as all other provinces and territories combined. At the time of European contact, at least 18 distinct languages were spoken here. These tongues fall into no less than seven families, linguistic groupings with no

known relationship to each other. By contrast, the rest of Canada was home to only five linguistic families.

Most of British Columbia's indigenous peoples lived near the coast. The Pacific shore was an environment of extraordinary generosity. Rivers and sea supplied salmon, whale and eulachon. Forests and flood plains gave meat and fur. Cedars yielded bark for baskets and clothing, and wood for great houses and canoes.

Like their ancient predecessors, most modern migrants to British Columbia settled near the sea. Today a majority of us live near the southern coast. This concentration of people makes it easy to forget how few our numbers really are. With fewer than four million inhabitants and almost a million square kilometres, British Columbia is one of the more sparsely populated places on Earth. In the northern part of the province, areas the size of Switzerland remain unmarked by roads or human settlement.

Once more the rugged landscape has played its part. Vancouver, Canada's third largest city, crowds the flat and fertile Fraser delta; but 30 kilometres to the north an almost unbroken swath of mountain wilderness stretches to the Arctic. Many valleys in the hinterland were settled in the mid-19th century; others remained unmapped until the mid-20th.

Montreal was an old city when Vancouver was still a rainforest. Railways linked Boston, Chicago and New Orleans before the first wagon road was pushed into British Columbia's interior. The vast eastern forests of white and red pine had fallen before large-scale logging even began in British Columbia.

We are still pioneers. Our moment in history is both exciting and appalling. We are one of the few peoples on Earth who can easily fill our lives with the joy of wilderness. Yet we are destroying our natural heritage at an unprecedented rate.

Half of Canada is still wild, but most of its untouched territory is locked in snow and ice for nine months of the year. Little temperate wilderness remains, and British Columbia has most of what is left. We inhabit a land where we can still walk alone for days in valleys that seem unchanged since the ice age, or sail the waters of inland seas and rarely see another vessel. We belong to the world's privileged few. We need not travel far to drink from wild rivers, rest on the moss of primeval forests, listen to surf on deserted shores.

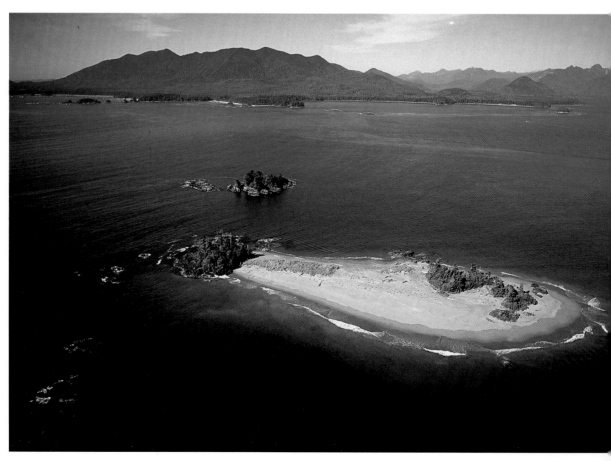

Whaler Islets,
Clayoquot Sound.

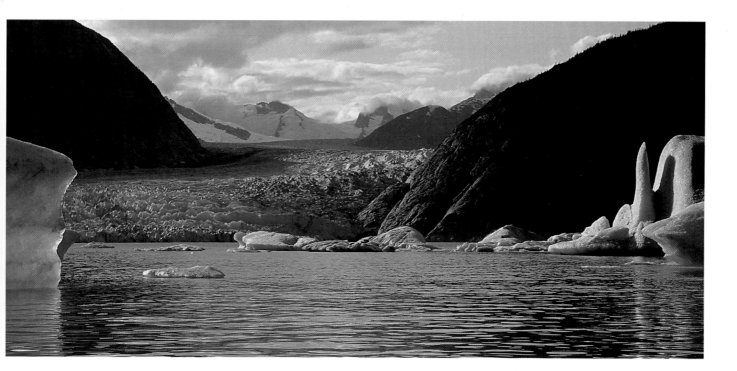

I took the photographs in this book between 1989 and 1995. Most of the areas they depict are remote. Wilderness, by definition, is roadless. Those who would see these places for themselves will have to do as I did, and travel there on foot, or with the aid of snowshoes, horses, canoes, small boats or aircraft.

When I began this project my ambition was to document the unknown wilderness of British Columbia. Almost none of the places described in this book fell within the boundaries of national or provincial parks. But in 1991, British Columbians elected a new government that showed a greater concern for wilderness preservation than any of its predecessors. The New Democratic Party administration announced plans to create a number of new parks, including ones to protect the Tatshenshini River, the upper Carmanah Valley, the Kitlope watershed and the lands surrounding Chilco Lake. I had already photographed many of the newly preserved areas. Rather than leave them out, I decided to change the scope of the book. I had originally intended a pictorial survey of threatened landscapes, but now the photographs also celebrate several important additions to the provincial park system. I earnestly hope that the many other places illustrated in these pages will soon receive the protection they deserve.

At the time of publication, sizable tracts of wilderness took up a third or more of British Columbia. The current government intends to preserve no more than 12 percent of this wilderness in parks. Most of British Columbia's wild lands remain threatened. Pristine landscapes totalling an area bigger than England remain open for logging and other industrial activity. It is impossible to do justice to such a vast territory in 128 pages. This book is only a sampling of endangered wilderness in British Columbia.

In making this sampling, three considerations have guided me. First, I have generally favoured large areas of wilderness over small ones. Second, I have concentrated on places most immediately endangered, or places that have been the object of public campaigns for preservation. Third, I have sought to illustrate some of the geographical and biological diversity of British Columbia. The photographs depict the landscapes and vegetation of every one of British Columbia's nine terrestrial ecoprovinces, of 35 of its 42 terrestrial ecoregions, and of all its 14 biogeoclimatic zones. The maps on pages 126 and 127 provide a guide to some of these ecological categories, and the location of the landscapes photographed.

I have organized the book in accordance with the ecoprovince divisions proposed by Dennis Demarchi. Thus, chapters 2 to 5 each cover a single ecoprovince. For reasons of convenience, I have chosen to cover both the Georgia Depression and the Coast and Mountains in Chapter 1. Chapter 6 covers the Northern Boreal Mountains, the Boreal Plains and the Taiga Plains, as well as the northern extremity of the Coast and Mountains.

Great Glacier at the Stikine.

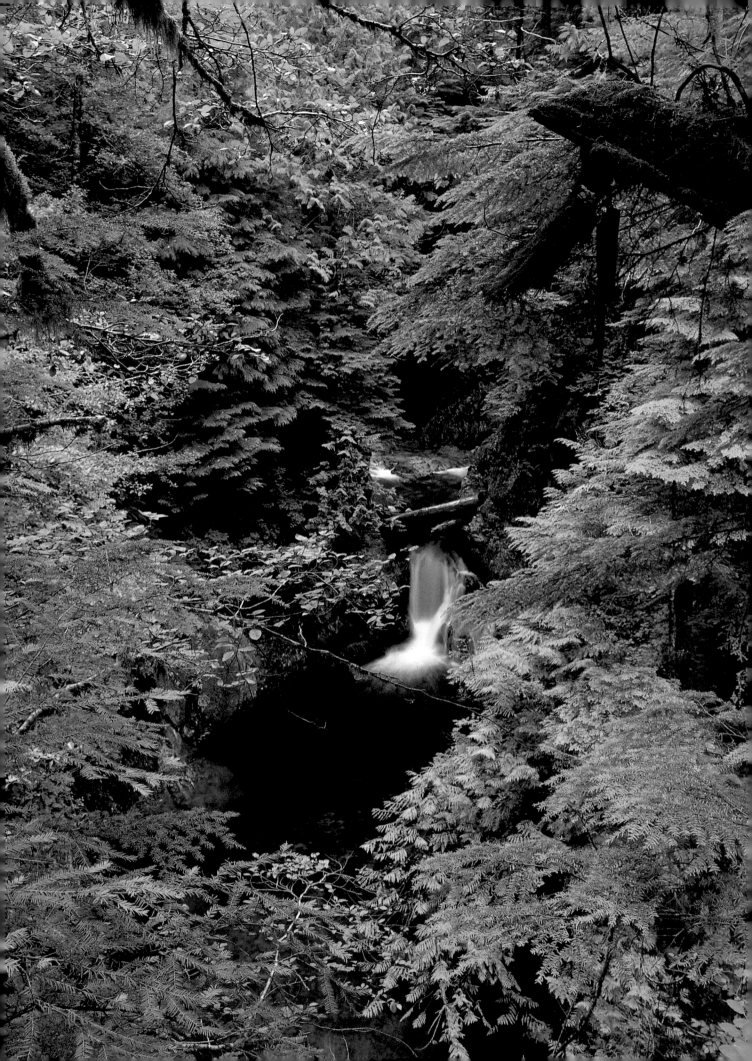

Coast and Islands

British Columbia is one of the few places on Earth where ocean waves lap the slopes of an immense cordillera. This encounter of mountain and sea has created one of the world's most extensive networks of fjords.

If you fly from the Alaskan panhandle to the Washington border, you travel only 830 kilometres. That same journey by boat tracing the mainland shore would cover more than 12,000 kilometres. If you also circumnavigated British Columbia's 6,500 islands, the total journey would exceed 27,000 kilometres — equivalent to setting forth from South America and sailing across the Pacific and Indian Oceans to the coast of Africa.

Although often compared to the fjords of Norway, the inland passages and seas of British Columbia are flanked by mountains much larger than those of Scandinavia. Patagonia is the only other place on Earth where peaks as tall as those of the Coast Range rise directly from the ocean.

Extreme landscapes create extraordinary weather. The western side of the Coast Range has one of the wettest climates in the world, with more than a hundred centimetres of rain each year. In many locations, the annual rainfall exceeds three and a half metres.

The abundant precipitation preserves remnants of a frigid past. The Cordilleran ice-sheet has left its marks everywhere on the landscape — in eskers, moraines, in the sculptured roundness of fiords and valleys — but the ice itself has all but gone. In this mild climate the ice would have vanished completely were it not for the coast's prodigious snowfall. Ocean moisture renews the great icefields of Mounts Monarch, Waddington, Queen Bess, and their neighbours. The glaciers of the Coast Range are the largest masses of permanent ice in temperate North America, and several times bigger than the glaciers of the Rockies.

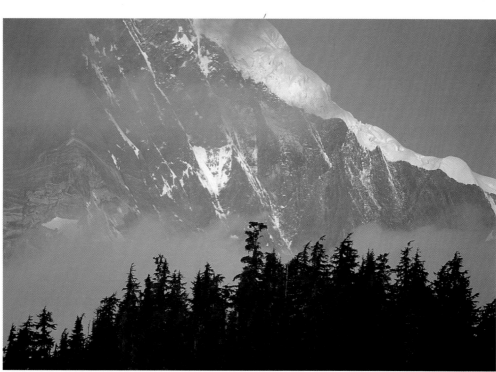

RIGHT: Lower Stikine River.

LEFT: Purity Falls, Upper Carmanah Valley.

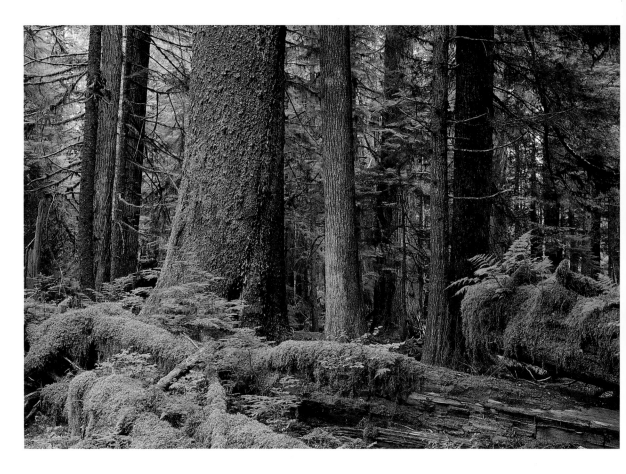

This same abundant moisture gave rise to one of the world's most extraordinary forests. It stood for some 10,000 years, stretching from Oregon to Alaska, cloaking islands and lining fjords, a swath of unbroken green from shoreline to alpine meadow.

This forest is the most profuse on Earth. There is a popular misconception that tropical jungles are the world's most impenetrable; in reality, their ground-level vegetation is sparse compared to the thickets of salal and salmonberry that thrive on the forest floors of the southern British Columbia coast.

The ancient Pacific rainforest has trees older, taller and greater in girth than the forests of Borneo or Brazil; and the trees stand much closer together. The average biomass per hectare is more than double that of a tropical woodland, and many groves of cedar and spruce contain four times the volume of wood of a comparable site in the Amazon.

Near the equator, a fallen tree rots quickly, and its neighbours soon draw its nutrients back into the canopy. The jungle has little topsoil. In the temperate rainforest, a dead titan may decay for half a millenium before its moss-clad trunk completely merges with the forest floor.

This slow rate of decomposition creates much of the beauty of the temperate forest. A dead snag may remain erect for decades, supporting a garden of moss and fungus. When it falls, it joins a lattice of decaying trunks from which new seedlings sprout. Much of the biological diversity of a temperate woodland is found within this layer of crumbling wood and accumulating humus. The visible component of the forest may consist of a dozen types of tree, but below the surface, thousands of species of microbe, fungus, worm and insect perform their endless function of digestion and decay.

By one measure, this forest is extremely young. Until some 12,000 years ago, the ground on which it stood was pressed beneath kilometres of ice. By another measure, the coniferous rainforests of British Columbia are the most ancient woodlands of our planet.

Their origins lie a quarter of a billion years ago, at a time when all continents were joined in a world island called Pangea. Dinosaurs were still a novelty. Birds had not evolved, and insects were the only creatures that could fly. Flowers did not yet exist. Yet Pangea had trees that bore needles and cones. Conifers had evolved, and forests of them steadily replaced the primordial jungles of lycopod and tree fern.

A hundred and fifty million years later a new class

of plant — the angiosperm, flowering and broad-leaved — began to steadily displace the conifers. Today, there are a quarter of a million species of flowering plant. Only some 500 species of conifers survive.

Angiosperms dominate the modern tropical forest. They have pushed their coniferous cousins to the margins of the Earth. Large pure stands of needle-bearing trees thrive only in the far north, in harsh mountain environments and in the Pacific rainforests of Chile and North America. The forest of British Columbia is a remnant of a primeval world.

The coastal forests are old in another way. Fire rarely burns the wetter areas, and trees there often reach great age. Douglas-firs can live for 10 or 12 centuries, western redcedars for almost 15. The stump of a yellow-cedar felled north of Vancouver in the late 1980s revealed 1835 annual growth rings. Given the slow rate at which fallen trees decay, the complete cycle — seedling to mature tree to fallen trunk to new humus — may take the better part of two millenia. By comparison, an eastern white pine forest completes this cycle in about about 500 years, a tropical jungle in perhaps 200. The lodgepole pines of British Columbia's dry interior often perish by fire within a century.

British Columbia's logging industry plans to replace the ancient Pacific rainforest with tree plantations that are to be harvested every 80 years.

Most of British Columbia west of the Coast Range falls within the Coast and Mountains Ecoprovince, an area extremes of altitude give rise to great diversity. Alpine tundra and subalpine fir surround ice-capped summits. Mountain hemlock and amabilis fir thrive at intermediate elevations. Western hemlock and redcedar dominate lower slopes and valley floors. Salt-resistant Sitka spruce form

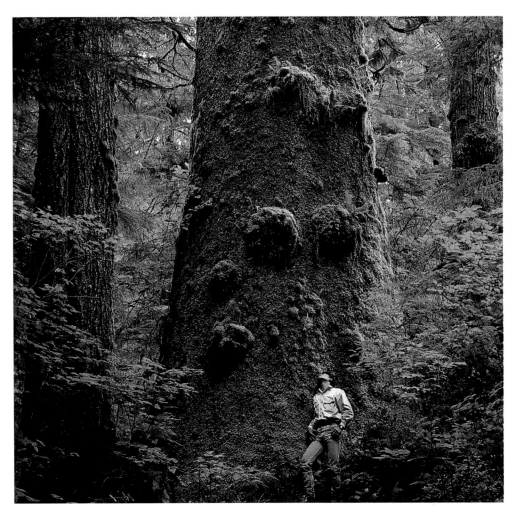

Sitka spruce, Flores Island.

palisades along the ocean and grow to mammoth size on riverine flood plains. The stunted shapes of ancient shore pines rise out of the peaty soils of coastal bogs.

Large tracts of wilderness survive in the Coast and Mountains Ecoprovince. But most of these are at high elevations. The old-growth forests of the valley floors are being steadily destroyed. At present rates of cut, very little will be left in 20 years.

A portion of the southwest corner of British Columbia falls within the Georgia Depression Ecoprovince, an area in the rainshadow cast by the mountains of Vancouver Island. The central part of this relatively dry area favours Garry oak, arbutus and above all Douglas-fir, a species both resistant to fire and adept at recolonizing burned-over areas.

The Georgia Depression Ecoprovince encompasses the most populous area of British Columbia. The only wilderness that survives is on its western fringe, high in the mountains of central Vancouver Island. On the valley floors, agriculture and second-growth trees have entirely replaced vast forests of giant fir.

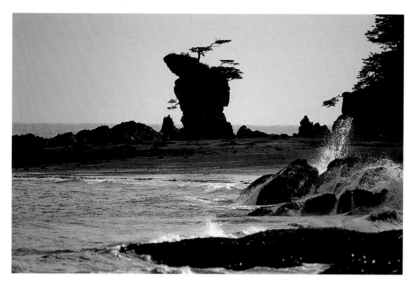

Haida Gwaii (Queen Charlotte Islands)

Twelve thousand years ago, an ocean of white spanned North America, its surface rippled here and there by black-ribbed mountain peaks. Almost nothing was alive.

On the western edge of the continent a few small patches of green hung on, sanctuaries of life in a world of ice. When the glaciers retreated, the plants and animals of these refugia recolonized the surrounding landscape. But some of them did not move far, and when the ice melted they were stranded on a close-knit group of islands. Haida Gwaii is the most isolated land mass in Canada.

Haida Gwaii remains home to a number of glacial refugees, forms of life found nowhere else on Earth. The largest black bears in the world live here, as do a half dozen other unique mammals. It has endemic insects, birds, flowering plants, mosses and liverworts.

Because of its biological uniqueness and geographical isolation, some people call Haida Gwaii the "Canadian Galapagos."

At one time old-growth forests of hemlock, cedar and spruce covered these islands. Much of these forests have been felled, and logging operations continue to expand into virgin territory.

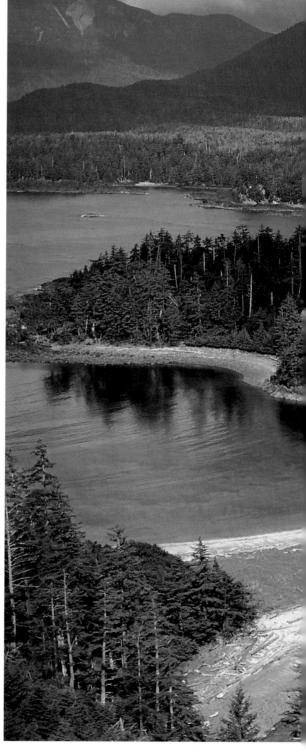

Duu Guusd

ABOVE:
The north shore of Duu Guusd near Pillar Rock.

The wilderness of Duu Guusd is almost as large as Gwaii Haanas (South Moresby), but it is not nearly as well known. Occupying the northwest corner of Graham Island, the landscape of Duu Guusd is quite different from the mountains and fjords of Moresby. Much of its 280 kilometres of coastline is a string of beaches separated by rocky headlands. Lashed by the full force of the open Pacific, this is one of the remotest shores in the province.

Parts of it, windswept and boggy, support only stunted growth, but this wilderness also has forests of large trees, particularly in its southern part.

In 1981, the Haida Nation unilaterally declared Duu Guusd a tribal park. This measure was part of its continuing efforts to protect its ancestral territories from overfishing and destructive logging.

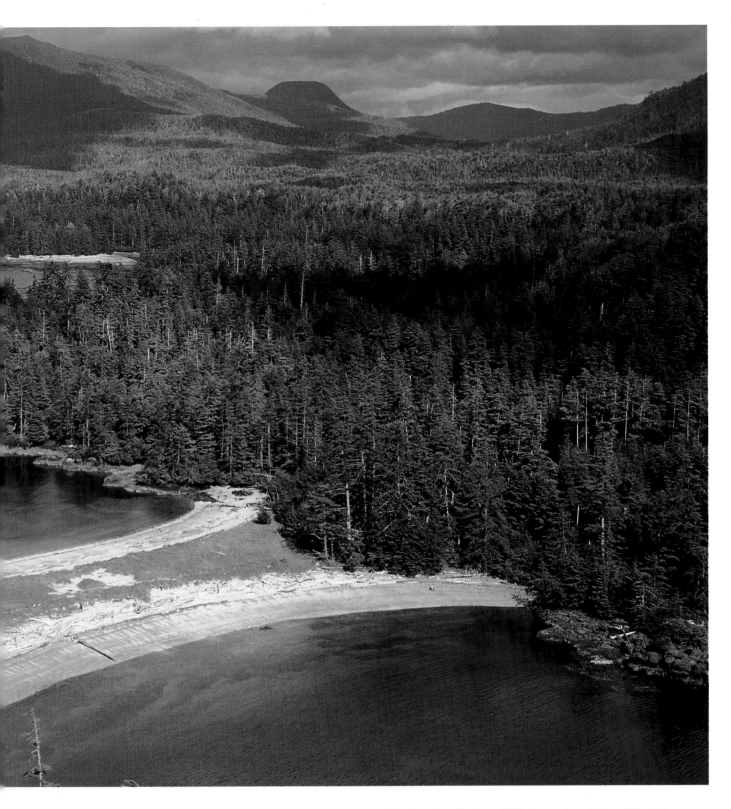

During the week I spent on the western shore of Graham Island, I was quite alone. Not even the night horizon was broken by the lights of passing ships.

When the motor began to fail, 40 kilometres of open coast lay between me and the nearest human outpost. I continued north at a fraction of my previous speed. I crossed the kelp beds in the lee of Frederick Island, and as I approached the beach at Beehive Hill, the engine died completely.

I landed near a stream the colour of tea. It trickled out of forest moss and after every tide carved a new channel in the sand. Wind-sculpted shore pines clung to a headland. The base of the rock, awash with foam, glistened in the uncertain sun. Mist shrouded the mountains.

Wind came, and then rain. I spent the night in the

Gillan Point, near the south end of the tribal park. Duu Guusd means "west coast" in the Haida language.

23

forest, in a rude framework a previous visitor had fashioned from beachcombed boards. I used my tarpaulin for its roof. The rain increased and the shelter leaked, and during a long damp night I awoke many times with glum thoughts of the motor.

I had a small auxiliary engine, but its tank was tiny, and I would have to refuel at sea several times between here and Cape Knox. There were no sheltered places to land. In a heaving boat, it is difficult to pour gasoline, and if the sea got truly rough, the trip would be impossible.

When the sun reappeared and my barometer showed no storm in the offing, I decided to embark. This beach was the most sheltered place on the coast, yet as I loaded my boat, every breaker threatened disaster. I carried my gear down the beach at a run.

The boat moved no faster than a canoe. After five hours I came into view of Lepas Bay. I knew I should continue north, to round Cape Knox while the weather was good, to get help at a fishing lodge at Langara Island. I was expected in Masset in two days, and knew I risked being trapped by the weather.

The former village of Kiusta on the north shore of Duu Guusd. Visible through the branches is the Edenshaw pole, and behind it stand the remnants of a row of great houses.

Kiusta was a major centre of the fur trade 200 years ago. According to one European visitor, its chief — Cuneah — was "acknowledged to be the greatest on the islands. His wife, of course, must be the Empress, for they are entirely subject to a petticoat government, the women in all cases taking the lead." The Spanish captain Jacinto Caamano recorded Cuneah's "graceful and easy manners" and wrote that "the bearing, simplicity, and dignity of this fine Indian would bear comparison with the character and qualities of a respectable inhabitant of old Castile." Some American observers recorded the business acumen of the Haida. The ship Jefferson *ran out of trade goods long before the Haida had run out of sea otter pelts. The ship's crew then bartered away sails, officers' trunks, flares, rockets, muskets, even the captain's spy glass. The Natives demanded and received 120 pounds of copper in exchange for 12 prime pelts. With nothing left to trade, the Haida invited the crew ashore to help with the smoothing, raising and painting of a totem pole in exchange for more otter skins.*

But I wanted to go east. I pulled out a crumpled map. It showed Lepas Bay, the rock pillars, Huck's cabin and many other landmarks in great detail. Thom Henley — "Huckleberry" as many call him — had drawn it from memory in New Guinea nine months before, during one of our interminable waits at a jungle airstrip.

Lepas Bay is four kilometres deep, and a series of sheltered coves make up its northern shore. I limped into the easternmost cove, and left the boat on the edge of a wide beach in the lee of a small island.

From a distance, Huck's cabin looks like a beehive. As I walked toward it I saw that it was octagonal, and I recalled the story he had told me of why he had chosen this shape. The shortness of the walls was imposed by necessity. He had been here alone, and could only use short drift-logs that he could carry on his own. Stacked in an octagon, the short logs made a spacious cabin.

I slid back the wooden bolt and found myself in a bright room with a hearth and rustic furniture. A ladder led to a loft beneath a skylight. Huck had not been here for years and the cabin was in poor repair, but the view of the beach through the trees was unchanged, as was the sound of the endless surf.

He had built the cabin in 1974. I met him many years later. The Huckleberry I know is an extrovert: campaigner for the preservation of South Moresby and the rainforests of Borneo, eco-tour guide, gregarious travelling companion. But for four months of his youth, Thom had chosen to live as a hermit on the shores of Duu Guusd.

After securing the boat I walked along the sand past the Haida longhouses of the Rediscovery Camp. The buildings stood silent. It was September, and the students who had gathered here had returned to a more conventional education. Next summer others would come to absorb the lessons of the landscape. Rediscovery is a program for Native and non-Native youth. Gatherings are

Sitka spruce near Kiusta. Black-tailed deer, introduced in the early 20th century, have considerably altered the vegetation of Haida Gwaii. In the absence of natural predators, these efficient browsers have multiplied and today you rarely see a fern on the forest floor.

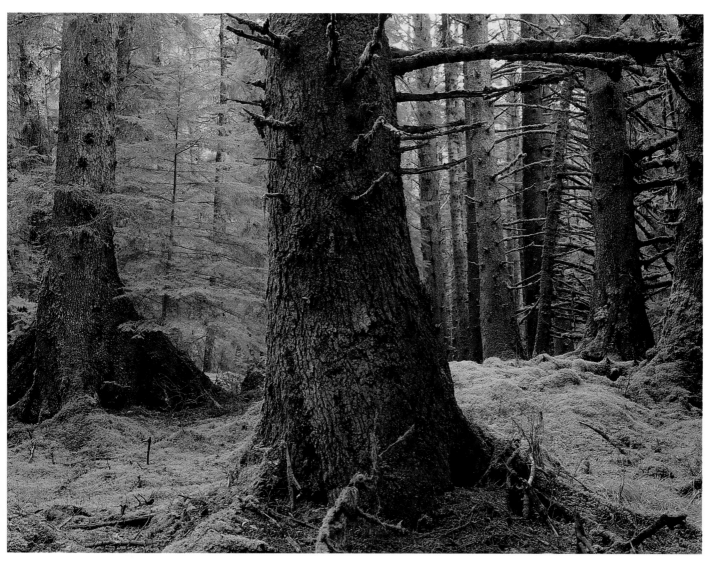

held in wilderness settings, and young people learn about nature, each other and themselves. The program is rooted in local community, and inspired by the relationship between indigenous people and their land. Today Rediscovery is an international organization, and there are camps in many places. The first one was here, in 1978, and Thom inspired and organized it. The seed of Rediscovery ripened in Huck's cabin.

I continued down the beach and reached the Pillar — a great stump of smooth stone rising from the beach. The top is green, as carefully arranged as a Japanese garden, topped with bonzai pines of exquisite shape. I was suddenly very envious of Thom's experience here.

Night fell, and I returned to the cabin. When I lit the candle I noticed an object on the wall. It was a small carved panel with a stylized face in its centre. Chiselled around this, in letters that looked like Thom's, was a fragment of a poem by Byron:

> There is a pleasure in the pathless woods,
> There is a rapture on the lonely shore,
> There is society, where none intrudes,
> By the deep Sea, and music in its roar.

My boat at Lepas Bay.

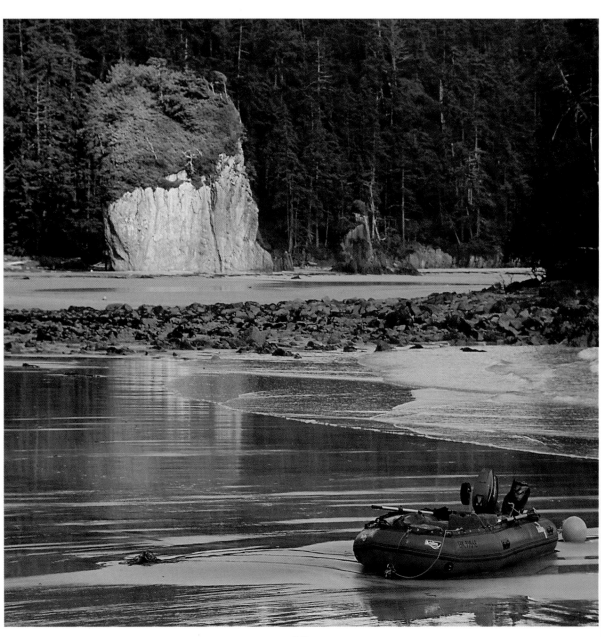

26

A Sitka spruce 9.8 metres (32 feet) in circumference stands near the shores of Yakoun Lake. Yakoun lies in the heart of Graham Island and is the source of the longest river on Haida Gwaii. Most of the Yakoun Valley has been stripped of its old-growth trees. Ancient forest surrounds the lake, but logging roads are nearby. This grove of giants is a 10-minute walk from a clearcut.

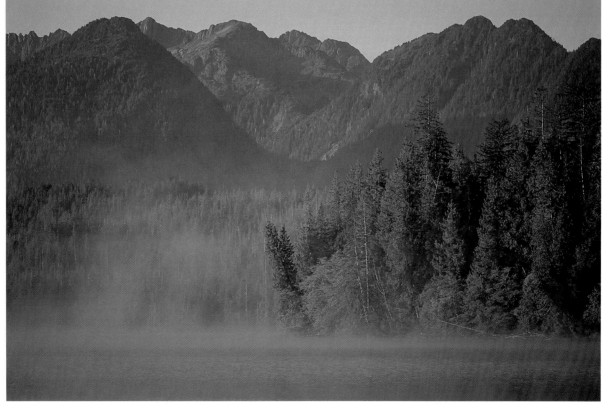

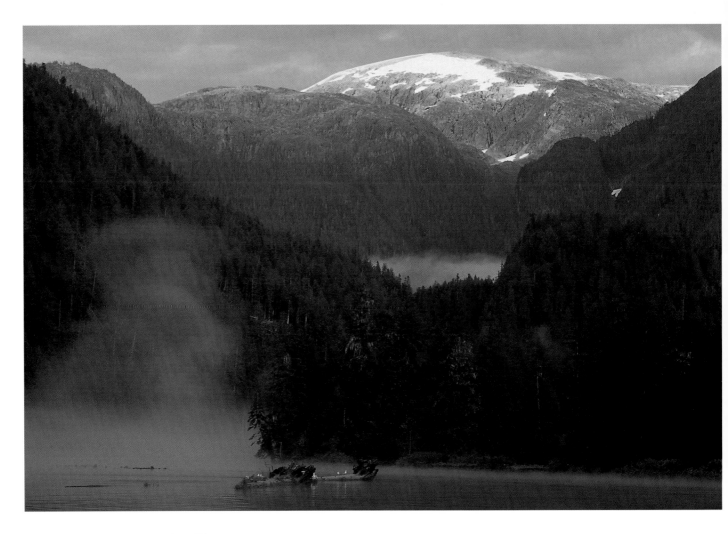

North Coast

Lying at the head of a pristine fjord, the 28,000 hectare Khutze Valley connects the Kitlope wilderness to the Inside Passage. It is part of the largest unlogged expanse of temperate rainforest on the continent.

My first trip to the north coast was a revelation. I had grown accustomed to southern shorelines marked by logging. Now, for the first time, I found myself sailing for hours in the shadow of mountains untouched by industry.

The greater part of British Columbia's rainforest falls within a strip 830 kilometres long by some 120 wide, stretching along the mainland coast from Washington to the Alaska border. In the southern half of this strip, only 18 watersheds of 5000 hectares or larger remain undeveloped. In the northern half, 94 remain untouched. In the south, these large watersheds occupy a total of 370,000 hectares; in the north, they cover more than 1.6 million. In the south, wild valleys of 5000 hectares or larger comprise only seven percent of the total area of a region that was blanketed in old-growth forest only 50 years ago. In the north, such valleys cover a third of the landscape. Most are remote. A number are not even named on maps. There are thousands of pristine smaller drainages as well.

Altogether, more than half of the northern rainforest coast remains in wilderness.

Much of this coastline is a labyrinth, part of the world's most extensive network of fjords and inside passages. It is this extraordinary terrain that has kept the region roadless and protected the forest until now. But with the exhaustion of much of the province's more accessible timber, large-scale clearcutting has begun. Forestry companies are stripping logs from remote fjords and valleys and dumping them into the sea for the voyage to distant mills.

Temperate rainforests are a rarity. They cover only some 0.2 percent of the planet's land surface. Half of them grow in the Pacific Northwest, and only those of the northern coast remain unfragmented. The temperate rainforest of northern British Columbia is a natural system of global significance, and much more than 12 percent of it warrants preservation.

His was the last human face I expected to see for a month. It was stormy that day, and we were alone at the boat ramp. Only the necessity of his work had brought him there, and when he approached for conversation there was desperation in his voice. "Why don't you join me in Giltoyees Inlet? It's only 30 miles. Beautiful place." His accent was Slavic, and he was clearly one of the many immigrants who had settled in the frontier town of Kitimat. His old homeland was a tame and populous place, and he had likely been raised in a crowded flat where early in life he had acquired the habit of constant human company.

We pushed off separately, bound for different parts of a vast network of inlets and sounds. In the hours that followed, I thought of him, alone, working his prawn fishery in that forest-lined fjord, so lonely that he had asked for the companionship of a stranger.

At first I shared his mood. My journey had begun in rain, and I knew that for the next four weeks my only shelter would be a tent. Perhaps my plan was over-ambitious. I had never travelled alone so long.

By the time I arrived in Princess Royal Channel the rain had stopped. The water was calm as oil, the air all stillness and mist. The trees were ghostly soft, and a cluster of maple leaves stood incongruously red against the moss-draped conifers. I passed a row of gulls, hundreds of

Green Inlet is joined to Green Lagoon by tidal rapids. A 19,000 hectare wilderness valley connects this fjord to Khutze, Kowesas and Kitlope.

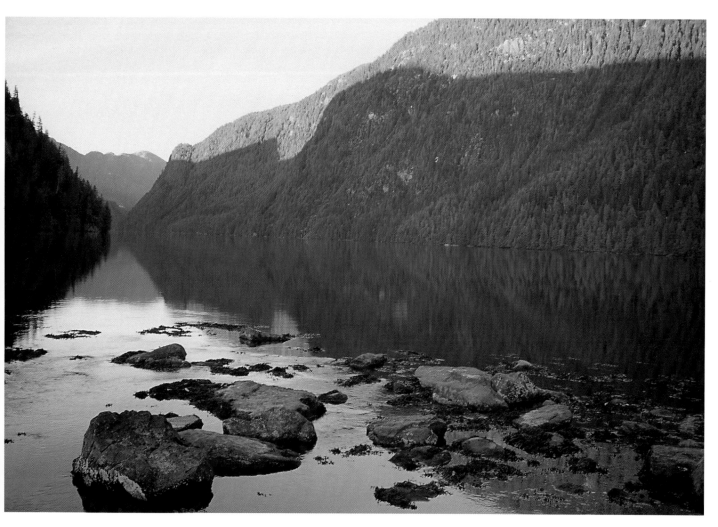

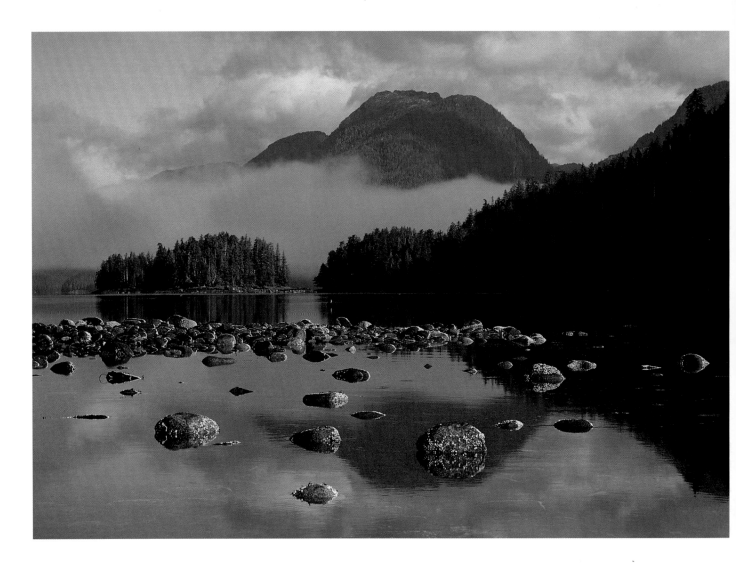

Separated from the mainland by a narrow passage, Princess Royal is the fourth largest island in British Columbia. It is home to the rare white Kermode bear and almost all of its 2274 square kilometres lie in wilderness.

them, perched on rocks at the water's edge, shining white through the fog like a pearl necklace strewn along the shore. They took wing, wheeled over my bow, and became grey silhouettes against a whiter sky.

In Khutze Inlet the mist was breaking, and mountain ice shone pink in a dying sun. I would sleep on a sedge meadow near the river mouth. As the motor sputtered into silence, a low flying heron left a trail of rasping cries. The last building was far behind, the final logging cut had yielded to forested mountain. The space around me was vast and wild. I was liberated.

The following morning my loneliness returned. Part melancholy, part panic, it loomed as large as the month that lay ahead. I did my best to push it aside. I stopped briefly at Swanson Bay, but found little solace among the overgrown ruins of a shingle mill abandoned for generations. The sight of other boats was comforting, but once I left the Inside Passage I was quite alone.

I made my second campsite in a small bay. As the

sea receded from the foreshore, I noticed a semicircle of stones, some 20 metres in diameter. It was a remnant of an ancient fishing weir. A century or two ago, it had supported a row of pickets, placed to trap fish in the ebbing tide. I imagined the people who had built it. Their houses may have stood on the place I had pitched my tent, long before smallpox and missionaries and government officials drove them to a distant settlement. Once there had been singing and laughter here and dancing in the light of cedar fires. Now there was silence and mist.

It was spawning season. I visited half a dozen stream mouths but found none with a sizable salmon run. I camped again, near the head of the inlet, and slept within earshot of a creek that plunged over a rock into the sea.

On the morning of the third day, I entered a bay filled with moving shapes. I pitched the tent inside the forest, beside a rocky bluff that overlooked a waterfall. It was the last of a series of small cascades. Every few seconds, a black form thrust against the hammering water,

then twisted backward into the ocean. I saw others, vaguely, enfolded in the frothing curtains, and knew that some of them would make it up the stream.

After a brief exploration, I returned to camp and found a black bear sniffing my tent. It looked at me and vanished into the trees.

I met a second bear while walking in the forest, in a place where deep shade allows only moss to grow. I was suddenly aware of a head, not five paces away, a wedge of black suspended in soft green. The animal's body was hidden behind an ancient stump. Eyes staring into mine, it half opened its mouth and let a string of drool fall from its tongue. The head sank out of sight. I approached the log and looked beyond, but saw only forest. The apparition had been soundless.

A third sighting sent me racing for my longest lens. There, lumbering along the shore 1800 kilometres from the Arctic Ocean, was a large white bear.

In 1900, a naturalist named Hornaday saw a pale pelt among bear furs from the northern coast. He thought he had found a new species, and named it *Ursus kermodei*, after a curator of the provincial museum. He was mistaken: the bear was *Ursus americanus*, the American black bear. Some bears on the north coast carry genes for whiteness. The trait is recessive — both parents must carry it to produce a kermode. These animals are rare, occurring in only a few places on British Columbia's northern coast. On Princess Royal Island, perhaps one bear in ten has a white coat.

I ducked behind bushes and crawled over rocks as I sought a succession of discreet vantage points. I fumbled with equipment that was scarcely in place before the animal moved out of view. It wandered over the intertidal zone, lingered at the lower waterfall, and disappeared up the creek.

Nothing in nature links death with life more perfectly than a spawning stream. Breeding and dying in the river of their birth, salmon are the central players in an existential drama. Just above the falls, most of them were quite alive. They stampeded at my approach, exploded into sudden maelstroms, found strength to crawl over shallows with backs and fins high in the air. But some had already lost their vigour, and the further upstream I went the more tattered they became. Thousands had already completed their final duty and lay on their sides, only their mouths still moving.

In death they were doubly generous. They passed their lives on to their offspring and surrendered their flesh to a variety of creatures. Ravens, gulls and eagles fed on carrion. Otters hunted swift-moving fish near the river mouth and wolves patrolled the upstream banks for more enfeebled prey. At almost every bend I met a bear, poised at a rapid or splashing through a shallow. Some were so preoccupied they hardly noticed me. I came upon a young one lunging futilely after fish in deep water. It scampered into the forest when it saw me.

A large kermode approached along the river, stopping here and there to sample a carcass. He had torn his right ear in some old battle, and he obviously rarely yielded to another bear. He paid little attention to me. He

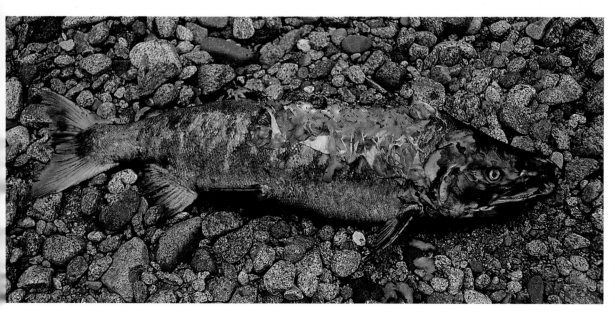

Many kinds of scavengers feed on the spent bodies of spawning salmon. When fish are abundant, bears often take a single bite from the upper back and then move on.

31

found a salmon to his liking and carried it into the forest. I was grateful for his lack of fear. His was the only community here and I felt a yearning to belong.

On my third day upriver, I awoke to rain. I unzipped the flap and found my tent almost awash. I had camped on the bank of a small tributary lake and during the night it had overflowed. The creek had risen with it. Gravel bars that had been littered with fish the previous day now lay beneath a foaming torrent. The salmon feast was over.

I had no choice but to return to my boat through the forest. The terrain was broken and the underbrush thick, and at nightfall I was still far from the sea. There was no flat ground, so I dug a space for my tent in some soft soil. I unearthed two fish that a provident bear had buried.

The sun was shining when I reached the bay, and I spread my things to dry. I rested till dusk on the moss-draped bluff and watched the tide slip out. A family of otters emerged from the waterfall and swam to their den at the base of my rock. Constellations appeared in familiar places. As I looked at the sea in the light of my headlamp, a hundred orange embers drew serpentines in the water. It took me a while to realize that they were salmon eyes.

My solitude was a sweet insanity. The frustration of an innate need for companionship should have caused me distress. Instead, I found myself in a strange state of bliss. Familiar faces faded into mist and my own appearance became a memory, yet I felt no yearning for humanity. Deprived of the pleasures of warmth and touch, I felt content to caress the landscape.

The only speech I heard was mine. My only connection to the world of words was a single volume, chosen for its physical lightness and spiritual weight. I savoured it every night by the light of the fire. It was a novel by Balzac, set in another country in a bygone age, the kind of book one normally reads as an escape to an exotic place. But here it served to ground me in the world that I had left, and the people in its pages were a reminder of my eventual return. Yet I still exulted in the knowledge that my trip was less than half complete.

The following morning, a yacht entered the bay. When I saw it I knew it was time to leave. Its tender came ashore, and as the crew approached I felt as vulnerable as a bear surprised in the forest. Speech came with difficulty. They told me that they had come to observe kermodes and I explained to them that the creek had gone into flood. They went to see for themselves, then returned to their ship and weighed anchor. When the noise of the motor had faded away I decided to stay another night.

OPPOSITE:
Kitlope Lake.

RIGHT; Kermode
bear, Princess Royal
Island.

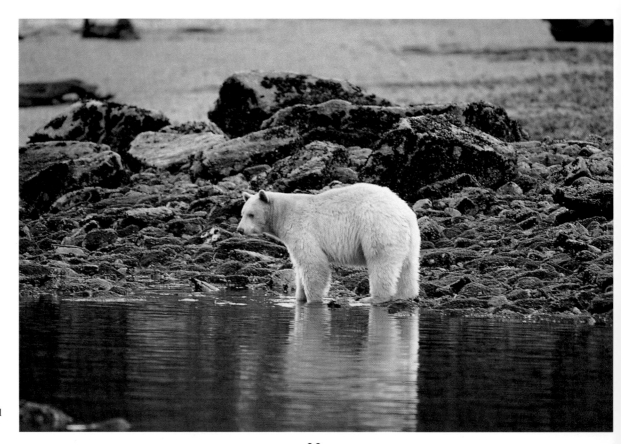

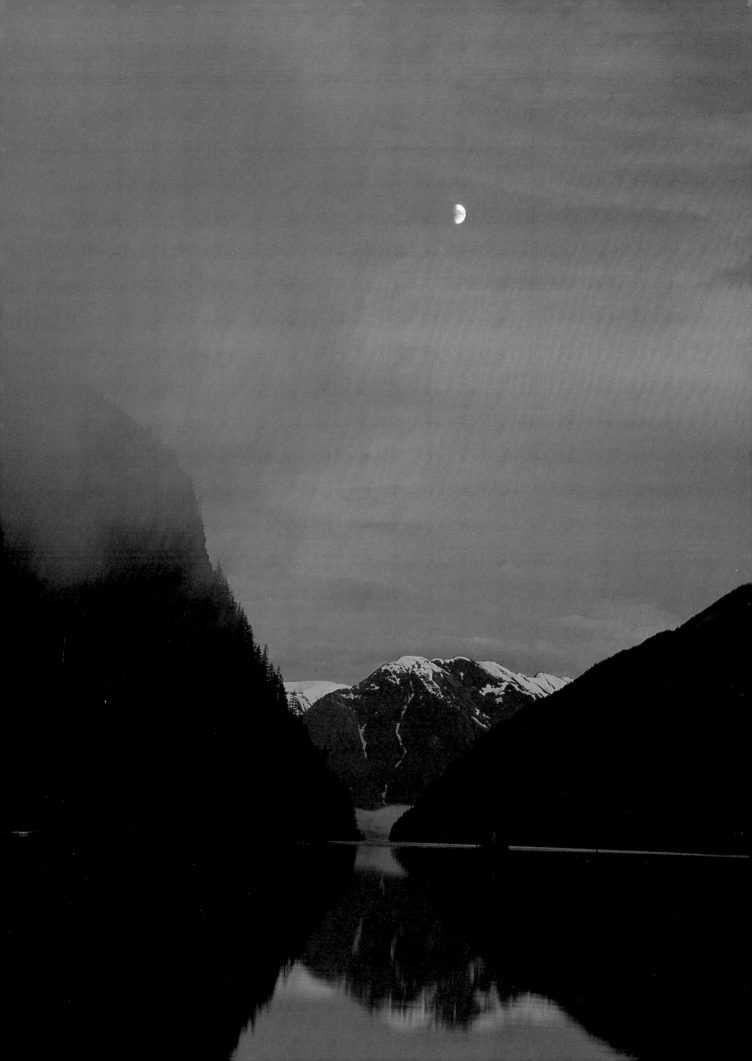

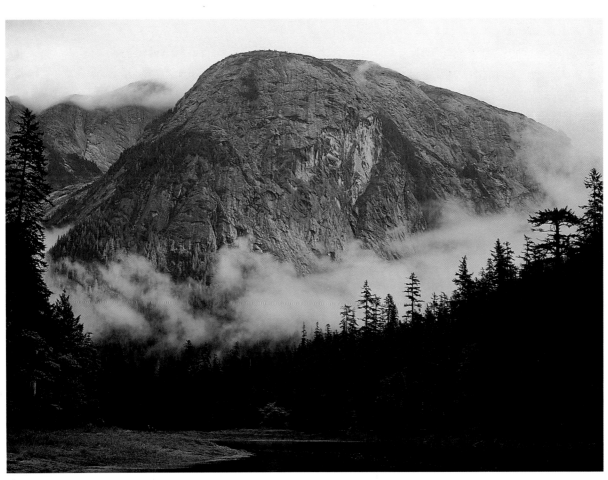

Owyacumish Bay on the Gardner Canal, gateway to the Kitlope.

BELOW: The Kitlope River, near its outlet at the head of the Gardner Canal. The Kitlope is British Columbia's largest intact coastal watershed. Along with neighbouring Tsaytis drainage, it covers 317,000 hectares, half of it forested. In 1994, the provincial government announced its intention to protect these watersheds. The Kitlope lies at the heart of a much larger wilderness.

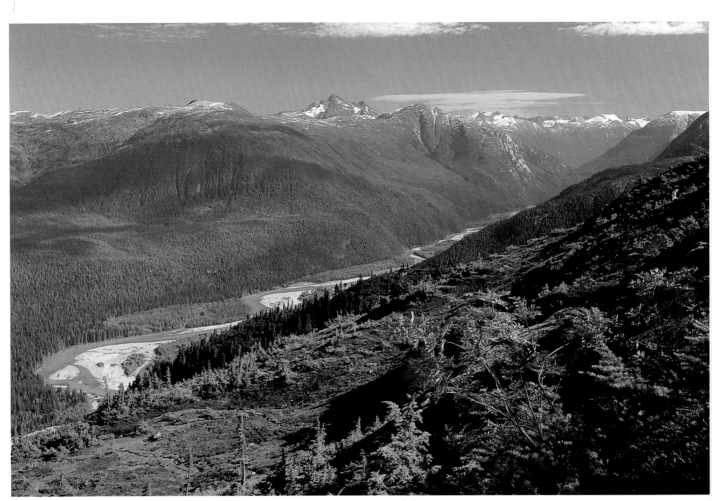

The Gardner is the longest fjord in the province and spring runoff makes its surface waters fresh as a mountain lake. Though washed by six metre tides, its granite walls are free of barnacles. Streams cascading from great heights plunge into deep water and envelop passing boats in spray. You can watch mountain goats from the ocean.

Not all its shores are vertical. It has small beaches where you can put ashore and pitch a tent in a pocket of moss-lined forest. At stream mouths there are grassy floodplains, gardens of wild roses, a hotspring, a waterfall with a resident rainbow.

The distance by sea from Kitimat to the head of the Gardner is 150 kilometres. During the first half of this voyage you pass massive logging cuts. During the second half, the only sign of human impact is the wharf at Kemano Bay. The forests of the fjord's steep walls remain intact — most trees are too small to be worth cutting — but the Gardner's pristine tributary valleys are in danger. A dozen of them each cover more than 5000 hectares. Ten are licensed to be logged, including the Kowesas, Barrie, Brim, Owyacumish and Kiltuish.

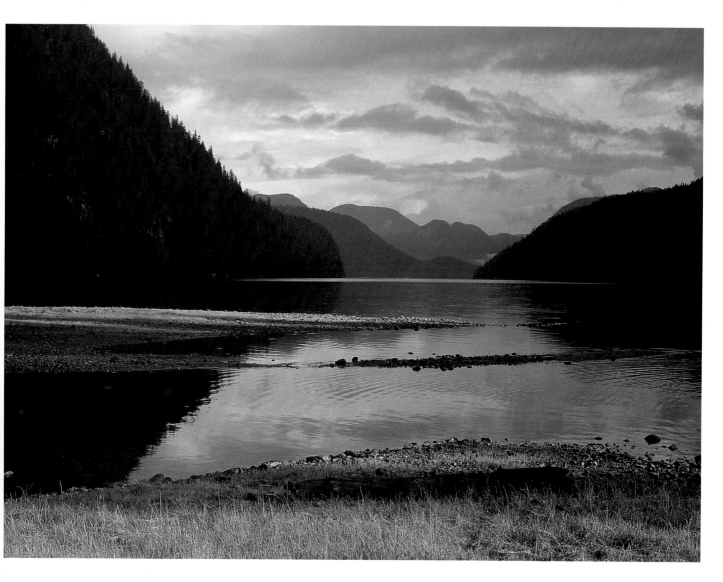

Looking south from the head of Spiller Inlet, 170 kilometres by sea from Bella Coola.

Just down Spiller Inlet lies Ellerslie, a wild lake with 80 kilometres of shoreline, whose waters thunder over a cliff into the sea. Spiller Inlet is in the southern part of 800,000 hectares of unbroken wilderness, an area that includes the Kitlope Valley and the Gardner Canal and connects the peaks of the Coast Range with the shores of the Pacific Ocean. A policy of protecting a maximum of 12 percent of the province's land base will condemn most of this wilderness to industrial development.

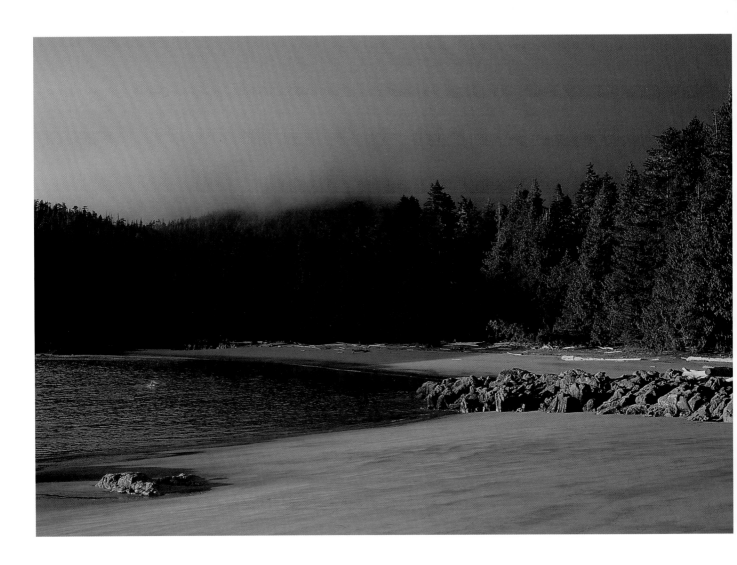

Fed by a series of low-lying lakes, the Koeye rolls through a gentle valley, an estuarine marsh, a tidal canyon and a beach-lined cove. This 19,000 hectare valley is almost entirely covered in cedar-hemlock forest.

Our complacency was born of the landscape, an inland sea of fjords and channels lined with pristine forest. Rarely was ocean travel so effortless and pleasant. For 120 kilometres, the distance between Bella Coola and the mouth of the Koeye River, we felt as if we were cruising the waters of a calm lake. But it was no lake, and the ocean would punish our presumption.

As we entered Koeye Cove, the beach glowed yellow in the sinking light and mist was gathering over the trees. The bay was shallow, and we saw a bottom that seemed to be covered with black stones. When the stones moved we knew they were salmon, vast shoals of them gliding over the sand and flowing around our advancing boat. We reached shore and turned off the motor and heard the sound of their jumping. At any moment, two or three of them flashed in the air, and when they fell back, like swollen drops at the start of a heavy rain, they covered the sea with rings.

Our bare feet sank into warm sand and we melted into languor. Some moments are too flawless, some places

excessively perfect. No mosquitoes troubled the August twilight, no clouds obscured the multiplying stars. Erecting the tent seemed a pointless exercise and hauling the boat up the beach an unnecessary labour. After unloading our gear, we left our craft floating in the motionless water, its bowline tied to a large log.

The night was black and the stars were bright, but the sea shone brighter still. A million radiant points floated in the invisible ocean. A shimmering band marked the place where the water lapped the shore, for wherever the sea is set in motion, the bioluminescence of the algae is intensified. The wake of every fish made a glowing gossamer trail.

The glow of those fish drew us to the ocean. We soon found ourselves walking in it and watching our legs fluoresce with every stride. I waded past the point where we had put ashore. On my right, I sensed the dark shape of the mooring log.

There was no rope. Blood rushed to my face. I splashed through the water to the place where I had

attached the line. The root I had used as a cleat was now covered by the rising tide. The ocean had untied my knot. Our boat was gone.

The coast here is flat, and, as it approaches the sea, the Koeye River winds through broad fields of sedge. This tidal marsh begins a kilometre from the sea and drains through a narrow channel between rocky walls. When I turned on my flashlight to examine the current, I made a startling discovery: the Koeye was flowing in reverse. The tide must have carried our boat into the estuary.

In an hour, the waters would cease to rise. In two, the river would resume its normal flow. I decided that if our boat should reappear, I would swim out to recover it. My plan presented both a risk and a difficulty. The risk lay in the danger of a cold swim in a black ocean. The difficulty arose from the impossibility of seeing an object more distant than 30 metres. The beams of our small headlamps would reach no further.

Some solutions appear in a flash. Ours unfolded in a series of small explosions. We built a fire on the point of land nearest the river mouth and every minute or so threw a half cup of gasoline into its flames. Fifty times our eyes strained in the surge of orange twilight. Fifty times we saw nothing but swirls on the surface of the oil-black water and our own flickering shadows against the fading trees. Our boat did not return.

As we prepared to sleep we heard the throb of a motor. A fishing boat appeared inside the mouth of the cove, dropped anchor, fell silent, and turned off its lights. We ran along the shore and shouted and blew our whistles, but there was no response.

The sound of the departing fishing boat woke us. It was first light and the tide was out. I followed the mud flats that line the mouth of the river. I passed three or four dilapidated cabins and a collapsing pier, which my chart told me had belonged to the Koeye Lime Company. Further east, I saw the sheer walls of the canyon. On either side stood dense forest and thick brush. I knew from the map that the estuary was large and might take days of bushwhacking to explore. In any case, I doubted we would find our boat upstream. I returned to camp.

Our predicament was rather strange. We were castaways in a wilderness a hundred kilometres from the nearest highway. Yet we were camped on an idyllic beach in summer weather and had food enough for two weeks.

In the distance, we watched boats ply the Inside Passage.

In time, one of those boats would surely enter the bay and rescue us. We sat on the beach and waited. When an airplane flew over, we waved our orange tarpaulin. When an Alaska-bound cruise ship appeared in the distance, we paused in the middle of our Scrabble game and flashed signals at it with the mirror of a pocket compass.

I was secretly relieved that our feeble efforts to summon help had apparently failed. I was not looking forward to the humiliation of explaining our predicament to a stranger — a fisherman, perhaps, or a Coast Guard officer politely listening to the story of a fool who couldn't tie a knot.

The following day a small boat entered the cove. We waved our tarpaulin and the vessel approached shore. When I saw "Canada" emblazoned on the bow, I vowed to never again begrudge my taxes. The lone crew member was a student whose summer job was monitoring salmon runs. He was friendly, not even slightly snide, and cheerfully offered to look for the boat. Ten minutes later he emerged from the estuary towing our orange inflatable. It had been stranded in the marsh. Our purgatory dissolved into an August day.

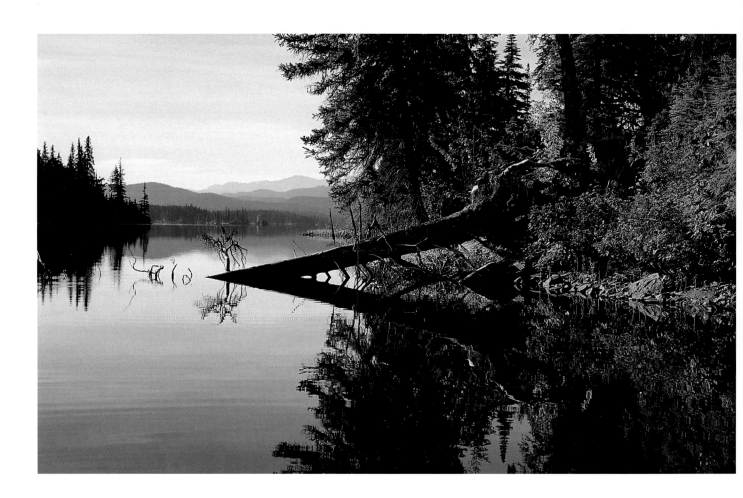

ABOVE: Swan Lake lies near the inland limit of the northern rainforest. The surrounding terrain is flat and if not for glimpses of distant peaks canoeists might imagine themselves in eastern Canada. Although invisible from the lake, the country to the south and west has been extensively logged. But endless wilderness lies to the north: the headwaters of the Kispiox and Nass, and beyond these the great boreal forest. A portage trail connects Swan Lake to Brown Bear Lake, which owes its name to the area's large grizzly population.

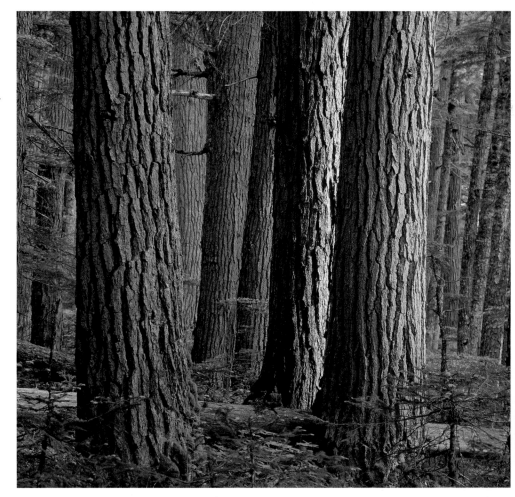

RIGHT: A stand of western hemlocks and mountain hemlocks on the western slope of the Seven Sisters. A compact massif of glaciated peaks some 60 kilometres north of Terrace, the Seven Sisters are a scenic highlight of the Yellowhead Highway. Around the flanks lie almost 100,000 hectares of forest, one of the few remaining undeveloped tracts of the Skeena River system.

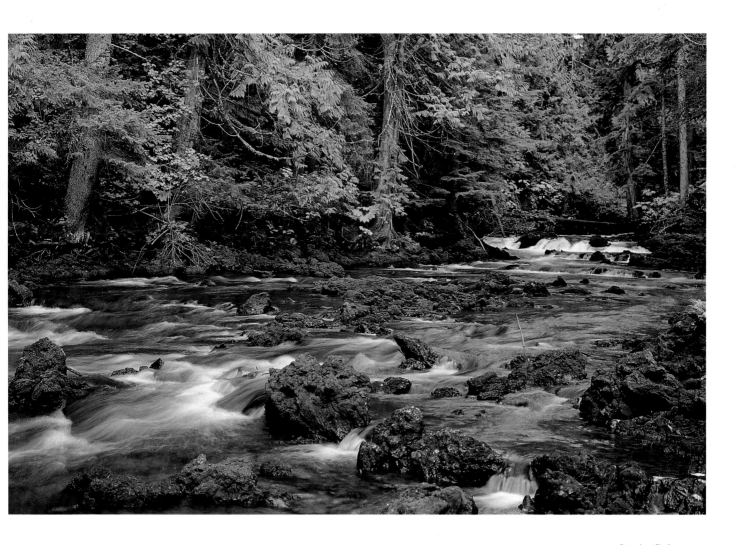

The northern component of the Interior Cedar-Hemlock Biogeoclimatic Zone lies between temperate coastal rainforest and cold interior woodlands, and borrows its diversity from both. This forest type characterizes the valley bottoms of the upper Nass and Skeena drainages. The Interior Cedar-Hemlock Biogeoclimatic Zone is interrupted by the Fraser Plateau and is found again 400 kilometres to the southeast, where it dominates lowland areas of the Kootenays.

Interior Cedar-Hemlock forest, Nisga'a Park.

Some 250 years ago a volcano erupted in the Hazelton Mountains. A flood of lava spread over more than 50 square kilometres, incinerating forest and raising an enormous cloud of steam as it diverted the Nass River. The lava must have flowed rapidly, for according to Nisga'a history it claimed the lives of some 2000 people. According to tradition, this disaster was punishment for the mistreatment of salmon, and the flow was finally stopped some 30 kilometres from its source by the intervention of spirits.

Nisga'a Memorial Lava Bed Park was created in 1992 at the initiative of the Nisga'a Tribal Council. The Council administers the park as a joint venture with the British Columbia government. It contains a number of interesting volcanic features including craters, lava tubes,

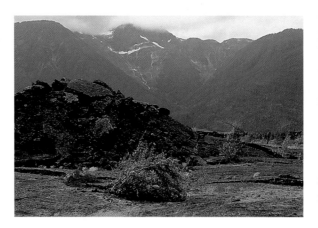

pressure ridges and tree molds. Sii T'ax (New Water) is a lake that formed behind a lava dam. Most of the park's 18,000 hectares are occupied by the lava plain, alpine meadows and ice-capped peaks.

Nisga'a Memorial Lava Bed Park, near New Aiyansh in the Nass Valley. This is Canada's most recent lava flow. Other than a fragile layer of pale green lichen, little vegetation has reappeared on the plain along the Nass River (left). But nearer the source of the flow in the headwaters of the Tseax, forest has reclaimed the lava (above).

Vancouver Island

Victoria was a bustling city by the end of the 1850s. The southeast corner of Vancouver Island was logged, settled and farmed earlier than any other region of the province.

Today, a majority of the island's population still inhabits this area: a corridor of dense settlement stretches from Victoria to Courtenay. Much of it consists of picturesque farms and pleasant towns, as tame and civilized as any country in Europe. Yet just to the west, on the other side of the island's mountain spine, survive some valleys that have scarcely changed since Captain Cook first sighted Nootka Sound.

Most of the island's ancient forest has been destroyed. As recently as 1954, around 1.7 million hectares of it remained. By the early 1990s, industry had reduced the forest to half this figure. Vancouver Island has 170 watersheds larger than 5000 hectares, but fewer than a dozen remain pristine. Despite a recent flurry of park creation, most of Vancouver Island's old-growth trees are destined to be logged.

The forest that remains is of immense biological and esthetic value, for it is unsurpassed in the world. Larger tracts of temperate rainforest survive on the northern mainland coast, but trees there are generally smaller. Western Vancouver Island is the mildest and wettest place in Canada, and in these ideal growing conditions, cedars and hemlocks reach their maximum stature.

In no other place on the continent do trees this large survive in such numbers so close to the ocean shore. The trees of Washington's Olympic Peninsula rival in size those of Vancouver Island. But after a century of logging and settlement, not one coastal valley larger than 5000 hectares remains intact anywhere south of the border.

It is no surprise that Canada's six largest redcedars were found on Vancouver Island. Two of them, each more than 18.9 metres (62 feet) in circumference, are unsurpassed in the world. Canada's tallest known western hemlock is also on the island. At 96 metres (314 feet), the Carmanah Giant is both Canada's tallest tree and the world's tallest known Sitka spruce. It stands in a wild valley 100 kilometres from downtown Victoria.

Douglas-fir and arbutus near Little Qualicum Falls, just west of Parksville. The second-growth Douglas-fir stand in the background typifies much of southeastern Vancouver Island.

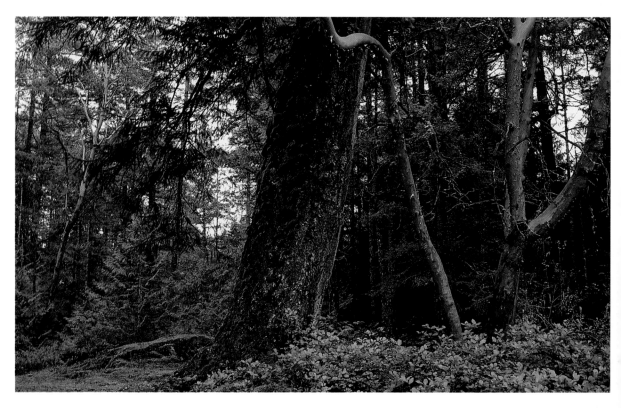

This landscape is part of the Coastal Douglas-fir Biogeoclimatic Zone, an area of reduced rainfall on the east side of the Vancouver Island Range. The relative dryness of this region results in periodic fires that favour Douglas-fir, the first conifer species to regrow after the forest has burned. No wilderness remains in this zone.

RIGHT: Near Power Lake on the wild and wet western side of the island.

40

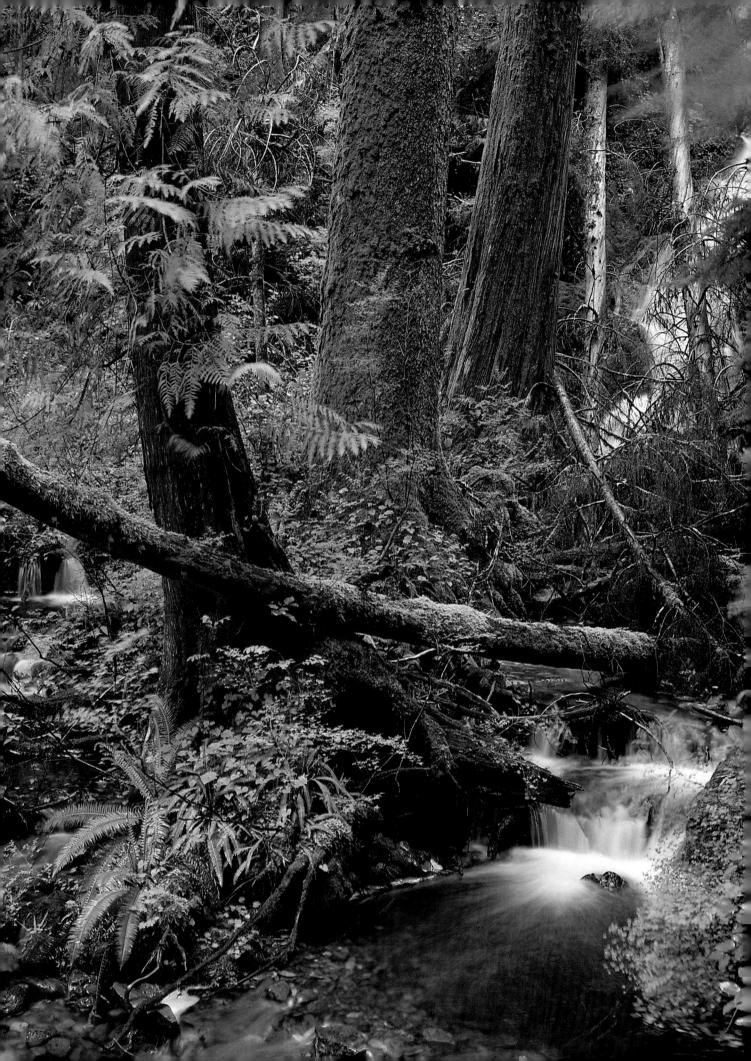

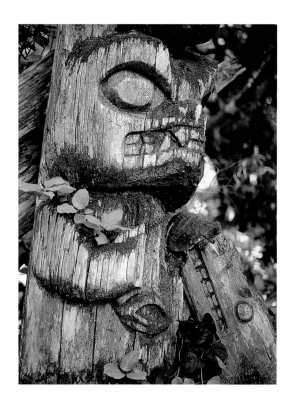

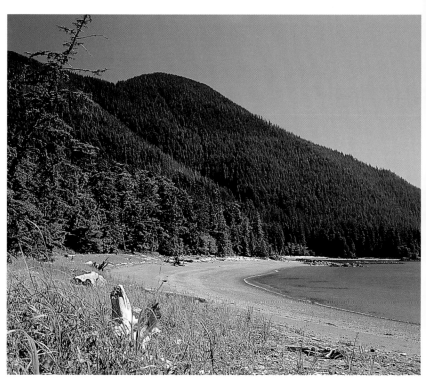

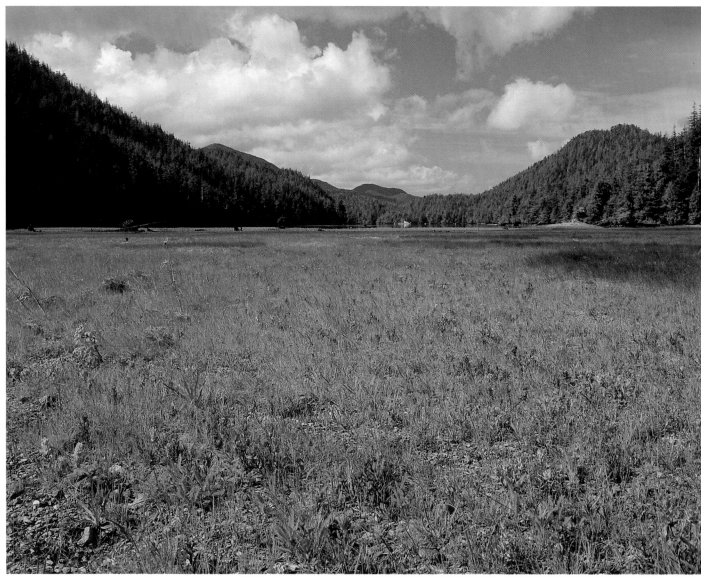

Brooks Peninsula Wilderness

Brooks Peninsula, a rectangle of rock 10 kilometres by 16, juts into the Pacific like a great broken tooth. It is the most isolated part of Vancouver Island. When the weather is good, you can reach it by sea: a 50 kilometre voyage through surge and spray, past forested islets, seething shoals, fields of kelp and breakers.

At the beginning of the voyage, vast clearcuts blight the landscape. The worst lays bare the seaward flank of Mount Paxton, a broad mountainside stripped from summit to shoreline. Just past the mountain lies a tiny emerald archipelago, the Bunsby Islands, home to a colony of reintroduced sea otters. Then comes Battle Bay at the southern corner of a 40,000 hectare wilderness, the largest enclave of pristine forest north of Clayoquot Sound.

Five wild rivers surround the landward end of Brooks Peninsula.

The largest of these rivers is the Power. It widens into a lake with a sandy beach, and its valley shelters groves of mammoth Sitka spruce.

Battle Bay Creek flows next to it, with a tiny natural harbour tucked into its estuary, a place where you can pull a boat onto the sand. Nearby are the ruins of an ancient village. Old bones lie on a graveyard islet.

The third stream is Nasparti Creek, home to British Columbia's largest spruce, judged on a combination of girth, height and crown spread. These three river valleys received protection in 1995.

The fourth stream lies north of Brooks. The Klaskish drains into a tidal basin that is one of the calmest anchorages on the coast. To reach it, you travel 40 kilometres around the windswept shores of the peninsula. At the upstream end of the Klaskish basin, wide grassy flats blend into forests of large spruce. Bear trails lead upstream through stands of hemlock and cedar.

The fifth stream is East Creek, and I visited its mouth only once. Even at high tide the estuary was too shallow for my boat. I looked into the distant forest and regretted not having brought my canoe. Perhaps one day I will return. Perhaps when I do the forest will be gone.

FACING PAGE, TOP LEFT: A totem pole at Battle Bay, near the northern limit of Nuu-chah-nulth territory. The Brooks Peninsula marks the boundary between the Nuu-chah-nulth and Kwakiutl peoples.

FACING PAGE, TOP RIGHT: Battle Bay.

LEFT: Indian paintbrush dots the flood plain of the Klaskish estuary. The Klaskish River and neighbouring East Creek drain 9000 hectares of old-growth forest. Both valleys are licensed to be logged.

RIGHT: Sitka spruce in Power River valley,

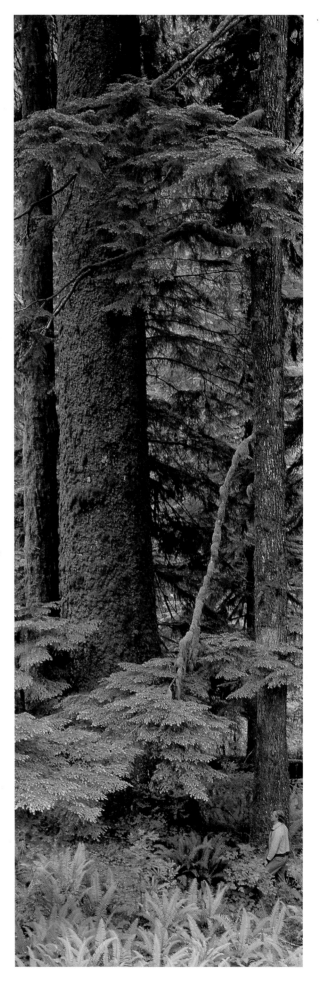

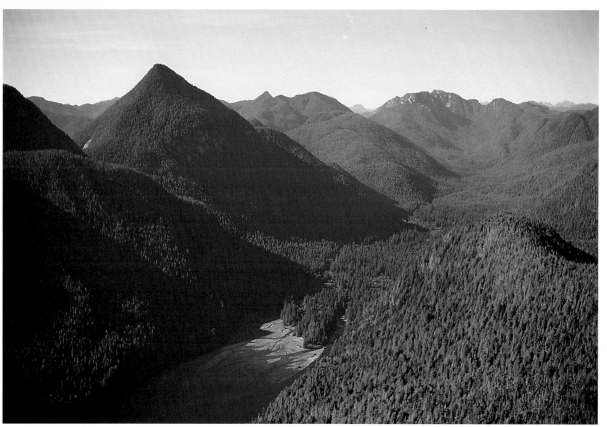

The 5300 hectare
Sydney Valley lies at
the western end of a
150,000 hectare
wilderness that
stretches from the
icy peaks of
Strathcona Park
to the waters of
Clayoquot Sound.
This wilderness
contains Vancouver
Island's largest
unbroken sweep of
old-growth forest.
Logging still
threatens the Sydney.

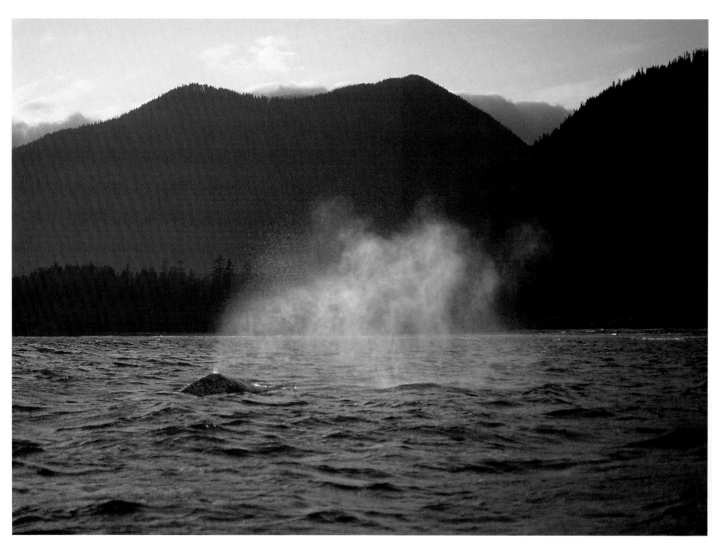

Clayoquot Sound

A century ago, some 2.3 million hectares of old-growth forest covered the valleys of Vancouver Island. Today, two-thirds of the forest is gone. Most of the rest has been fragmented by roads and clearcuts.

By far the largest tracts of the island's remaining ancient woodland grow near the shores of Clayoquot [kla-kwot] Sound. Three-quarters of Clayoquot's ancient hemlocks and thick-trunked cedars survive. The valleys that drain into the sound, and the islands that rise from its depths, support some 160,000 hectares of primeval woodland.

Until recently, the trees of Clayoquot have enjoyed a natural protection. Roads are costly in this difficult terrain, and forming log booms in the open Pacific is not an option. The survival of this wilderness is a gift of the mountains and the sea. They are the reason for the miracle of Clayoquot: the edge of this great forest is only a three-hour drive from British Columbia's capital.

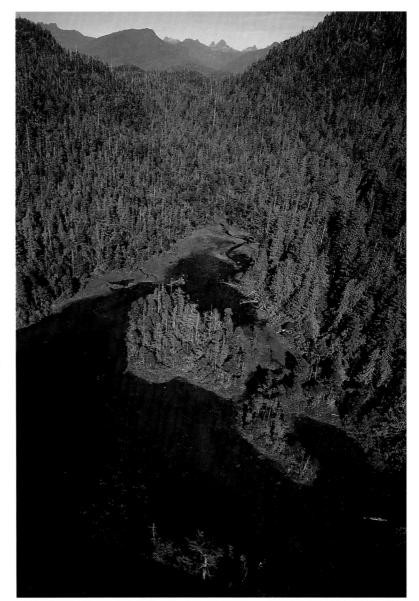

UPPER RIGHT: An unnamed lake in the interior of Flores Island. Some 12 kilometres wide by 15 long, Flores is the largest island in Clayoquot Sound. Its hinterland is trackless. Three-quarters of the island remains available for logging.

LOWER RIGHT: Pretty Girl Lake, in an area of Clayoquot designated for logging.

LEFT: Whale in Cow Bay, Flores Island. Every March, hundreds of grey whales travel past Clayoquot on their annual migration from the Sea of Cortez to the Gulf of Alaska. A few of them remain here. These resident whales spend the summer months straining crustaceans from the sand and mud of Clayoquot's bays.

OVERLEAF: Cow Bay on the southern coast of Flores Island.

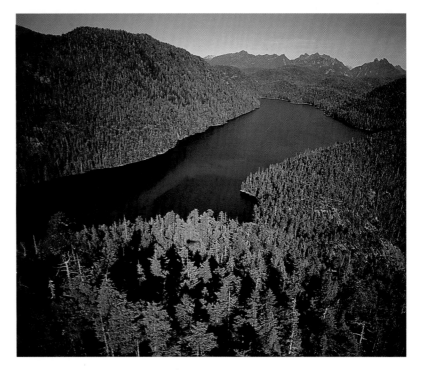

45

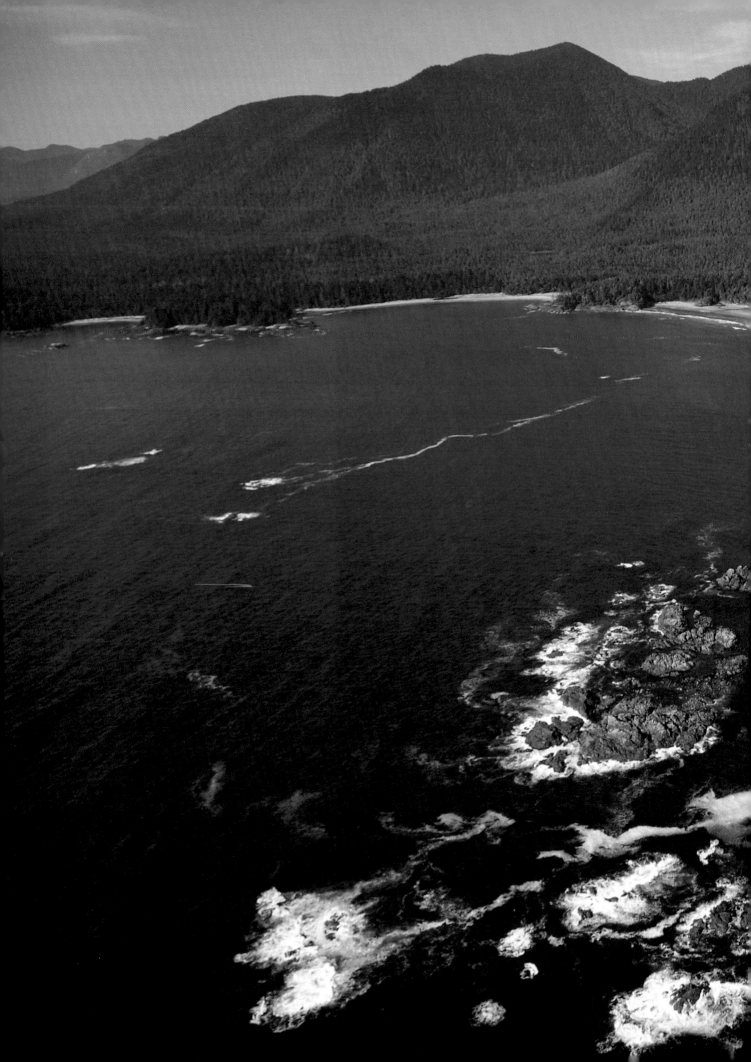

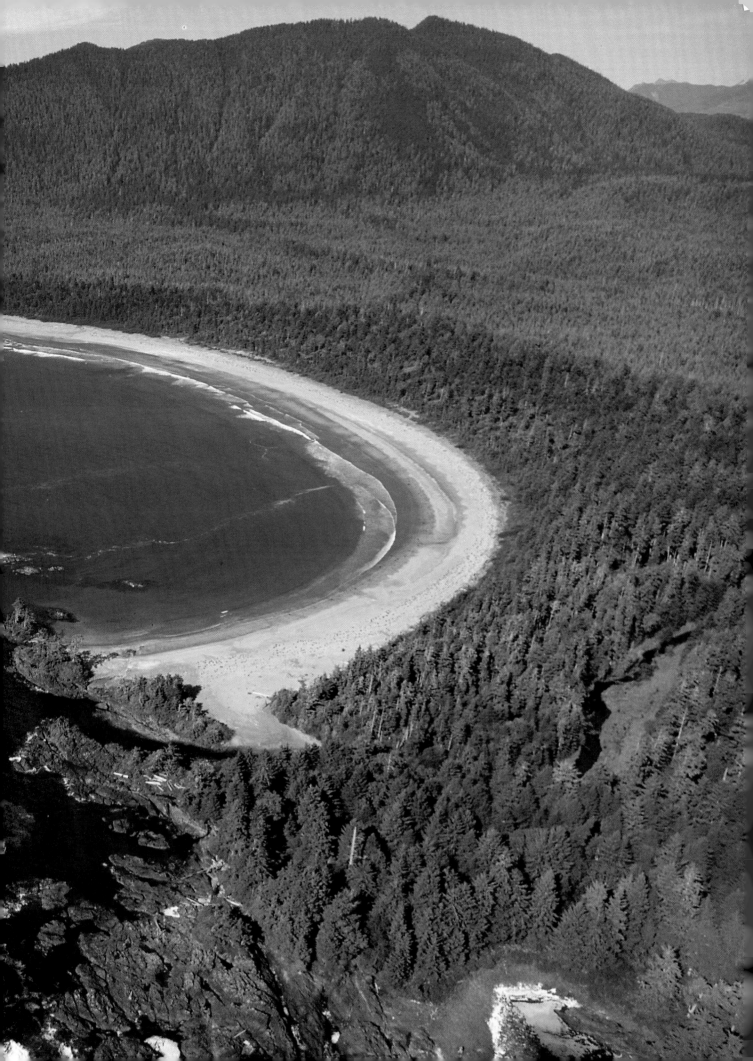

ABOVE: An unnamed lake on Flores Island. On a windless day, you can watch thousands of pink salamanders crawl among the roots of the water lilies. Salmon spawn here in the fall. Groves of giant cedar grow nearby.

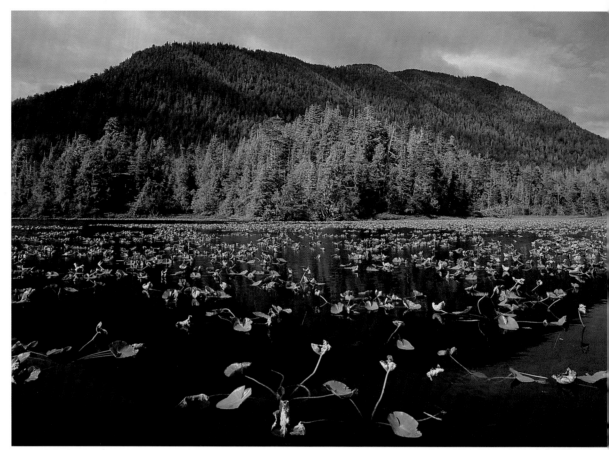

BELOW: Looking east after sunset from the shore of Vargas Island. The mountains are on Meares Island, forest backdrop of Tofino and home to some of Canada's largest redcedars.

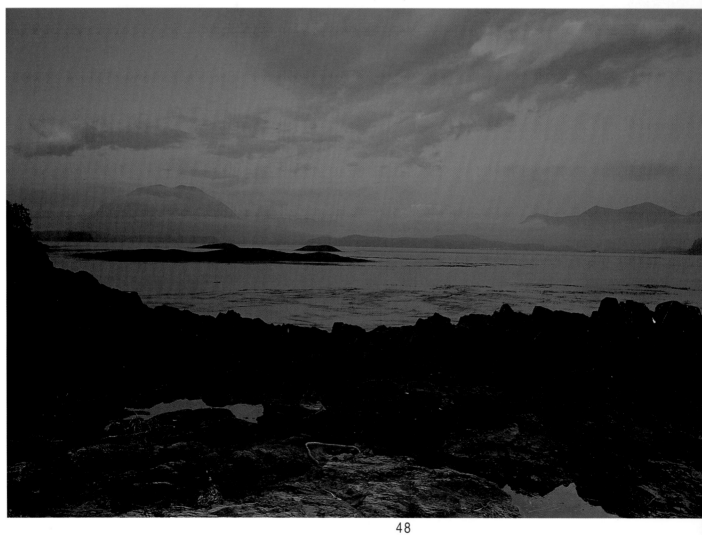

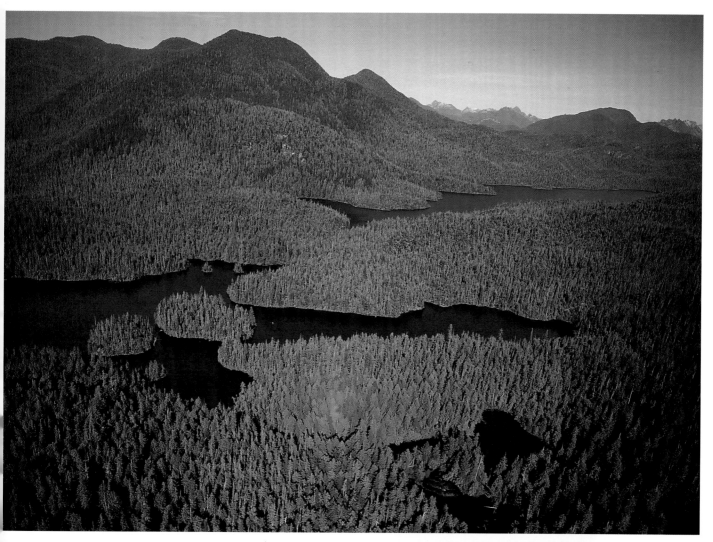

ABOVE: Cecilia and Easter Lakes, an area adjacent to the Megin watershed. This landscape is still zoned for logging.

LEFT: I took this picture during a flight over Flores Island in 1994. None of the local people to whom this picture was shown were aware of the existence of this natural monolith. When, a year later, my brother and I made a second flight for the purpose of determining the exact location of this curious object, we were unable to find it.

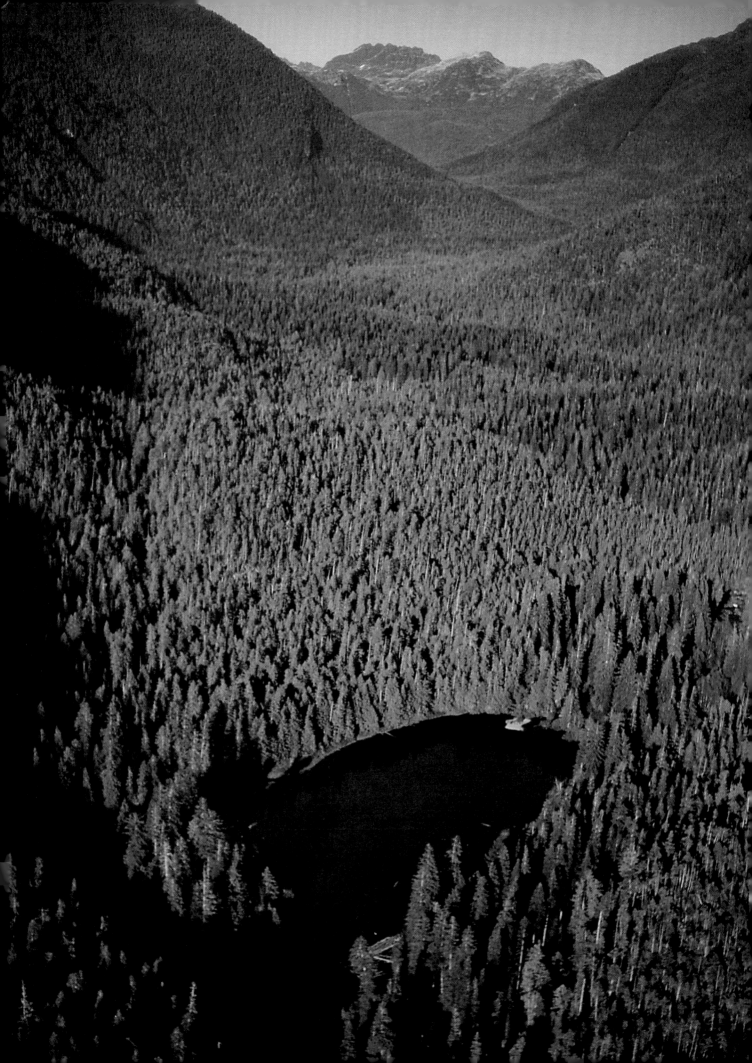

Clayoquot is a meeting of the forest and the sea. Thickets of salal sprout among logs tossed high by long-ago storms. Moss and fern grow atop cliffs pierced by grottos and foaming coves. The sound of surf on white beaches sinks to a whisper among trees older than the cathedrals of Europe.

Clayoquot is the richest remnant of primeval British Columbia. Extinct volcanoes rise over tree-cloaked fjords. Waterfalls thunder down granite cliffs. Streams meander through lush valleys and collect in crystalline lakes. Great cedars rise from ancient middens. In March, the breath of whales blends with ocean mist. In April, tidal islets break into flower. In August, small lakes become as warm as bathwater. In October, the evergreen huckleberry yields its sweetest fruit.

Every year, Clayoquot attracts more and more admirers from around the world.

The preservation of the sound became a national issue in 1984 when First Nations peoples blocked attempts to log Meares Island. In the following year, the Tla-o-qui-aht declared Meares a tribal park. Campaigns to save the rest of the sound continued over the years, and intensified in 1993 when the government announced that it would protect Megin valley but allow most of the other tall-tree forests to be logged. During an ensuing blockade of logging operations, more than 800 peaceful protestors were arrested. Local, national and international efforts to save the forests of Clayoquot Sound continue.

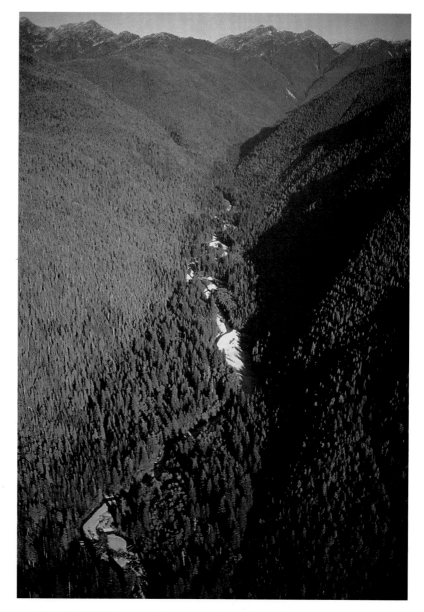

LEFT: Bulson Creek was once one of Clayoquot's wild watersheds. Logging has fragmented the lower part of the valley, and the forest in this picture awaits its fate.

UPPER RIGHT: Ursus Creek, the fourth largest undeveloped watershed in Clayoquot Sound, covers 6567 hectares. It is part of the traditional territory of the Ahousaht people.

LOWER RIGHT: Bog on Vargas Island, in one of many areas declared protected in 1993. About half of the land set aside at that time consisted of sphagnum bog or wind-stunted trees. Two-thirds of Clayoquot Sound, including 74 percent of the ancient temperate rainforest, remained open for development. In 1995, the government accepted the recommendations of a scientific panel that called for a much reduced level of logging.

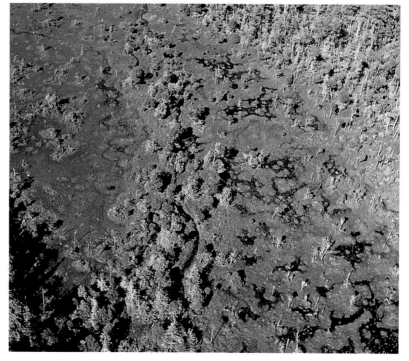

Government policy calls for the clearcutting of coastal forests every 80 years. This 80-year period, called a "rotation," is supposed to allow new forest to mature and become harvestable. In reality, 80-year-old forests are young, and their juvenile wood is of poor quality. Foresters invented the notion that 80-year-old trees are "mature" to rationalize short rotations and excessive rates of cut. Nature, not professional forestry, defines the normal lifespan of a tree.

Take the case of the western redcedar, which easily lives for a thousand years.

This remarkable tree is a comparative newcomer to the northwest coast. The forest that appeared at the end of the ice age some 12,000 years ago was dominated by lodgepole pine. As the climate grew warmer and wetter, first Douglas-fir and then hemlock prevailed. Redcedar languished beside rivers and marshes, and it was only some 5000 years ago, when rainfall reached today's levels, that it become a common tree.

The increase in moisture that allowed the success of redcedar also greatly reduced the frequency of fire. Many forests in the wetter regions of the coast have rarely burned in five millenia. Places may exist on the British Columbia coast where only five or six generations of western redcedar have stood since the end of the Pleistocene, an epoch of ice that lasted about 1.6 million years.

True cedars are native to the Middle East and the Himalayas and are closely related to pines. The western redcedar is not really a cedar at all. It belongs to the cypress family and its Latin name is *Thuja plicata*. According to some, the correct English term is "giant arborvitae." Although rarely used, this name is quite fitting. The tree is truly giant: it is the largest plant in Canada, and rivals the coastal redwoods of California for size. The world's thickest redcedar was found in Clayoquot Sound in 1990 and is 19 metres (62 feet) in circumference.

The second half of the name is equally appropriate. "Arborvitae" is Latin for "tree of life." When Jacques

Old redcedars in Clayoquot valley, an undeveloped watershed of 7000 hectares. The Western Canada Wilderness Committee in co-operation with the Tla o qui-aht, in whose territory it lies, built a hiking trail in the valley in 1993. The trailhead is half an hour by highway from Port Alberni.

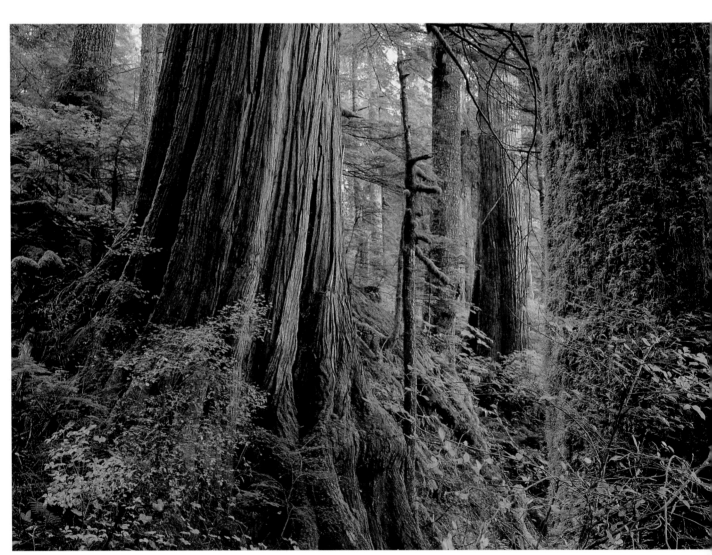

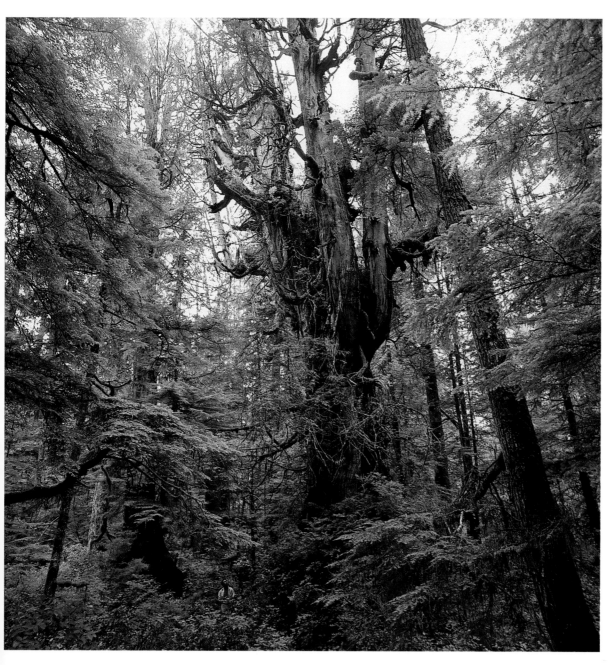

Candelabra cedar on Flores Island. The "candelabra" results from the repeated death and regrowth of the tree's top. Scientists are unsure of why this phenomenon occurs. The ancient silver spars that result from this process stand out against the forest canopy. At sea, they are visible from a great distance, a telltale sign of old-growth forest.

Cartier wintered on the shores of the St. Lawrence in 1535, he and his crew suffered from scurvy. Twenty-five of them died, and the rest would surely have perished had the local Iroquois not brought them an infusion made from cedar bark. It contained vitamin C. The French recovered and named the source of the miraculous cure *arborvitae*, or "tree of life." Today we know Cartier's cure as white cedar, *Thuja occidentalis,* and it is a close cousin of western redcedar.

The Natives of the Pacific coast used redcedar for shelter, clothing, transportation, even food. Their culture — technically advanced and artistically accomplished — had thrived for 5000 years, ever since the tree of life had begun to dominate their forests. They built great dwellings from cedar planks, beams and posts. They wove cedar bark into clothing, rugs, baskets, rope and ceremonial objects. They shaped cedar logs into canoes, some so large they could carry 60 people. They stored edible oil in cedar boxes and cooked food by dropping hot stones into cedar vessels. They caught salmon in traps and weirs fashioned from split cedar. To this day, the world-renowned art of the Pacific coast is chiseled from the trunk of the cedar tree.

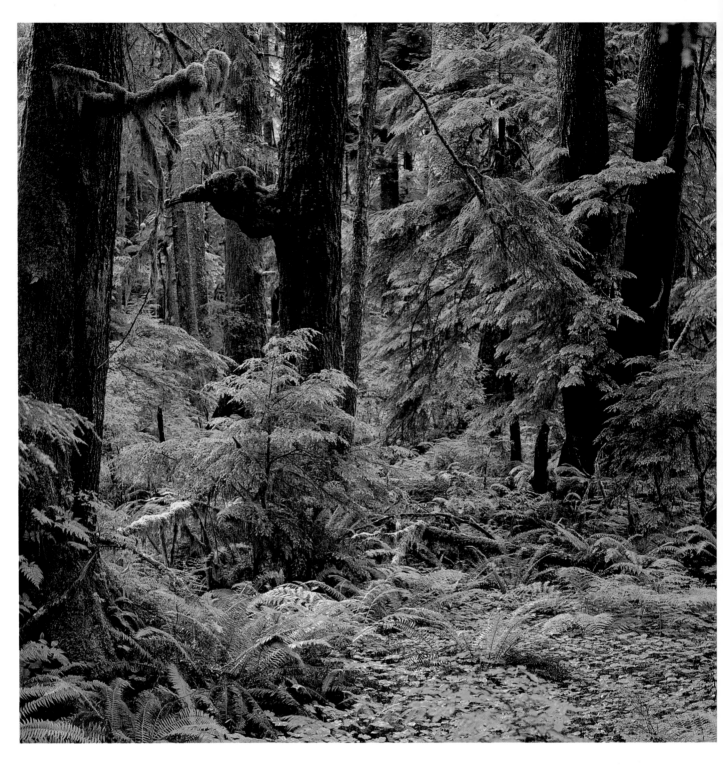

Sitka spruce, lower Carmanah valley.

The term "last frontier" conjures up places like the Amazon, the Antarctic or the ocean floor. Yet some of the Earth's final frontiers exist only a few kilometres from the cities of British Columbia's southern coast. Here you can still find rainforest more impenetrable than any jungle in Borneo or Brazil.

Salal dominates the understorey of the southern coast. It can grow higher than a person and form a thicket so dense that it barely yields to the weight of an advancing body. You walk through it only if you must. Because of salal there are doubtless places on Vancouver Island that have rarely had human visitors. Even Natives on their journeys inland would seldom have had cause to leave the trail and plunge into this ocean of leaves and stalks.

As logging roads tighten like nooses around the last wild valleys, the first non-Native visitors are often timber cruisers. When Bristol Foster and Randy Stoltmann arrived by helicopter in the Carmanah Valley in June of 1982, they found logging survey marks. Bristol was director of the provincial government's ecological

54

reserves unit, and Randy was a young naturalist with a passion for wilderness and big trees. "In 1982 I had never been in a forest that tall. I didn't know what to compare it to. After a while, we just got tired of measuring all the eight and nine foot diameter trees."

When Randy returned to Carmanah in 1988, he found more indications of imminent clearcutting. He and Clinton Webb were able to drive to the edge of the valley. They continued on foot along a road so new that they sank up to their knees in its uncompacted bed. It was early spring and raining heavily, and by the time they had crawled through "ten-foot high salal and horrible salmonberry thickets," they were soaked to the skin. They reached the valley floor, and a place that would later be called Heaven Grove. There they saw "great spruce trees scarred by fresh yellow blazes, brightly coloured survey tapes and spray-painted numbers." It was clear that MacMillan Bloedel, the company that held the timber rights, was about to log the valley. Officially, it was not supposed to start until 2003.

This time, Randy fully understood the importance of the forest. "It was a whole valley, low elevation, completely unlogged — maybe what Vancouver looked like before it was settled. I remembered a picture I had taken from the helicopter in 1982, and it showed pristine forest on the north side of the valley, not those massive new clearcuts we had just passed through."

Upon his return to Vancouver, Randy approached Paul George of the Western Canada Wilderness Committee and impressed upon him the need to defend this watershed. At first Paul was skeptical: he thought it was too late to save Carmanah. Randy threatened to resign from the committee unless it acted. Soon Paul and the WCWC were leading a national campaign in defence of the valley.

In the course of the campaign the Carmanah Giant came to light — a Sitka spruce 96 metres (314 feet) high, the tallest tree recorded in Canada. Its existence galvanized public opinion. Only a very special valley could have nurtured such a marvel. People throughout Canada demanded the preservation of the entire watershed. Today, Carmanah is a provincial park.

Randy saw a special significance in the movement to preserve the valley. "It was a huge eruption of support for saving wilderness. Before Carmanah, most people didn't understand what was happening on Vancouver Island. Only later did the Sierra Club prepare a map of remaining old-growth forest. Carmanah-Walbran-Clayoquot were like a chain reaction. I have a hunch that if there hadn't been a Carmanah struggle, there would never have been a Protected Areas Strategy."

For a defender of wilderness, success can be bittersweet. Carmanah, to be saved, was made famous. The inevitable result was an influx of visitors. Randy returned to the lower valley after it had became a park. In the place where he had crawled through brambles to reach Heaven Grove he found a gravel trail — "a monster park road that looks like it was built by a logging company. Quite disturbing." At the bottom of the valley, boardwalk trails protect the site from the thousands of visitors who come every year. "The strange remoteness of the place is gone now. It seems civilized — there's none of that real wilderness feel to it anymore."

While the saving of Carmanah is a source of inspiration, its taming must give us pause for thought. We have to preserve more than mere fragments of wilderness. Human imagination needs vast wild spaces and impenetrable forests, even if we visit them only in our dreams.

A few weeks after our interview, Randy Stoltmann fell to his death in a back-country skiing accident in the remote Kitlope Valley. The wilderness he loved so much claimed him, but too soon. He was only 31. He was a writer, photographer, mountaineer, tireless defender of nature, and friend. His death left a large gap in our ranks.

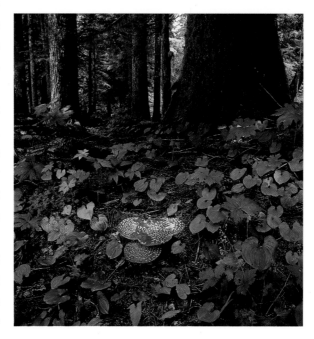

Amanita muscaria, upper Carmanah Valley.

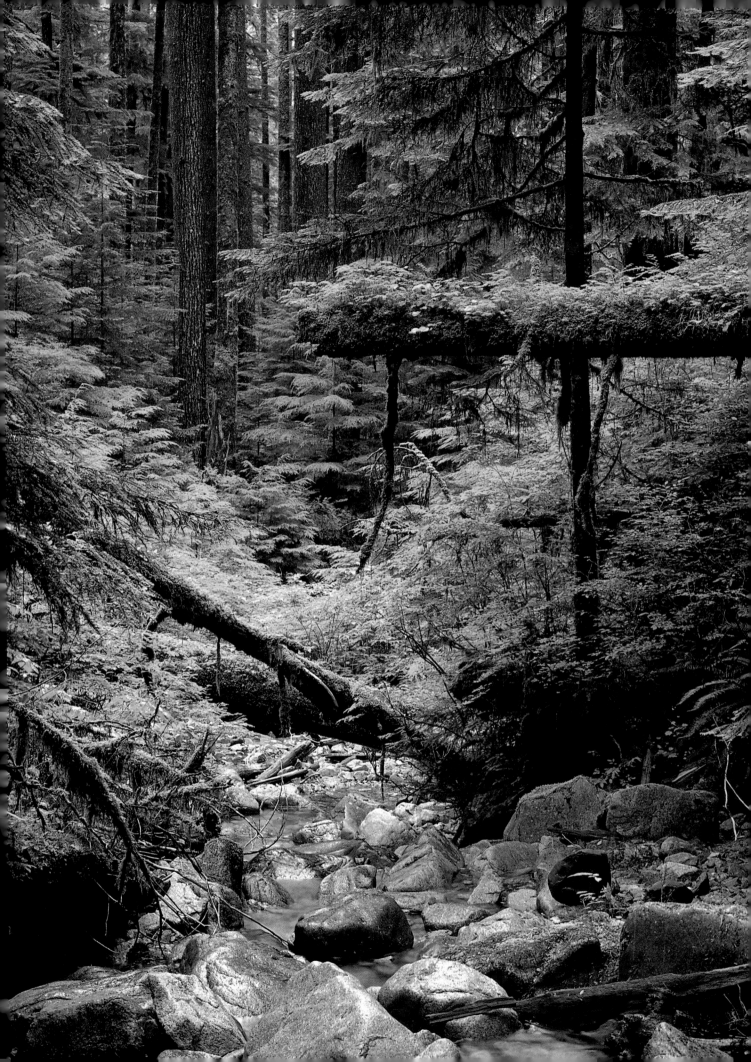

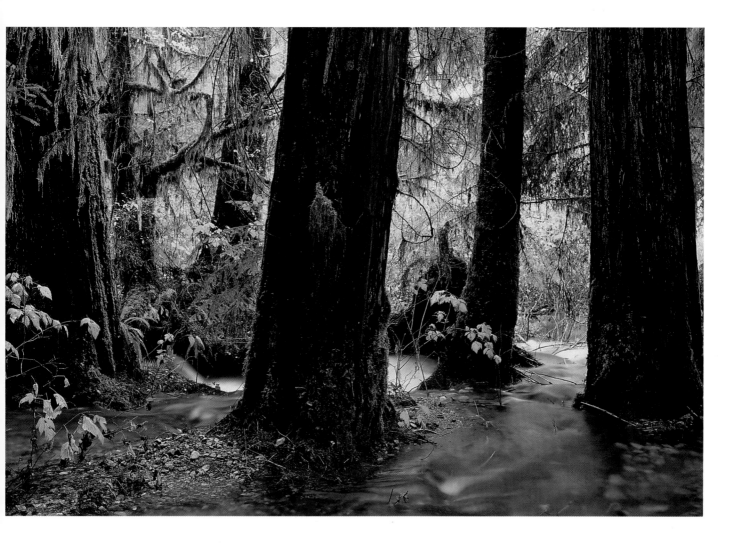

Western hemlock is the most common tree of British Columbia's rainforest. It forms a canopy denser than any other western tree, and its seedlings survive the shade that kills competing species. Thus, a stand of mature hemlocks is a self-perpetuating or "climax" forest: hemlocks replace hemlocks in an equilibrium broken only by fire or chainsaw. All of British Columbia's low elevation coastal rainforest falls in the Western Hemlock Biogeoclimatic Zone. The second most common tree in this zone is the western redcedar, which is also shade tolerant.

When summer brings drought to the west coast, parched grass rustles in the wind and dust cloaks the roadside stumps. But water is as close as the nearest old forest. Damp hangs in the air around the trees, the smallest plants are miraculously lush, and the cushions of moss feel moist to the touch.

Ancient forests regulate water. The canopy disperses rain into droplets that percolate down through the foliage and filter through the layers of humus that have accumulated over the centuries. It enters the water table slowly. During periods of drought, the shaded soil retains this moisture like a sponge, slowly releasing it to sustain vegetation and replenish streams.

Clearcuts expose the land to the full force of rain. Without humus, rotting logs and roots to retain it, water sluices downhill causing erosion, landslides, floods and silt-stained rivers. Dry weather creates conditions at the opposite extreme. Land deprived of shade and stripped of its organic layer by logging, slash burning and erosion cannot store moisture, and the streams it normally feeds simply go dry.

Water filtered through forest is the purest it can be. A sure way to reduce the quality of a city's drinking water is to log its catchment area.

ABOVE: Minor flooding following a heavy rain in the Walbran Valley. Heavy rain seldom causes problems in intact forest. When a valley such as this is clearcut, however, heavy rain can bring catastrophic flooding.

OPPOSITE LEFT: Hemlock climax forest in the upper Carmanah Valley.

57

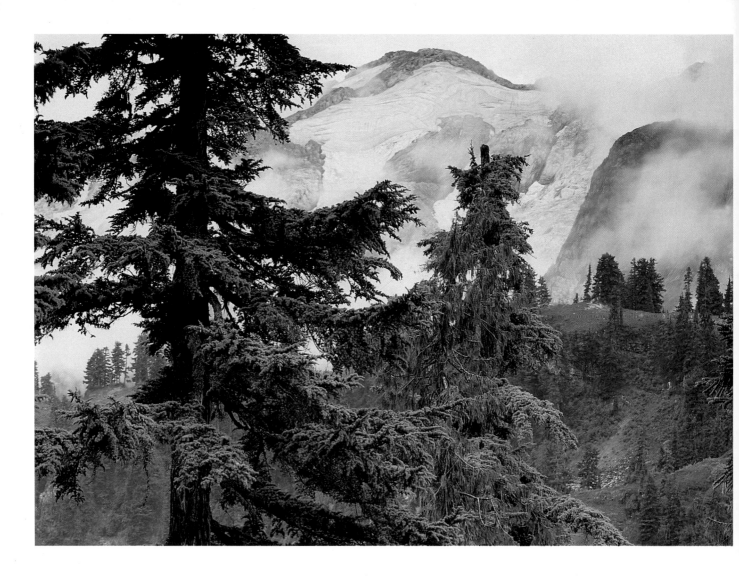

The Mountain Hemlock Biogeoclimatic Zone is that component of the coastal rainforest that lies at higher elevations. Mountain hemlock, amabilis fir, and yellow-cedar are its characteristic species. In the lower parts of the zone, trees grow in closed stands; near its upper limits, they form clumps or small groves separated by patches of heather. Until recently, this high altitude zone with its long seasonal snow cover and slow-growing trees was considered beyond the reach of commercial logging.

ABOVE: Mountain hemlocks near the headwaters of Boise Creek. The Boise Valley is part of a new 38,000 hectare provincial park that stretches from the northern end of Pitt Lake to the southern boundary of Garibaldi Park. A trail into the valley begins east of Squamish, and you can reach it by car in two hours from Vancouver.

RIGHT: View from Raccoon Pass at the head of the Clendenning Valley, in the Randy Stoltmann Wilderness.

South Coast

It sprouted when the Roman Empire was at its zenith, and lived until a chainsaw reached it in the late 1980s. Canada's oldest known tree was a yellow-cedar in the Caren Range of the Sechelt Peninusula, 80 kilometres northwest of Vancouver. When researchers examined the stump, they counted 1835 annual growth rings. The tree was destroyed in the course of a routine logging operation. Government regulations do not prohibit the cutting of ancient trees.

The Sechelt cedar was not unique. Many of Canada's oldest trees grew along the southern mainland coast.

The buildings of Vancouver rise over land where Douglas-firs once stood 30 storeys tall. In the 1860s, logging concessions in Point Grey supplied the Royal Navy with the best masts and spars it had ever seen. Many felled trunks were so massive that they had to be split with dynamite to produce sticks of timber thin enough to mill. The forest seemed so inexhaustible that logging licences were sold for one cent per acre per year.

In the early decades of the 20th century, loggers moved to other forests on the south coast. They used railways and steam donkeys to extract giant firs and cedars from valley bottoms. Later, they pushed roads up hillsides,

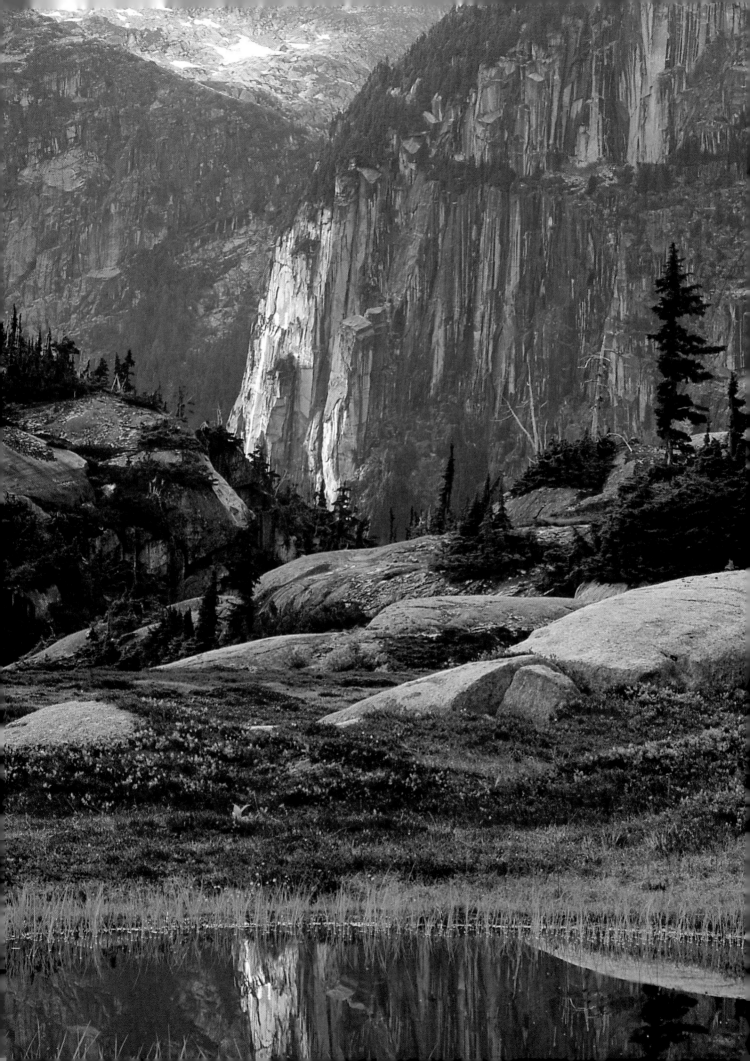

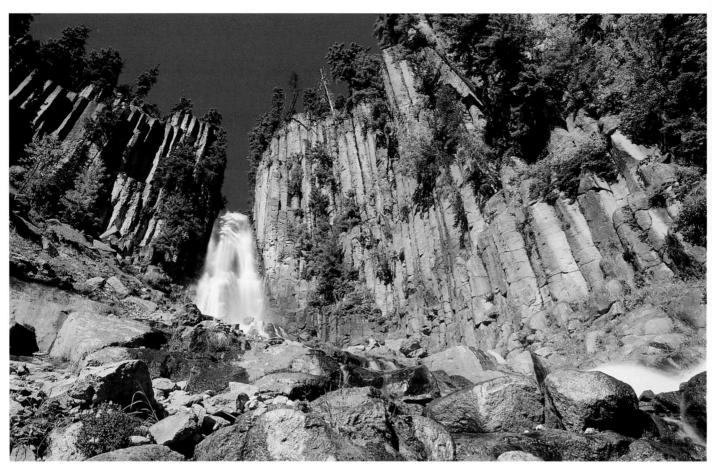

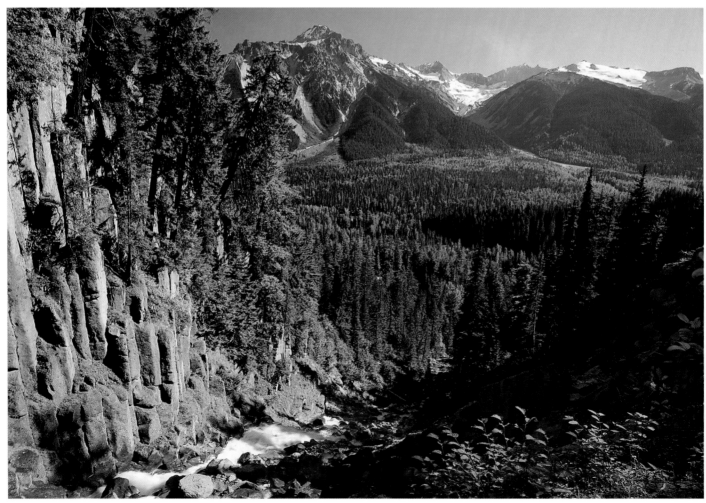

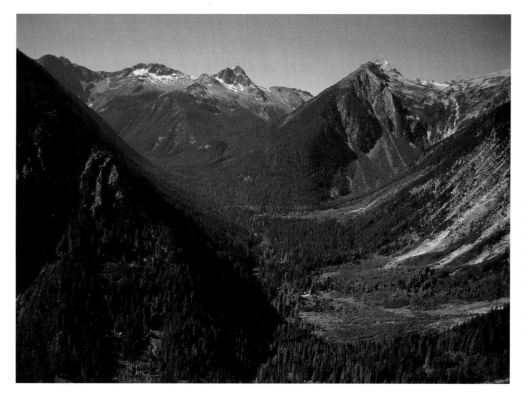

The 29,000 hectare Mehatl Valley lies immediately south of the Stein. Flowing through a trackless valley filled with ancient forest, Mehatl Creek empties into the Nahatlach, which in turn drains into the Fraser at Boston Bar. The mid-Nahatlach is roaded but unlogged, and a chain of beautiful lakes has made it a popular recreational destination.

The Mehatl Valley is one of the last large refuges for the northern spotted owl. The owl and its principal prey, the northern flying squirrel, need the cavities that only old-growth trees, snags and downed logs can provide. Driven to the brink of extinction by logging in the United States, the owl's presence in British Columbia is rather limited. It occurs only in the rainforest of the southern mainland coast, and the Mehatl Valley is at or near the northern limit of its range.

and trucks began to carry logs directly out of clearcuts. Today, most valleys between Vancouver and Bella Coola have been stripped. In many cases old trees survive only on ledges beyond the reach of roads. Even these groves are now vanishing, as rising timber prices make helicopter logging increasingly profitable.

Many of the newer clearcuts reach almost to the treeline. Slow-growing sub-alpine timber is often of excellent quality: the yellow-cedar that sprouted in Sechelt in 150 A.D. was so fine-grained that a magnifying glass was needed to count its rings. If forests ever regrow on these high elevation sites, it will be centuries before the trees are large enough to harvest.

Time is running out for what remains of the southern coastal rainforest. By the turn of the century, every pristine area of significant size will have been either logged or protected.

The largest valley-bottom old-growth forests remaining on the south coast lie within the 260,000 hectare Randy Stoltmann wilderness. This undeveloped area

begins 120 kilometres north of Vancouver. It encompasses Clendenning Creek Valley, the valley of nearby Sims Creek, and the Elaho River Valley into which they both drain. These valleys shelter the last significant stands of old-growth Douglas-fir on our mainland coast.

Defenders of this wilderness have named it in honour of the young naturalist who fought for its preservation in the months preceding his accidental death in 1994. Randy wrote a detailed report of the region, in which he listed some of its unique features: "Rich volcanic soils [that produce] flower-covered alpine meadows rivalling those of the Black Tusk region of Garibaldi Park. ... hanging valleys and cirques, talus slopes, glacial lakes ... a wide variety of unusual plants and wildflowers ... a cluster of ornate volcanic towers ... 100 major glaciers, including 18 kilometre-long Lillooet Glacier, and Terrific Glacier which ends in a fantastic 1,200 metre vertical icefall ... the rare and magnificent fir/redcedar stands." It is this unique forest that is the most endangered part of the landscape, as logging roads advance into the wilderness.

OPPOSITE LEFT: Basalt columns flank the headwaters of the Lillooet River. The Lillooet flows 145 kilometres from a glacier source to its mouth on Harrison Lake. Only the upper 10 kilometres of the valley have not been roaded, settled or logged. The upper Lillooet is the northern part of the 260,000 hectare Randy Stoltmann wilderness.

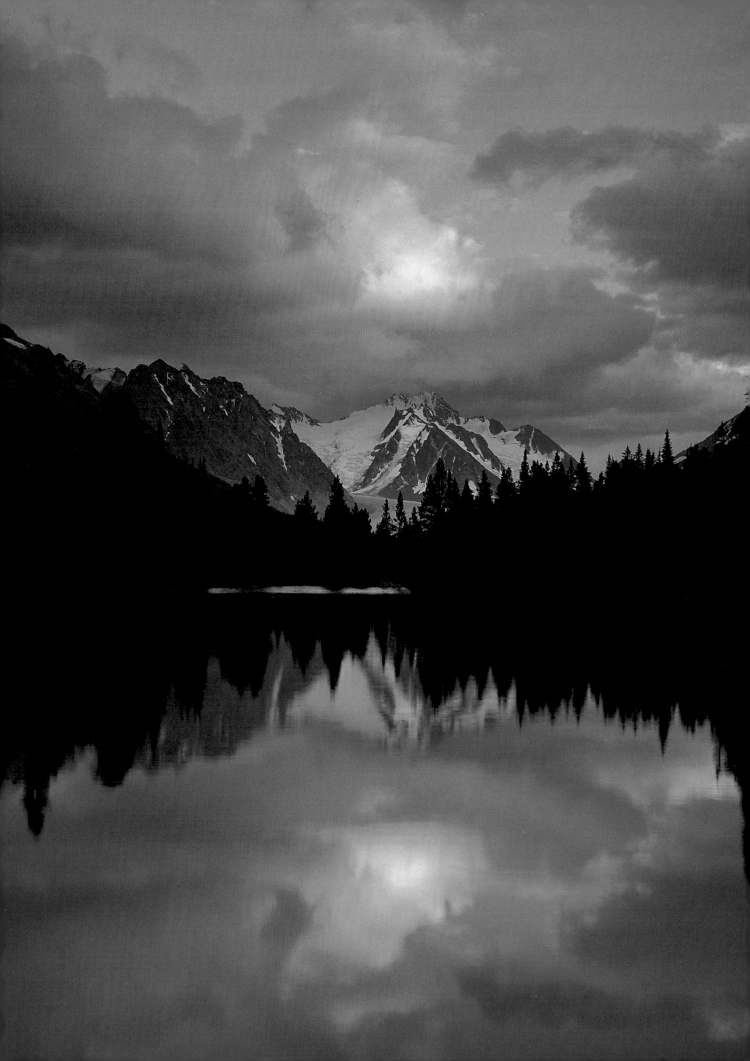

Central Interior

The Central Interior Ecoprovince is largely a land of plateaus. The Fraser Plateau begins four hours by car from Vancouver; on the east, separated by the deep valley of the Fraser River, is the Cariboo Plateau; to the west lies the Chilcotin Plateau, which blends northward into the Nechako Plateau. Most of these uplands are flat or gently rolling, and lie above 1200 metres. The Coast Range forms the western boundary of the ecoprovince.

Partly because of the altitude, the vegetation of the Central Interior evokes more northerly regions: lodgepole pine, white spruce and sub-alpine fir are typical trees. The southeast corner of the ecoprovince holds a surprise. By descending a thousand metres or so into the valley of the mid-Fraser, you travel from a semi-boreal landscape of spruce, pine and stunted Douglas-fir into a riverside swath of treeless grassland that resembles the steppes of the Columbia Plateau.

Most of the Central Interior Ecoprovince has been modified by logging and ranching. But large tracts of wilderness remain in the western half of the ecoprovince, and particularly in its southwest corner, known as the Chilcotin. About a third of the Chilcotin is part of a vast roadless area that includes the spine of the southern Coast Range. Nowhere else in British Columbia is so much unbroken wilderness found so far south. Every year logging reaches further into the Chilcotin's remaining forests of spruce and lodgepole pine.

Even in its settled areas, the population of the Chilcotin is sparse. Natives remain a majority, and decades ago successfully adapted to an economy of cattle ranching. The Chilcotin is a true "wild west" — there is even a rodeo circuit. But here, the "Indians" are the cowboys.

OPPOSITE: Mount Monmouth rises over an unnamed lake at the head of the Tchaikazan valley in the Chilcotin Ranges. The landscape shown is protected in Ts'yl-os Provincial Park, created in 1994.

BELOW: Morice Lake, near the northern end of the Central Interior. The lake's eastern shore lies in the Sub-Boreal Spruce Biogeoclimatic Zone, while its western end reaches deep into coastal rainforest. Forty kilometres long, Morice is one of several major lakes in a large area of wilderness that covers much of the Hazelton Mountains and extends into the Coast Range. Just south of Morice lie Nanika and Kidprice Lakes, popular for canoe touring. To the north, not far from Smithers, are Burnie Lakes, accessible by air.

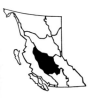

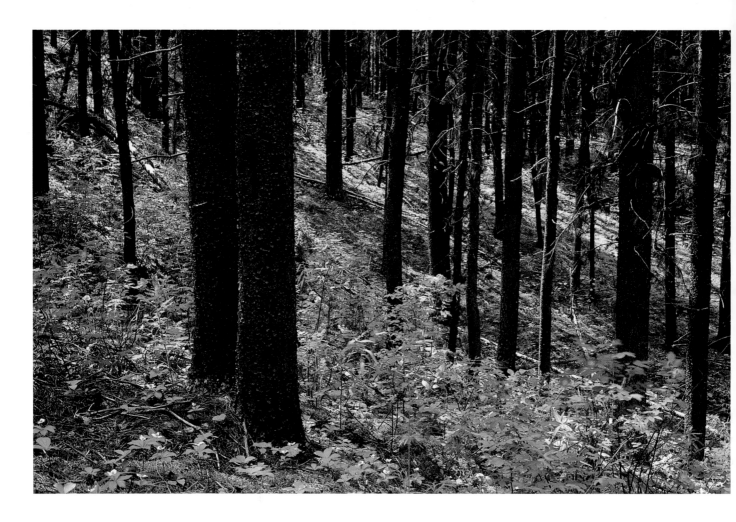

Lodgepole pines north of Anahim Lake, in the Blackwater-Dean wilderness.

The Sub-Boreal Pine-Spruce Biogeoclimatic Zone characterizes much of the Chilcotin plateau and the southern part of the Nechako plateau. The landscape is rolling and dotted with wetlands, and the climate is cold and relatively dry. Lodgepole pine dominates the forests. Lodgepole cones open in extreme heat, and enable the species to rapidly recolonize land cleared by fire. Lodgepole pine is the most adaptable of all British Columbia's trees. It tolerates nutrient-poor soils and ranges from valley floors to the treeline, from the Yukon border to the western shore of Vancouver Island.

Alexander Mackenzie named it the West Road River. He chose the name well: between its outlet in the "Great River" (the Fraser) and its headwaters on the Nechako Plateau, the stream was never far from a trail — a "road [that] was good and well traced." The local people had told him of this route to the Western Ocean. "They assured us that the road was not difficult ... this way is so often travelled by them, that their path is visible throughout the whole journey.... It occupied them, they said, no more than six nights, to go to where they meet the people who barter iron, brass, copper, beads, &c, with them, for dressed leather, and beaver, bear, lynx, fox, and marten skins." The route turned out to be so well travelled that the locals kept rafts at river crossings.

Unlike Simon Fraser, who ventured into these parts 15 years later, Mackenzie chose to believe the Natives' warnings about the "impassable" falls and rapids and "perpendicular rocks" of the Great River. He opted for the shorter overland route. His reliance on the local Athabaskan-speaking people was complete. They guided him and provided his party with much of its food. On July 22, 1793, he reached the Pacific Ocean at Dean Channel. He and his men became the first Europeans to cross the continent north of Mexico.

Mackenzie, the first literate person to traverse British Columbia, had an open and enquiring mind. Although he travelled an average of 32 kilometres a day, he found time to keep a detailed journal. It contains

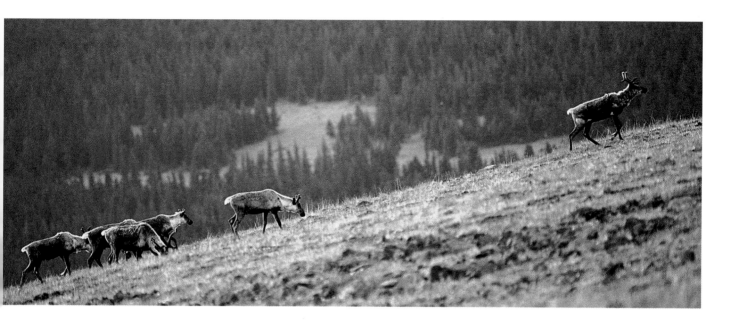

fascinating glimpses of the economies, customs and languages of the peoples he encountered.

Mackenzie describes a house on Gatcho Lake, 20 kilometres northwest of the Ilgachuz Range: "The timber was squared on two sides, and the bark taken off the two others; ... the end [of the ridgepole] was carved into the similitude of a snake's head. Several hiergłyphics and figures painted with red earth ... decorated the interior of the building." Next to the house stood poles from which were suspended "rolls or parcels of bark" containing human bones. Funeral rites were elaborate, involving both burial and cremation. Mackenzie observed a woman removing weeds from a small circular area. "The spot to which her pious care was devoted, contained the grave of an husband, and a son, and whenever she passed this way, she always stopped to pay this tribute of affection." The Natives also revered the elderly. "Age seemed to be an object of great veneration among these people, for they carried an old woman by turn on their backs who was quite blind and infirm from the very advanced period of her life."

ABOVE AND BELOW: The Ilgachuz Range, just south of the West Road (Blackwater) River, at the northern end of the Chilcotin Plateau. Caribou graze in a wilderness little changed since Alexander Mackenzie passed this way in 1793. In 1995 these mountains were included in a new provincial park. Other wilderness in the area remains unprotected, including the 170,000 hectare Entiako River valley just north of Blackwater.

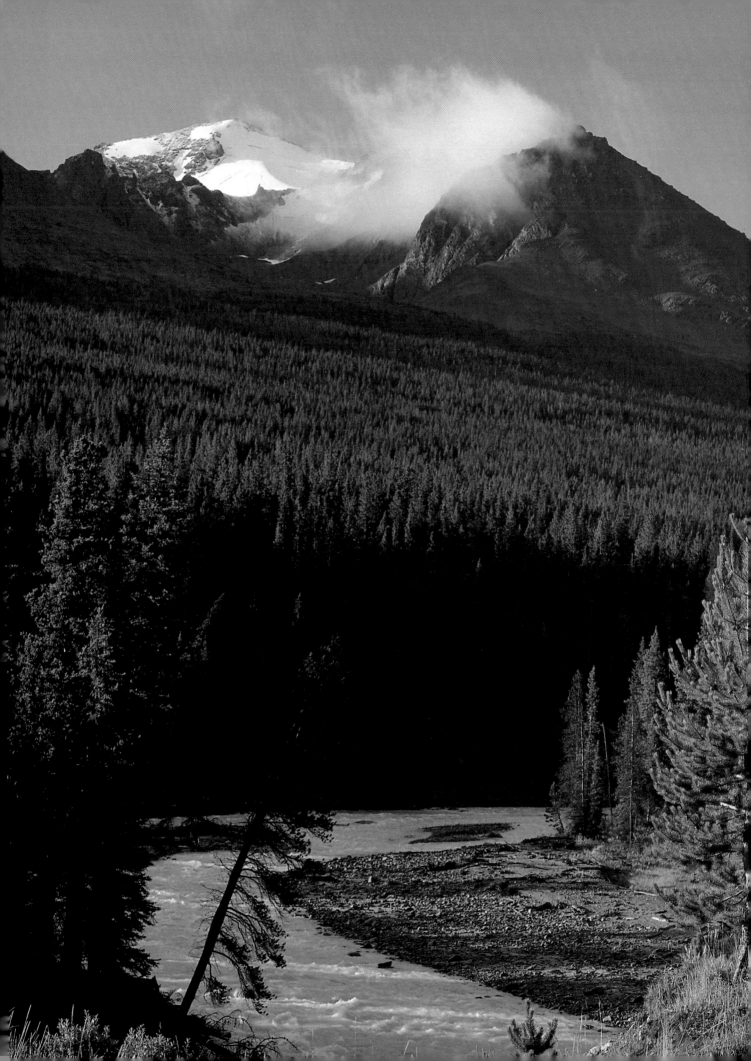

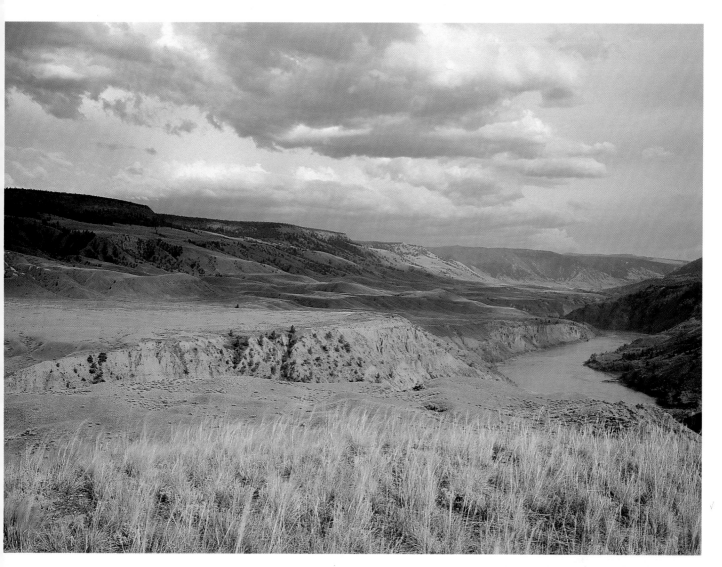

ABOVE: The Fraser River, some 20 kilometres south of its confluence with the Chilcotin. Although hardly a wilderness — cattle graze on these lands and a gravel road follows the river — this area is largely unsettled and unfenced, and is one of the few areas of the province where a large area of native grassland remains in near natural condition. The area shown does not enjoy any form of protection.

LEFT: The Tchaikazan River near its mouth on Taseko Lake, just beyond the eastern boundary of the new Ts'ylos Provincial Park. The landscape in the middle ground resembles the greater part of the Chilcotin Plateau. The plateau is relatively flat and thickly forested. Logging continues to expand into its untouched areas.

RIGHT: *Opuntia fragilis*, one of British Columbia's two species of native cacti. It grows abundantly in the Fraser grasslands.

The scene on the left is in the Montane Spruce Biogeoclimatic Zone, a middle elevation zone that occurs in the central and southern interior of British Columbia. Its characteristic species are Engelmann spruce, hybrid white spruce and subalpine fir, but owing to past wildfires, successional forests of lodgepole pine are common, particularly at lower elevations of the zone.

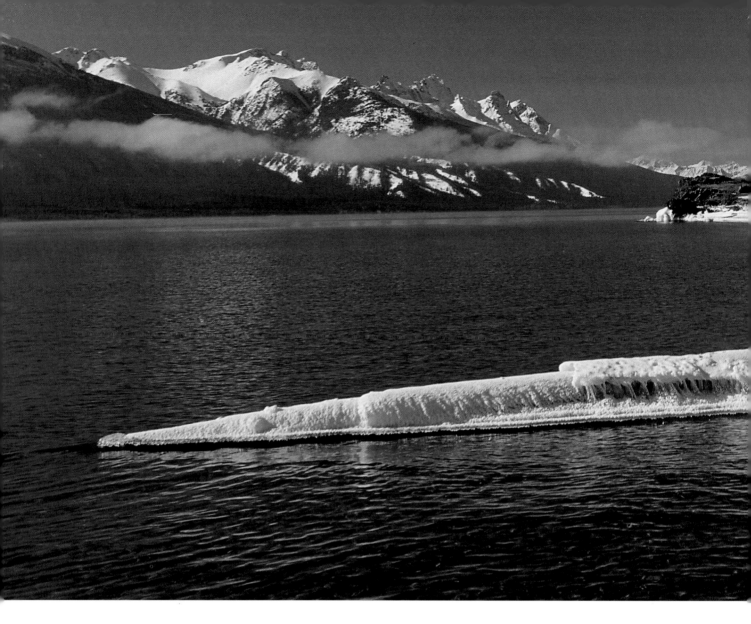

Chilco Lake. In 1994 the provincial government announced the creation of 230,000 hectare Ts'yl-os park, protecting Chilco Lake and its surroundings. Ts'ylos makes up about one-quarter of a band of wilderness that begins near Gold Bridge in the south and joins Tweedsmuir Park in the north.

The igloo was shrinking. At first I thought it an illusion caused by soot accumulating on the ceiling. But once we installed the window, I could clearly see that our dwelling had sagged a foot since its construction four days earlier. The subsidence must have begun on the first day, when the stove flared up and melted little tunnels deep into the dome. We shoveled snow onto the roof to thicken it, and afterwards were careful to keep the temperature below freezing.

We had built our first igloo only a week before on the slopes of Snowy Mountain in the southern Okanagan. The weather had been kind to us. Even at night, the temperature stayed above minus 15. But as we headed north onto the Chilcotin Plateau, the temperature dropped and our misgivings increased. When we turned off the highway, gusts of wind were lifting sheets of powder from roadside drifts.

Nightfall found us at the end of a spur road, parked next to a wood. We would sleep in the vehicle. It was minus 20 when we bedded down, and even in our parkas the cold would wake us before dawn. Our husky slept fitfully and every few minutes tried to curl himself into a tighter ball. Hoarfrost grew on our sleeping bags.

The moon set behind mountains shining pink in the rising sun. It was minus 31. We hastened from our beds and ran into the forest and warmed ourselves by cutting firewood.

Chilco Lake was a two-hour walk across a rolling landscape of woods and fields. In summer you can drive to it, but under a layer of snow this stretch of shoreline becomes remote.

We chose a site at the edge of a bank, so that our entrance tunnel would slope downhill. An igloo works by trapping warm air.

At our last site we had stamped the snow with our skiis, waited, then sliced it into chunks. But here nature

68

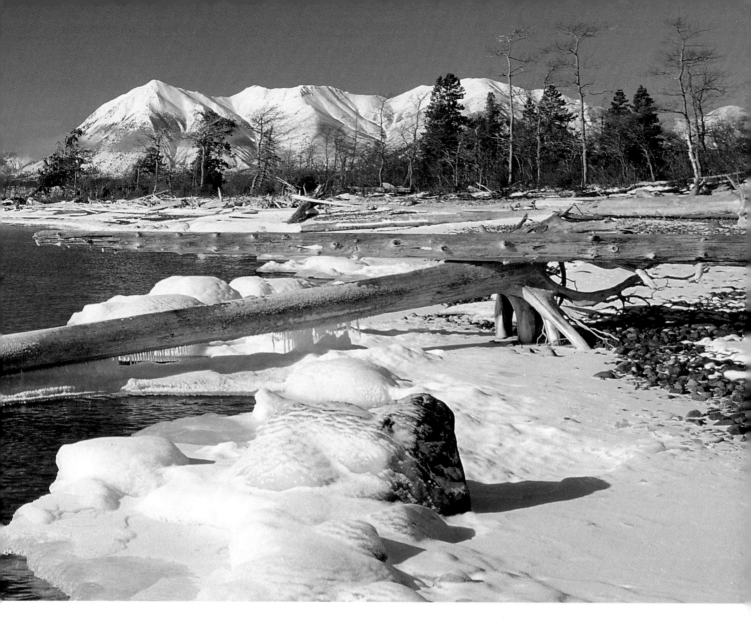

had done the job and we we cut our blocks directly from wind-packed drifts.

There is an extraordinary satisfaction in building a dwelling in a frozen landscape, with no tool but a machete and no material but snow. An igloo is a play-fort that an adult can build without shame. But it was more than a game for us — it was a matter of survival.

Each snow block in an igloo is a blunt wedge prevented from falling inward by its neighbours. A completed ring of snow blocks makes a self-supporting structure of considerable strength. The Romans perfected this architectural form and used it to construct great buildings. Arctic peoples discovered it independently, and each winter built more domes than ever existed in all the empires of Europe.

When night fell, the crown of our dwelling was still incomplete. We lit a candle inside and cut our last blocks by the faint light that diffused through the walls.

Winter camping proved less challenging than we had expected. Cold is more of a problem in spring or fall. Moisture is the enemy of warmth, and it does not rain in February. Snow will melt, given the chance, but the powder here was so dry it did not cling to our clothes.

Inside the igloo, the temperature averaged minus 5. On the lakeshore it often dipped to minus 30, and seemed far colder in the frequent wind. We were snug in our home, but could not see out, for our window was made of ice. Curiosity often conquered us and we slid down the entrance tunnel to observe the landscape.

Chilco Lake does not freeze. It is restless, and its presence fills the hibernating valley. Its breath rises in the cold air and hides nearby summits behind shifting sheets of mist. One day the wind was so strong it overturned my tripod, and waves dashing against rocks left sculptures of ice. One night the air was clear, the moon was up, and the mountains across the lake glowed fluorescent white.

69

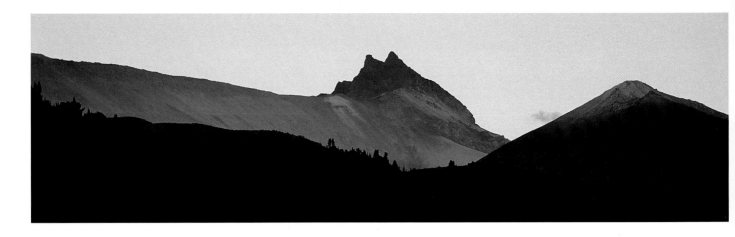

The west side of Mount Sheba.

There ain't nobody up there." His gesture swept up 30 kilometres of valley, across forest so free of underbrush, across hillsides so forgiving that you could ride a horse clear up to the mountain tops. There was pride in the voice of our guide-outfitter. "Nobody." His stetson was visibly worn, his cowboy boots were for real, and he spoke with a drawl. His horses would take us up Gun Creek to Trigger Lake, then return to his ranch near Gold Bridge. He would leave us alone in the wilderness with our backpacks.

We spent the first night in the Trigger Lake cabin: one room, weathered logs, hooks to hang our packs out of reach of the mice, old cross-cut sawblades across the windows to discourage another bear from smashing its way in. After that, we slept in the tent, and when the crackle of our fire died away we listened to the wind, and the rustle of aspens, and the howl of distant wolves. The guide-outfitter was right. For the four remaining days, we saw no other human beings.

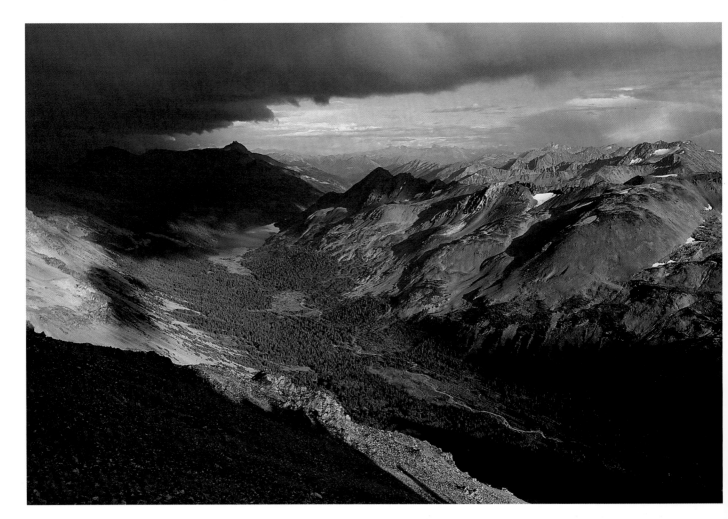

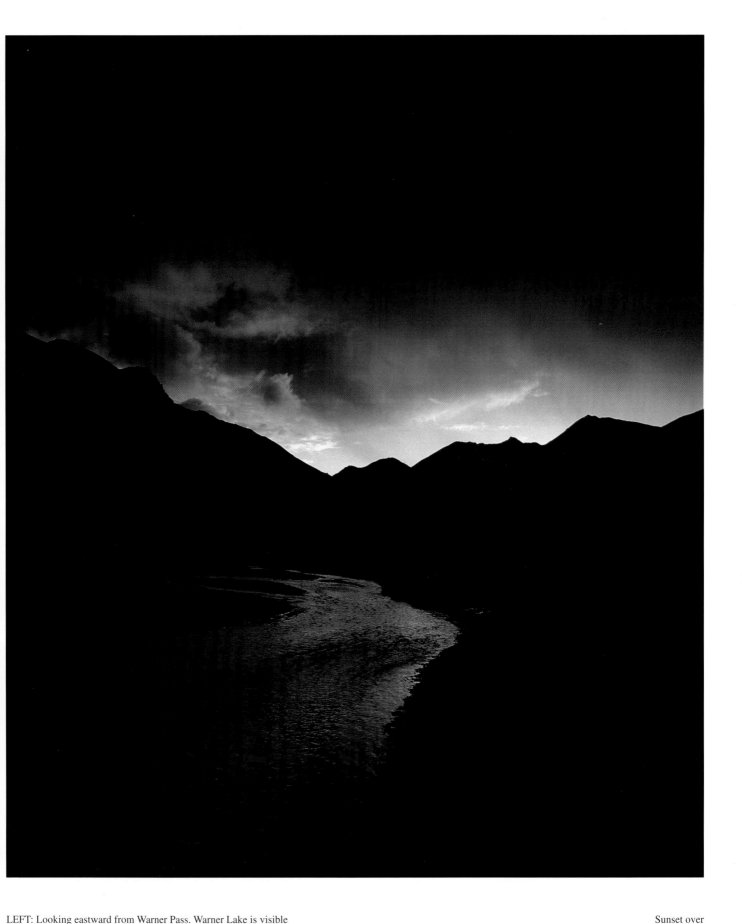

LEFT: Looking eastward from Warner Pass. Warner Lake is visible
on the valley floor; directly behind is Mount Sheba. The scene is near
the southern end of the great Chilcotin wilderness, six hours by road
from Vancouver. Twenty kilometres west of Warner Pass lies Taseko
Lake, and beyond it, Tchaikazan valley and Ts'yl-os Provincial Park.

Sunset over
Warner Creek.

Southern Interior

I have never felt rain in the Stein. I once walked the valley for 10 hot days in July and I often drank my canteen dry before the trail led me down the canyon wall to another encounter with the river. I was there one October, when the cottonwoods stood gold against blue sky, and I walked shirtless through a valley filled with the dry scent of pine. I camped there in February and woke to a chinook wind that had melted the thin snow and brought the first insects of spring.

It does rain, of course, but mostly near the river's source, just east of the coastal rainforest. Halfway down the valley, spruce gives way to Douglas-fir, and near the river's mouth, orange-barked ponderosa pine cling to the sides of the canyon. The Stein is a wilderness gateway to the dry southern interior.

The Stein is the traditional territory of the Nl'akapmx, a Salishan people who live at its mouth. They embraced the struggle to prevent logging in the valley. The lower canyon and beyond show many ancient signs of their presence: hundreds of red pictographs are painted on cliff walls, and living redcedars still bear the scars where Natives removed strips of bark to make baskets, rope and blankets.

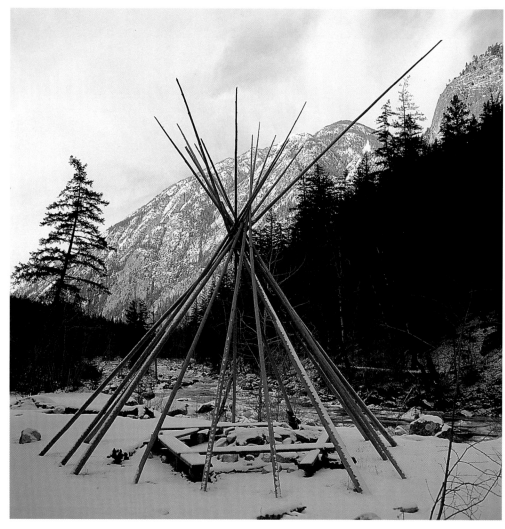

In the lower
Stein Valley.

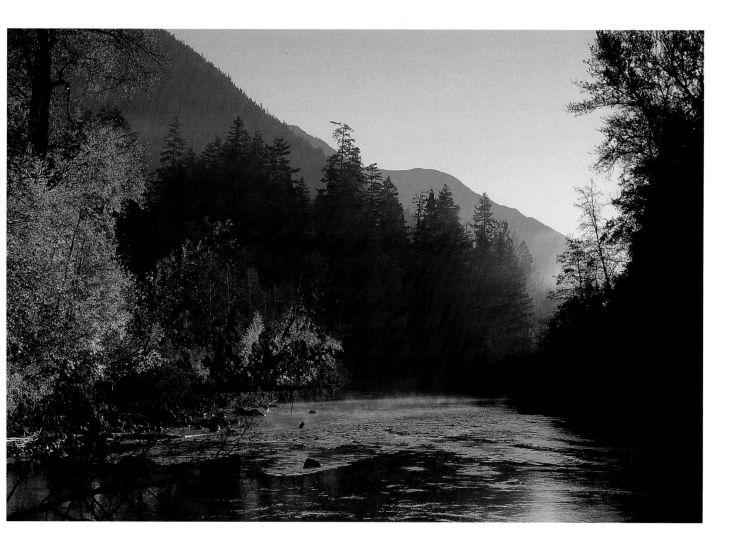

OLD-ONE

The following is a story told by Kwelkwelta'xen (Red-arm), an Okanagan elder, in the early years of this century. It is an extract from one of many Interior Salish stories collected and translated by James Teit (1864-1922), an ethnographer and prominent advocate for Native rights.

Old-one, or Chief, made the earth out of a woman, and said she would be the mother of all the people. Thus the earth was once a human being, and she is alive yet; but she has been transformed, and we cannot see her in the same way we can see a person. Nevertheless she has legs, arms, head, heart, flesh, bones, and blood. The soil is her flesh; the trees and vegetation are her hair; the rocks, her bones; and the wind is her breath. She lies spread out, and we live on her. She shivers and contracts when cold, and expands and perspires when hot. When she moves, we have an earthquake. Old-one, after transforming her, took some of her flesh and rolled it into balls, as people do with mud or clay. These he transformed into the beings of the ancient world, who were people, and yet at the same time animals.

Old-one made each ball of mud a little different from the others, and rolled them over and over. He shaped them, and made them alive. The last balls of mud he made were almost all alike, and different from any of the preceding ones. They were formed like Indians, and he called them men. He blew on them, and they became alive. They were Indians, but were ignorant, and knew no arts. They were the most helpless of all things created; and the cannibals and others preyed on them particularly.

The 110,000 hectare Stein Valley is on the threshold of the dry southern interior.

73

Old Douglas-firs on the slopes of Brent Mountain in the southern Okanagan. Brent Mountain is 10 kilometres west of Penticton and is surrounded by 6000 hectares of wilderness. It is one of the few undeveloped areas in the southern Thompson upland. Most of it lies at high elevation and supports wildflower-filled meadows and forests of spruce and pine. The lower part of this landscape has been logged, but a few stands of old-growth Douglas-fir remain on the fringes of the wilderness.

The people and animals were made male and female, so that they might breed. Thus everything living sprang from the earth; and when we look around, we see everywhere parts of our mother.

The people were much oppressed and preyed on, and so much evil prevailed in the world that the Chief sent his son Jesus to set things right. After travelling through the world as a transformer, Jesus was killed by the bad people, who crucified him, and he returned to the sky. After he had returned, the Chief looked over the world, and saw that things had not changed much for the better. Jesus had only set right a very few things. Jesus worked only for the people's spiritual benefit. He taught them no arts, nor wisdom about how to do things, nor did he help to make life easier for them. Neither did he transform or destroy the evil monsters which killed them, nor did he change or arrange the features of the earth in any way.

Now, the Chief said, "If matters are not improved on earth soon, there will be no people." Then he sent Coyote to earth to destroy all the monsters and evil beings, to make life easier and better for the people, and to teach them the best way to do things.

Coyote then travelled on earth, and did many wonderful things. He destroyed the powers of all the monsters and evil beings that

The Interior Douglas-fir Biogeoclimatic Zone covers most lower mountain slopes in the drier regions of the British Columbia Interior. Douglas-fir owes its dominance to frequent fires. It survives a moderate burn, and over time, it outgrows the other trees that reappear after a major conflagration. The Interior Douglas-fir is a subspecies. It is smaller and stockier than its coastal counterpart, and has shorter cones.

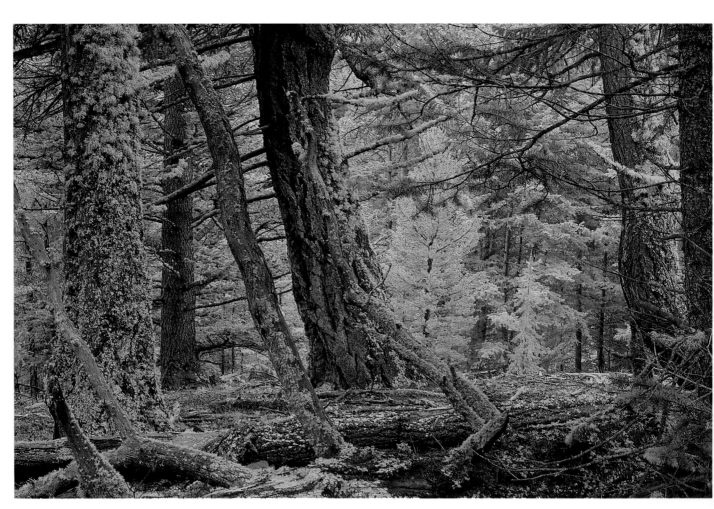

preyed on the people. He transformed the good ancients into Indians, and divided them into groups or pairs, and settled them in different places; for the Chief desired the earth to be inhabited everywhere, and not only in a few places. He gave each people a different name and a different language. These pairs were the ancestors of all the present Indian tribes; and that is why Indians live all over the country. He taught the people how to eat, how to wear clothes, make houses, hunt, fish, etc. Coyote did a great deal of good, but he did not finish everything properly. Sometimes he made mistakes; and although he was wise and powerful, he did many foolish things. He was too fond of playing tricks for his own amusement. He was also often selfish, boastful, and vain. He sometimes overreached himself, and occasionally was duped by persons whom he intended to dupe. He was ugly, and women generally did not like him. He often used cunning to gain his ends. He was immortal, and did not die as we die.

Coyote is the subject of many Interior Salish tales. They are often humorous, even ribald. The following story comes from the Nicola Valley.

Once Coyote changed himself into a baby. Some women who were picking berries nearby heard him crying. They said, "Some woman must have been picking berries here, and has forgotten her child; let us take it home!" They camped on the way home, and put the child between them to keep it warm. In the morning the baby was gone, and they felt itchy. They also felt their bellies wet. They examined themselves, and found some Coyote hairs. They began to swell; and when they reached home, and were just in the entrance to their lodges, they gave birth to children.

Adjoining the U.S. border, the 19,000 hectare Snowy Mountain wilderness is one of the most significant natural areas remaining in the Southern Interior Ecoprovince. It begins just south of Keremeos, and Cathedral Provincial Park borders it on the west. It provides habitat for bighorn sheep, mule deer and cougar. Although mostly high in elevation, its eastern fringe includes some old forests of Douglas-fir.

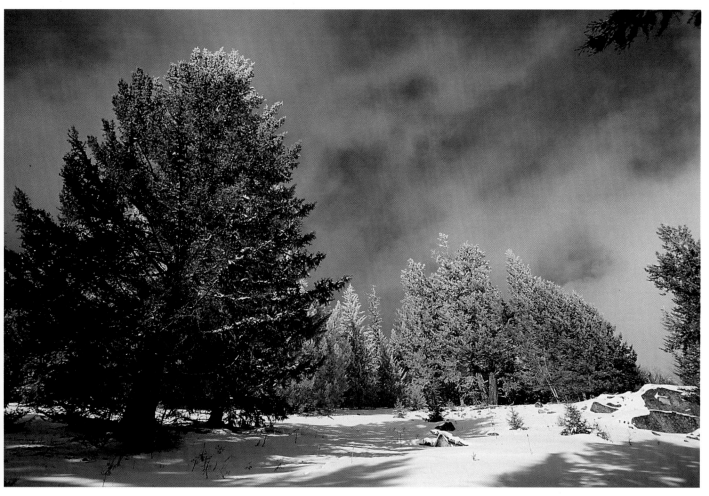

"The profusion of grass that covers both woodland and meadow, affording rich pastures for domestic animals ... gives to this district an extraordinary value, as every part of the surface ... may be turned to account and made available either for tillage or stock farming." James Douglas, the first governor of British Columbia, wrote these words in 1860. Today, the Okanagan Valley is the third most populous region of the province and almost every part has indeed been "turned to account." Cattle ranches, orchards and urban development cover almost all of this northernmost tongue of the Columbia Plateau Steppe. The Okanagan is one of the three most endangered ecosystems in Canada, and, at the time of writing, only one percent of it is protected in parks or ecological reserves. Most of its grasslands and wetlands have been lost. It is home to more species at risk of extinction than any other area of British Columbia.

Elsewhere in the Southern Interior Ecoprovince, the situation is hardly better. With its eight biogeoclimatic zones, this ecoprovince is British Columbia's most biologically diverse. Yet to date less than two and a half percent of its lands are protected, and most of these are at high elevations. For many of the region's ecological systems it is already too late to achieve even a minimum 12 percent protection.

The Ponderosa Pine Biogeoclimatic Zone covers a number of valley floors in both the Southern Interior Ecoprovince and the southern part of the Rocky Mountain Trench. It typically forms an open parkland with bunchgrass as the main understorey plant. Upslope, it blends into the Interior Douglas-fir zone. Downslope, it often gives way to natural grassland. Ponderosa is one of the most abundant of all North American pines, and southern British Columbia marks the northern limit of its range. No large wild forests of ponderosa survive in Canada.

OPPOSITE RIGHT: Ponderosa pine in the lower Nicola Valley.

The Bunchgrass Biogeoclimatic Zone occurs in several valley floors in the southern interior. This zone receives less than 30 centimetres of rain a year, and experiences severe summer drought. In many areas, overgrazing has led to a reduction of grass cover and a corresponding increase of sagebrush and rabbitbrush.

Bluebunch wheatgrass grows in a pasture near Osoyoos in the southern Okanagan near the northern tip of the Columbia Plateau Steppe.

Southern Interior Mountains

T he southeast corner of the province is a microcosm of the whole. The alternation of fjord, rainforest, mountain and dry valley — the primary drama of British Columbia — is repeated here on a smaller scale. The fresh-water fjords of the Southern Interior Mountains Ecoprovince are almost as majestic as their coastal counterparts. The Arrow Lakes snake below mountain walls for 200 kilometres, and Quesnel Lake is both the deepest lake in British Columbia and the deepest fjord lake in the world.

Cedar-hemlock forest near Rainbow Falls, Monashee Mountains. The Monashees, an hour's drive from the Okanagan Valley, are a land of icefields, alpine lakes and lush forest. For many years a small, high elevation area has enjoyed protection within Monashee Provincial Park; at the time of writing, most of the low elevation forest was slated for logging. There are some 50,000 hectares of unbroken wilderness here. The two largest watersheds, Vigue and Gates creeks, together cover 19,000 hectares, almost half of which is in cedar-hemlock forest.

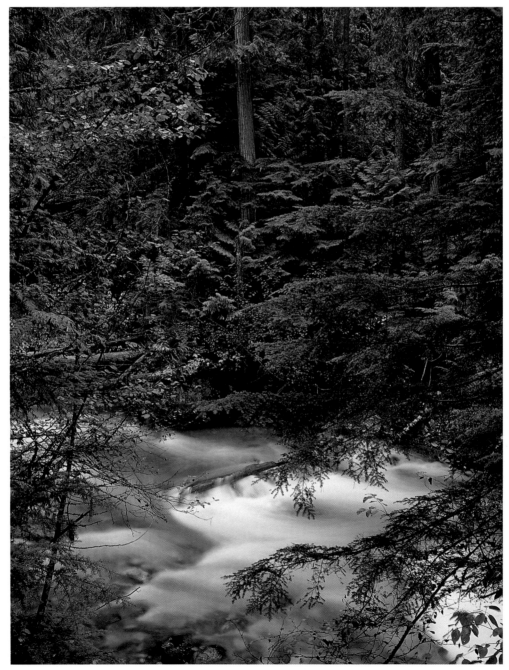

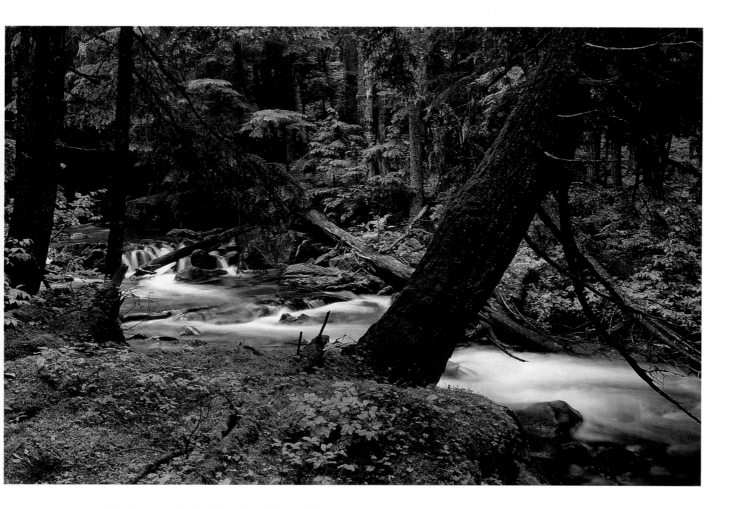

The Interior Cedar-Hemlock Biogeoclimatic Zone is the only temperate rainforest in the world that is separated from the ocean by a vast dry area. This forest is very diverse. In addition to western hemlock and redcedar, it includes western white pine, interior Douglas-fir, Engelmann spruce, white spruce, western larch and subalpine fir.

Lasca Creek flows through an unlogged valley and drains into Kootenay Lake's West Arm.

The rainforest here, as lush and monumental as on the Pacific shore, displays even greater botanical diversity. It grows on the western flanks of mountains which, like those of the Coast Range, rise through flower-splashed meadows to fields of eternal ice. Beyond the easternmost of these ranges lies the southern Rocky Mountain Trench, a zone of dryness echoing the Okanagan and supporting forests of Douglas-fir and ponderosa pine. The eastern foothills of the Rockies define the edge of the ecoprovince.

The Southern Interior Mountains Ecoprovince, with its seven ecoregions and seven biogeoclimatic zones, is the second most biologically diverse ecoprovince in British Columbia. And it contains one of the world's rarest forest types. Most of the Earth's interior cedar-hemlock rainforest is found here.

In the southern third of the ecoprovince, little of the original cedar-hemlock forest remains. Many of the ancient trees were destroyed a century ago, when timber was free to anyone who cared to claim a treelot, and silver miners, to facilitate prospecting, set whole mountainsides ablaze.

In the northern part of the ecoprovince, large areas of this globally unique cedar-hemlock forest survive. But in many areas, the trees are wantonly destroyed. For reasons little understood, most of the ancient cedars around Quesnel Lake are hollow. The Ministry of Forests considers these trees valueless, and gives out permits to fall and burn vast tracts of them to clear new sites for tree plantations. Only sound spruce logs are taken to the mills. Under the guise of cedar liquidation licences, logging companies pay as little as 25 cents per cubic metre for some of the highest quality old-growth spruce in British Columbia.

Lasca Creek is a well-loved watershed. I could see this in the carefully restored old mining trail. Volunteers had done it, many of them the same people who had blockaded the logging road in 1991. Six hundred people had taken part in that demonstration, and 64 had been arrested.

It is an easy trail through the forest, with the creek an unfailing companion. I heard it always, sometimes faintly through fir and pine cloaked in witch's hair, sometimes loudly, with glimpses of mossy banks and foaming water. The trail bisects small natural meadows, traverses tiny tributaries on rough-hewn bridges, and passes the ruins of an old cabin.

I made my bed on moss that night. It was mid-summer, and although the forest was wet and lush, the air was unexpectedly free of biting insects.

The trail into the 7000 hectare Lasca Creek valley begins 30 kilometres by road from Nelson, via the ferry at Harrop. The valley is part of a 58,000 hectare wilderness that lies just south of the West Arm of Kootenay Lake. This is the largest tract of undeveloped land in the Southern Columbia Mountains. Even if preserved in its entirety, the West Arm wilderness is barely large enough to ensure the long-term survival of threatened species such as grizzly bear and mountain caribou. In 1995, the government announced the protection of only the western half, including Lasca Creek. The eastern half of the wilderness remained open for logging.

Witch's hair hangs from lodgepole pine in the Lasca Creek valley.

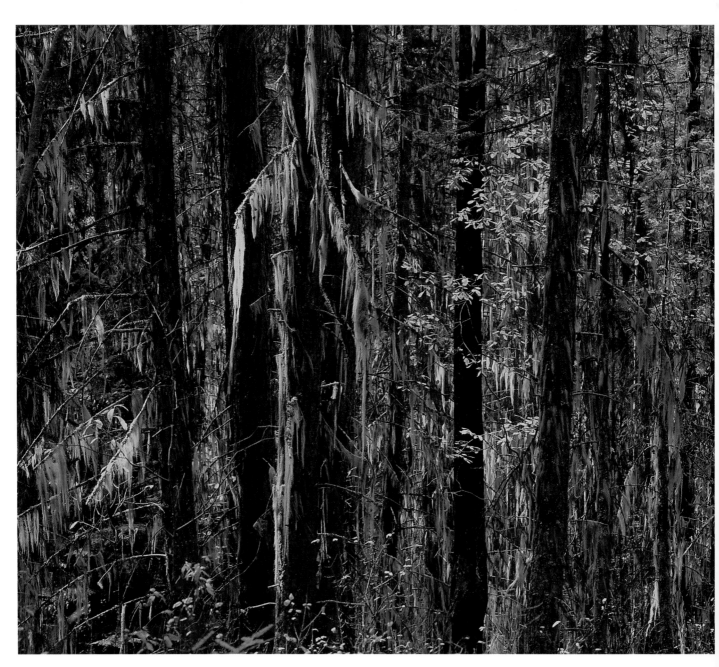

RIGHT: Upper Kianuko Valley. To the west, beyond these mountains, are the headwaters of Lockhart Creek. To the east lies the upper Goat River. Along with the Kianuko, these watersheds make up an undeveloped area of roughly 25,000 hectares. The landscape shown is typical of most of this wilderness, with its high elevation forests of spruce and subalpine fir. The lower Goat and Kianuko drainages are easily accessible from Creston via logging road. The Lockhart Creek trailhead is on the highway that follows the east shore of Kootenay Lake.

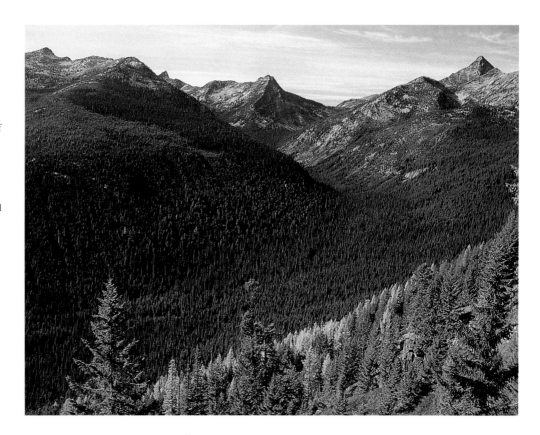

BELOW: Western larches in the mid-Kianuko. The Kianuko supports two of British Columbia's three species of larch — western and sub-alpine. Larches are the only conifers in British Columbia to lose their needles, and their autumn gold is a distinctive feature of the eastern Kootenay landscape.

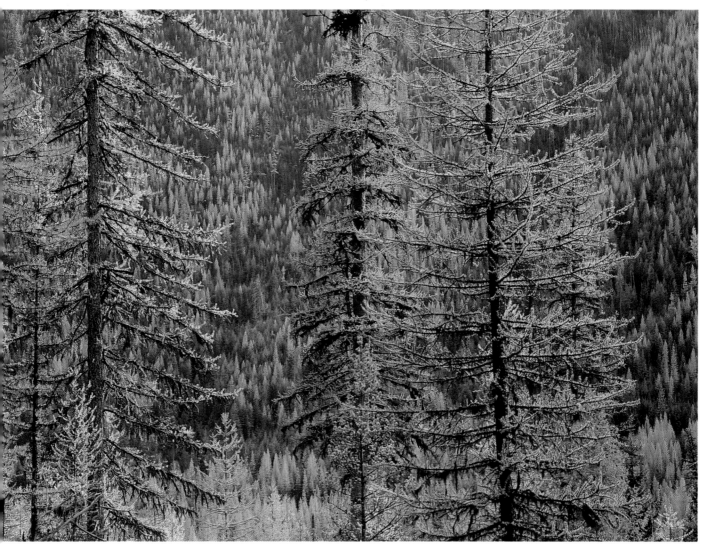

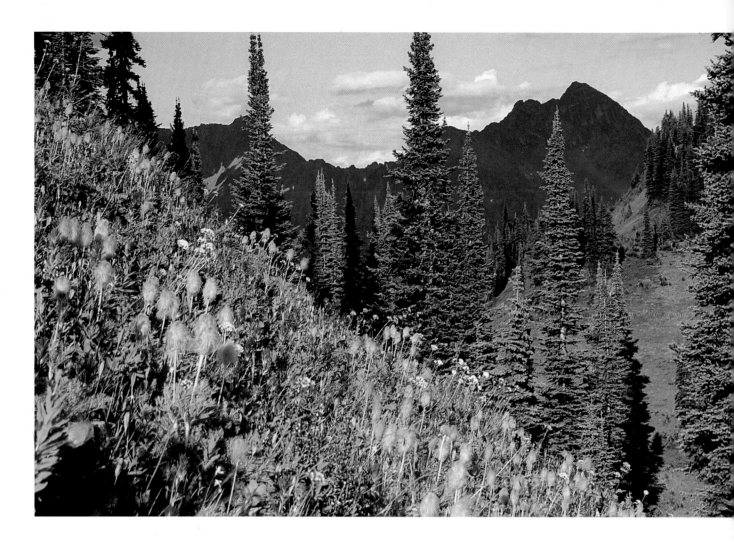

ABOVE: At the
headwaters of
Dennis Creek.

OPPOSITE: Night
in the White Grizzly
Wilderness.

White Grizzly Wilderness

I saw it coming down the old hiking trail on the opposite side of the valley, a moving speck on a line etched in the hillside. I knew instantly from the way it moved that it was a bear, and after watching it a while I made out the large shoulder hump that identified it as a grizzly. It seemed grey in the half light, and its legs looked darker than the rest. Perhaps it was "white," a rare colour variant, less rare in this wilderness than in most other places. The fur of "white" bears is silvery, and their legs and ears are dark. The animal left the trail and lumbered toward the valley bottom, perhaps to sleep or feed on lily corms. Night was falling. I had forgotten my light, and I hastened toward my tent at the headwaters of Whitewater Creek.

The White Grizzly Wilderness, one of the largest undeveloped areas in southeastern British Columbia, covers some 120,000 hectares. It lies between Valhalla Provincial Park and the Purcell Wilderness Conservancy, two other large pristine areas.

Besides grizzly, this land shelters a number of important or threatened species, such as cougar, wolverine, elk, golden eagle, pileated woodpecker and mountain goat. The area forms part of the range of a population of mountain caribou — perhaps the continent's southernmost viable population of this species. The caribou use the old forests of the valley bottoms for forage and protection.

When the government announced an 80,000 hectare park in 1995, it placed many of these lowland forests outside park boundaries. It excluded much of the southern end of the wilderness, including Kane Creek with its ancient cedars, Whitewater Creek with its accessible and safe grizzly viewing and Dennis Creek with its extraordinary alpine meadows.

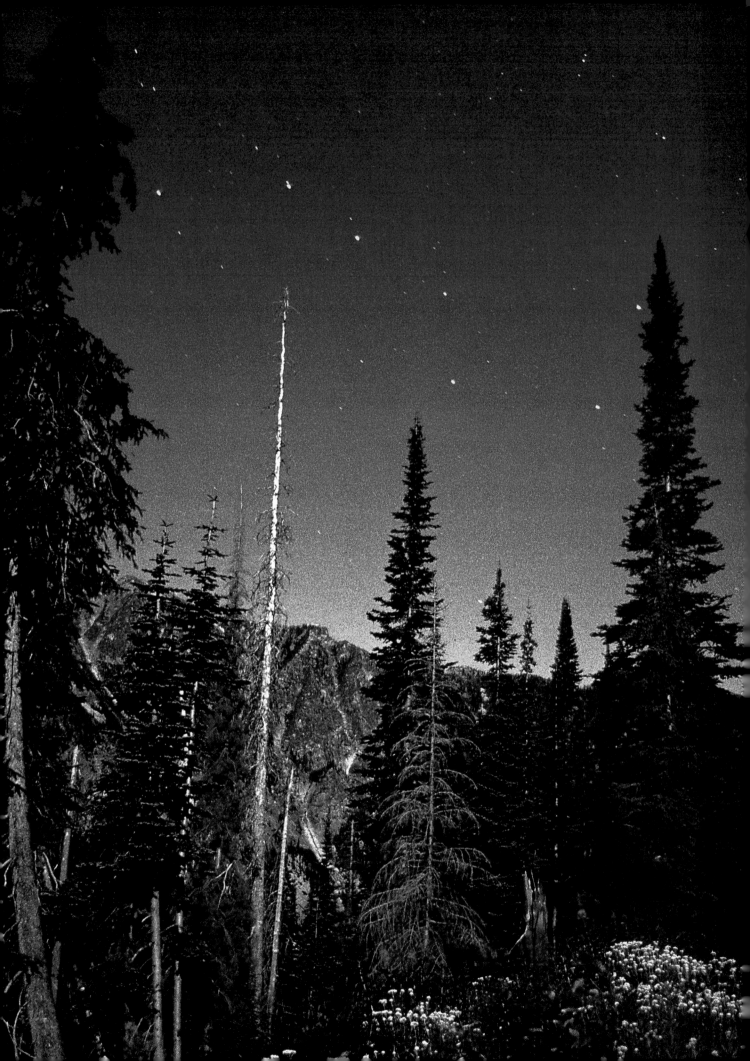

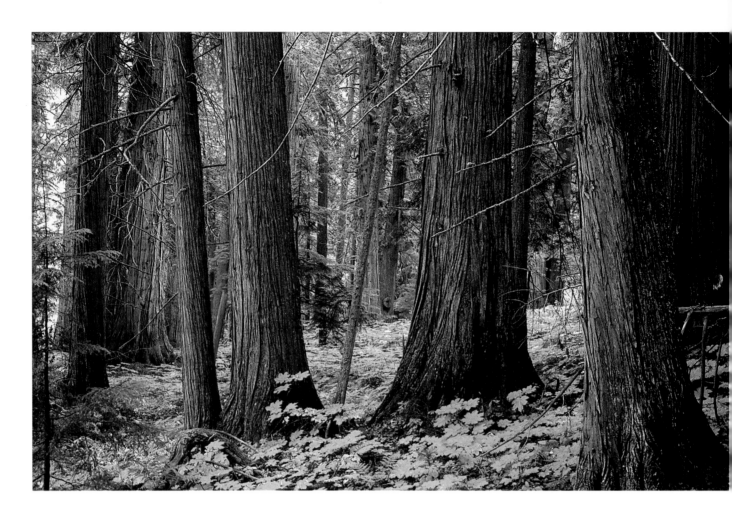

ABOVE: Giant cedars near Carney Creek, in the heart of the west Purcells. The Purcell wilderness is the largest roadless area in the Kootenays. Forests of cedar, hemlock, larch and spruce surround mountain meadows and glaciated summits. It has small lakes, remote hotsprings, and alpine valleys carved from pink granite. This wilderness covers more than 200,000 hectares. The most mountainous part of it has been protected for many years in the Purcell Wilderness Conservancy. In 1995, the government announced major additions to this park, but excluded much of the shoreline of Kootenay Lake, including the landscape shown below.

BELOW: The wild side of Kootenay Lake, opposite the town of Kaslo.

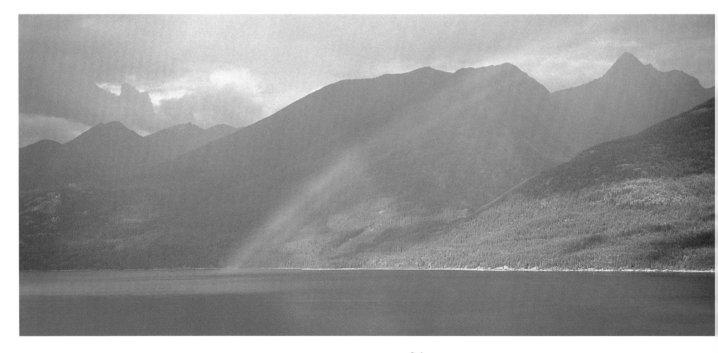

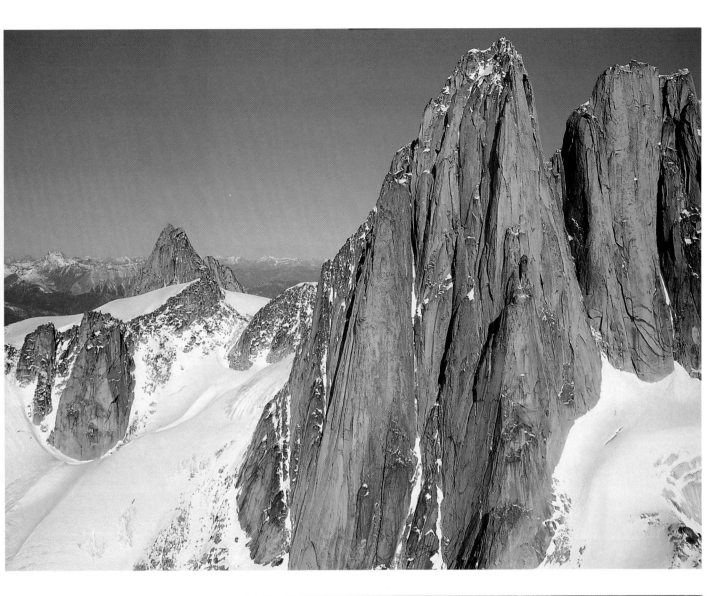

ABOVE: The Bugaboos in the northern part of the Purcell Range. The western slopes of these spectacular peaks rise out of an undisturbed area of more than 30,000 hectares, a quarter of it low elevation rainforest.

Western larches in the Skookumchuck Valley, east Purcells. The Purcell Mountains divide the Kootenays into West and East, wet and dry. Western larch thrives in the semi-arid conditions of the lower eastern slopes.

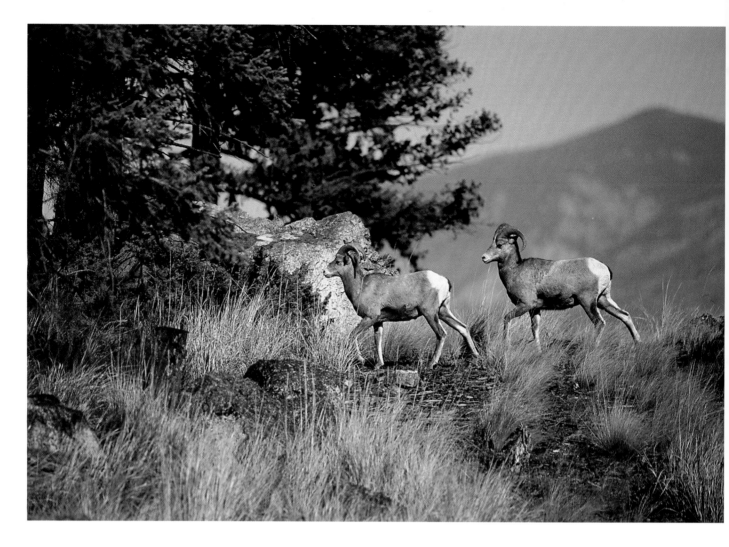

Bighorn sheep near Canal Flats, southern Rocky Mountain Trench. Some wildlife biologists call it the "Serengeti of North America." It may be the richest concentration of ungulate species on the continent. Although other regions support greater densities of certain kinds of animal, this wide valley is unrivaled for its sheer variety of "big game" species and their predators. Little of this area is wilderness, and the animals and their habitat are under increasing pressure from logging and ranching.

Ancient archers on a cliff near Canal Flats. This pictograph is in the territory of the Kutenai people. The Kutenai became distinct so long ago that their language has no known relationship to any other. They borrowed heavily from the culture of the neighbouring Plains peoples. In the eastern part of their lands they relied on large mammals, including bison. In the western part, they depended more on salmon and the bounty of marsh and lake.

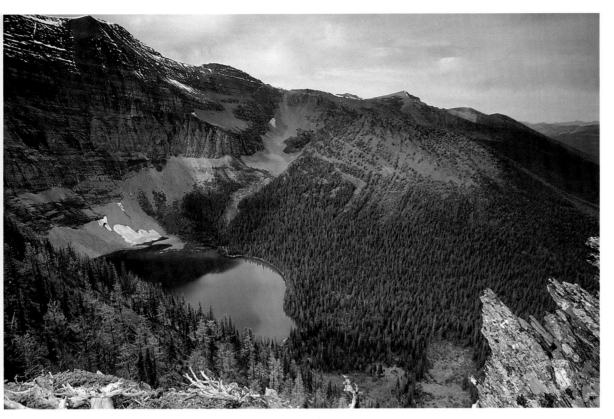

Wall Lake in the Akamina-Kishinena wilderness, near the Continental Divide, two kilometres northwest of the point where B.C., Alberta and Montana meet. To the south lies Montana's Glacier National Park; on the Alberta side, Waterton Lakes National Park. British Columbia's share of this wild domain is mostly unprotected. This southernmost part of the Canadian Rockies offers geology of unique beauty, and its relatively warm and dry mountain environment supports a number of species that exist nowhere else in Canada.

Transformation of Deer

A tale told by Barnaby, an old Kutenai man, to Franz Boas in 1914.

Long ago Deer used to bite the people. Only the men who were skillful could go hunting. The others were bitten by Deer.

There was a village, and the people in it were hungry because Deer was bad. And when Coyote said, "Let me go hunting!" the people of that village said to him: "Don't go hunting! Deer might bite you."

But Coyote replied: "I'll use my manitou power. Deer will not bite me."

So Coyote set forth, and after a while he worked his manitou power. He said to it: "Tell me, how shall I change that Deer? Later on there will be many people, and they will need to eat. How will they hunt Deer if Deer kills them?"

His manitou replied: "I will tell you how to change Deer. If Deer runs after you, take hold of it and pull out its teeth, and then make a tail for it."

So Coyote continued on, and after a time Deer caught his scent, and began to track him. When Coyote passed through a thicket, he heard the noise of Deer behind him. He waited until Deer came out, then ran after it and seized it. He held its mouth and pulled out its teeth. He stuck some grass on its behind to make a tail.

Coyote said to Deer: "Now I have finished with you. Look at yourself! Look how good you are! Bite no more! You shall be afraid of people. When you see them, you shall snort and run away. Only the skillful shall kill you."

Coyote continued on his way, and saw a deer, and killed it. Then he returned to the village. A little way out, he came across some children who were playing. They looked at him, and were frightened by the deer he was carrying, because Deer used to kill people. Coyote said to the children: "Why do you stare in fright? Shout for joy! Later on, when there are many people, and when children see someone coming home with meat, they will cry out with joy. The people in the village will hear the sound, and will know that a hunter has returned with meat. That is why the children will cry out."

But these children did not know what word to use. So Coyote said to them: "Say 'Hohowu!'" And this is the word the children shouted.

When the people in the village heard the children cry "Hohowu!", they said to each other: "Why are the children shouting that?" And then they came out and saw Coyote carrying the two deer. Coyote said to them: "Now go out hunting. I have transformed Deer. It will not bite you; but from now on it will be wild."

87

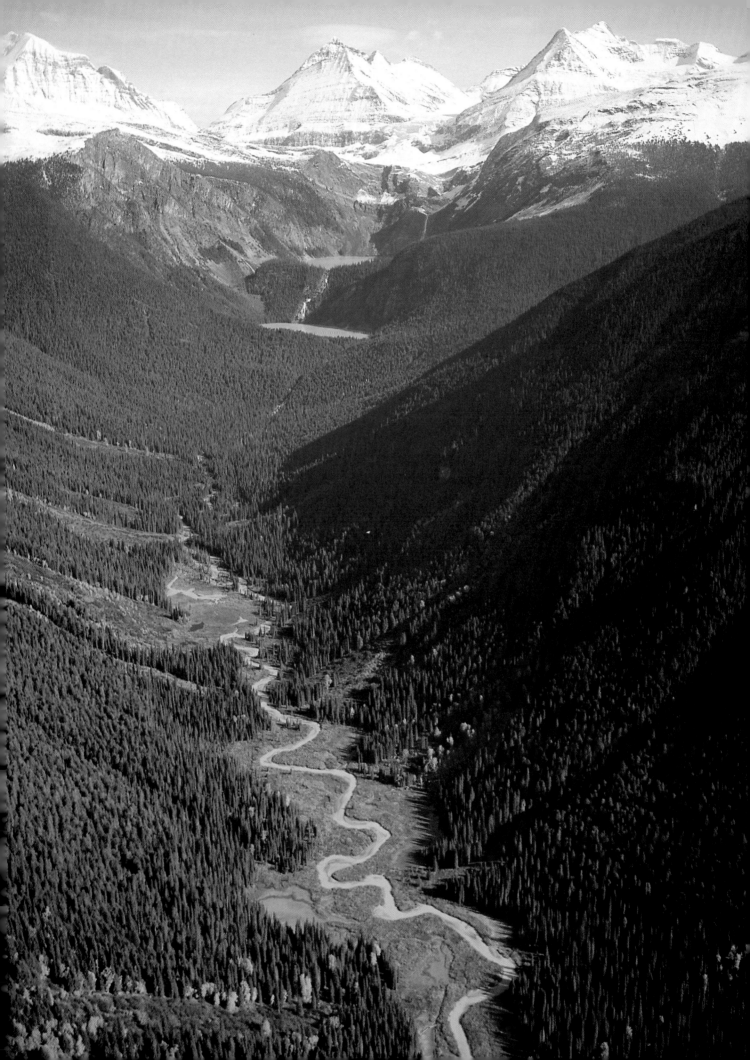

It was once the largest park in the province, a 200 kilometre stretch of forest and mountain, an expanse of wilderness twice the size of Prince Edward Island. It embraced a third of the southern Rocky Mountain Trench and extended to the Alberta border. Today, Hamber Park is a tiny mountain sanctuary. A deal formalized in 1961 reduced it from 900,000 hectares to 25,000, from four biogeoclimatic zones and seven ecoregions to a small area of tundra, rock and ice.

Hamber Park was the victim of a land swap. At the time, the deal seemed reasonable to park planners, and perhaps it would have been, had the government honoured it. Hamber Park gave up 875,000 hectares in a trade for 200,000 hectares around the Bowron Lakes chain in the Cariboo Mountains, an area of greater recreational value. The natural boundary for Bowron is the height of land surrounding the lakes. But the Forest Service wanted a smaller area protected. When Bowron Lake Park was declared, it was a mere 120,000 hectares, little more than half the size proposed in the original deal. That unfortunate decision resulted in the Wolverine Clearcut, a swath of destruction that almost reaches the shore of Isaac Lake, part of the main canoe circuit in one of the province's most popular parks.

Most of the original area of Hamber Park has now been flooded, roaded and logged, but some 150,000 hectares of British Columbia territory next to the present park remain wild, including three major watersheds: 70,000 hectare Wood River, 34,000 hectare Cummins River and 25,000 hectare Kinbasket River. The lower parts of these valleys support some of the last large tracts of interior rainforest remaining in the Rockies. These forests are not protected.

OPPOSITE: Cummins Valley in the Rocky Mountains, once at the heart of British Columbia's largest park. The government's 1995 land-use plan calls for much of the valley to be logged.

BELOW: Alpine lake at the Continental Divide near the southern border of Banff National Park.

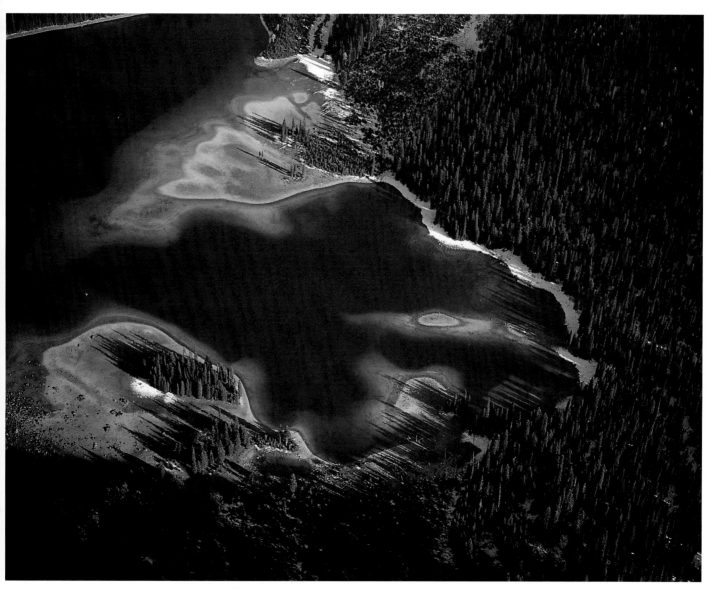

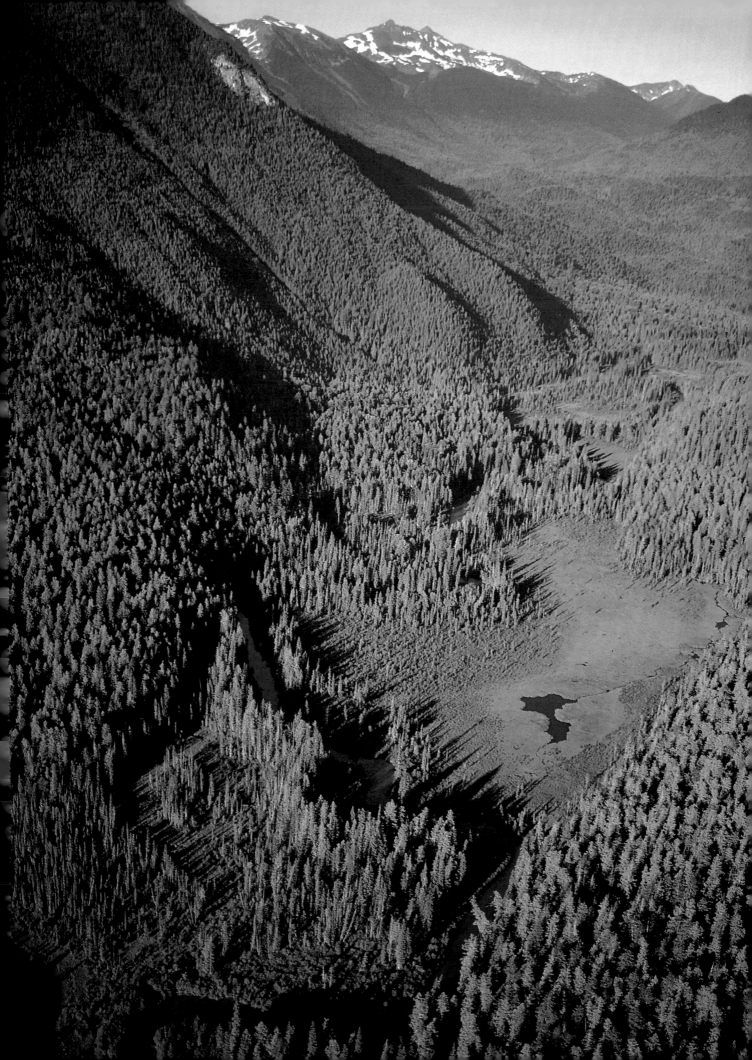

It's the water. After moving eastward across the dry interior plateau, you suddenly arrive at a new coastal rainforest — 400 kilometres from the sea. I really feel attracted to dense, green, dripping forest. Streams teaming with blood-red sockeye salmon, surrounded by rich green." Doug paused and looked wistfully out his window in Vancouver's West End. I had commented on the view of English Bay. He had replied that the only thing he ever really noticed was the parade of freighters. Many of them were waiting to load timber, some of it cut from his favourite wilderness.

I met Doug Radies and Ocean Hellman in an unusual manner. In 1991, two friends and I, hiking in the Cariboo Mountains, had come across a cabin in the forest. It had no lock and we had spent a night in the cabin before climbing the ridge overlooking the upper Matthew Valley. Four days later, we found ourselves in the cabin again and I decided to leave a message for our unknown hosts. The only paper I could find was a roll of adding machine tape that the owners used to kindle fires.

When Betty Frank, the owner of the cabin, showed Doug and Ocean the yard-long coil of mouse-chewed paper covered with my scrawly writing, they had laughed. But my message was serious. I had offered thanks for the unlocked cabin and more importantly, I had expressed my concern for the future of the lands surrounding it. To reach the forest where the cabin stood, we had driven through the largest clearcut we had ever seen — 8000 hectares of devastation that stretched from valley floor to alpine tundra. I had urged the owner of the cabin to join a campaign to save what was left of the wilderness and had appended my phone number.

Doug called me. My note was one of a thousand leads that he and Ocean had followed over the years in their efforts to save the Cariboo Mountains.

During 1989, Doug Radies lived in the Cariboo community of Wells, assisting his cousin with a small gold mining operation. Local people who depended on tourism were fighting to preserve a corridor of unlogged forest along the highway to Barkerville. "During my work at Wells, I was out on the back roads a lot and I really started to notice the logging. I realized there was much more at stake than a pretty roadside view for tourists. Vast areas of back country were being chewed up and nobody was doing anything about it. Then one day I went up Two

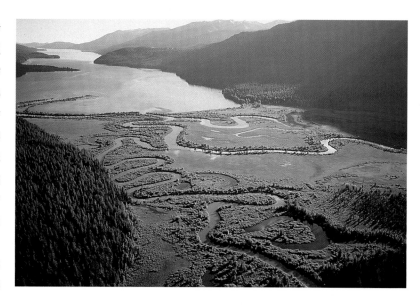

Sisters Mountain and saw the Bowron clearcut for the first time. That was when the 'twig' snapped."

The Bowron clearcut is a wonder of the world. When it is covered in snow, it is one of the easiest man-made features to see from space. It took just five years to make it and it covers more than 1600 square kilometres.

"Shortly afterwards, I happened to see a satellite photo of the area. On it I saw the Bowron clearcut, and many smaller ones as well — a patchwork of destruction spreading out from the big mill towns and scheduled to swallow everything except the parks. A couple of days later while driving to work, I suddenly said to my partner 'I have to go back to Vancouver.' We turned around on the spot. He asked me the reason, but I couldn't yet explain it.

"When I got to the city, I went to the office of the Western Canada Wilderness Committee. I expected them to understand the importance of the issue right away. They did. But I naively thought it was enough to draw their attention to the problem. I was shocked when Ken Lay told me that if I wanted to save the Cariboo Mountains, I would have to do it myself. Only then did I realize how small the environmental movement really is, how just a handful of overworked people are running most of these campaigns. So Ocean and I took up the challenge. We thought it wouldn't take long to convince the government. Setting aside a relatively small amount of land linking Bowron Lake and Wells Gray Provincial Parks would result in a huge continuous area of wilderness. It was so logical. We hadn't yet realized that politics doesn't have much to do with logic. We told our parents it would be all over in a year. We didn't think of anything else, least of all

ABOVE: The waters of Penfold Creek feed a major wetland. The meandering stream on the left is the Penfold; to the right is the Mitchell River. They flow into the north arm of Quesnel Lake. The pristine forests of the north arm are scheduled for clearcutting.

OPPOSITE: The Penfold Valley in the Cariboo Mountains, at the heart of a million hectares of undisturbed land. The valley is a vital corridor linking the northern and southern parts of southeast British Columbia's largest tract of wilderness. Much of this area has been protected, yet under the terms of a 1994 land-use decision the Penfold is to be logged. In 1995, the first four kilometres of a logging road were pushed into the valley.

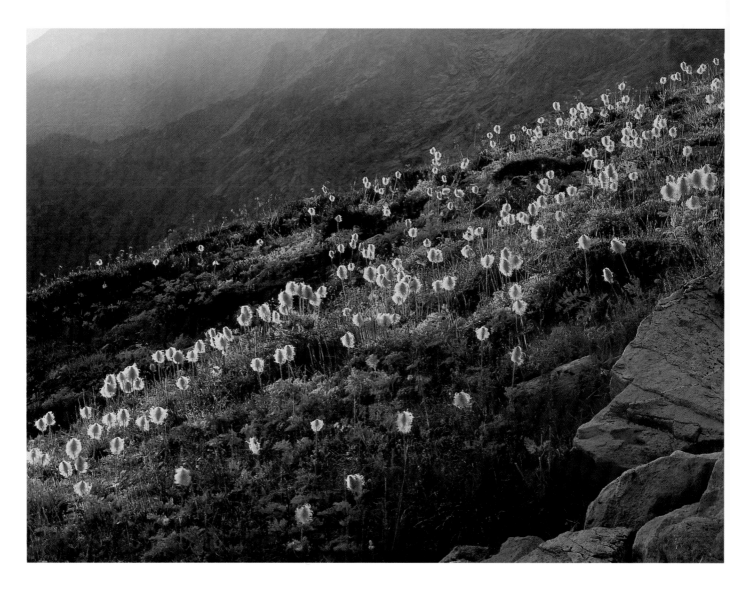

Western anemones in the alpine tundra of the Cariboo Mountains.

our finances. We were living on our savings, and we just began to campaign full-time. Our only concern was the speed of the logging and the urgency of saving this wilderness."

Over the course of four years, Doug and Ocean held hundreds of meetings with community groups, activists and government officials; put on more than 50 slide shows; created flyers, posters, a tabloid newspaper and magazine articles. They organized two paddling trips on Quesnel Lake to generate publicity. They built trails and surveyed wilderness by land and from the air. They took hundreds of photographs.

"No one had organized a Cariboo campaign before. We really didn't know what we were doing. We walked into those mill towns and gave slide shows. I guess we looked so naive that we didn't encounter a lot of hostility. If we'd had savvy, maybe it wouldn't have worked. We've really stirred it up in the Cariboo. We've been told that

one of the main reasons CORE (the Commission on Resources and the Environment) was established in the Cariboo was because of the conflict around the Cariboo Mountains issue."

In June of 1994, the United Nations Association presented Doug Radies and Ocean Hellman with the Eugene Rogers Environmental Award. Those who attended the presentation took a collection and gave the money directly to Doug and Ocean, for their personal use, without conditions. No one had the slightest doubt about the propriety of the gesture. For four years they had lived on money they had saved in their previous careers: Doug as a deck hand in the Coast Guard, and Ocean as a young film and TV actress. After the birth of their son Silas in 1992, they had additional expenses, yet they continued to pay many campaign costs from their own pockets. Their savings finally ran out in October 1993. That month they paid their rent with Visa. The following month they stayed

afloat by selling calendars. After that they survived, in part, through the generosity of other environmentalists.

Before the Cariboo Mountains campaign, neither Doug nor Ocean had been activists. Overnight they had become dedicated campaigners. I asked Ocean if there was anything in her past that could explain this transformation.

"I was raised with a natural affinity for nature. On Vancouver Island even 20 years ago there was lots of forest left. I spent whole summers without putting my shoes on once. When, at age 12, I began acting in *Danger Bay* (a CBC television series) I was exposed to environmental issues. The show dealt with a lot of serious subjects — logging, poaching, overfishing. All this reinforced my love of nature."

Doug, with a degree in physical education, fits few of the stereotypes of an environmentalist. His passion for wild places did not come until 1987, during the first of two winters spent in a remote prospecting camp in the Yukon. "We flew 250 air miles into the middle of nowhere and built two cabins. So there I was, living in this remote wilderness, just me and a friend. I began to sense that we're all on a big rock turning slowly in space. I became totally tuned in. I didn't think about it, it just happened. It takes time to make that connection. I believe in outdoor education, and a week in the wild is better than nothing, but I think everyone should have the opportunity to share the experience that I had. Just to be in the wilderness long enough to see a full cycle of the moon. To get used to hearing the same owl every night. To go into a place when it's just starting to freeze, and not to come out until it's thawing."

Interior cedar-hemlock rainforest is one of the Earth's rarer ecosystems: most of it occurs only in British Columbia. Almost all of it is slated for logging. The world's largest unbroken tract of old-growth interior cedar-hemlock forest lies in the Cariboo mountains. The ancient trees protect the spawning grounds of sockeye salmon and the endangered bull trout, and provide critical habitat for caribou. Caribou also depend for their survival on the spruce forests that cover higher elevations of the Cariboo Mountains and the nearby Quesnel highlands. The logging industry continues to push roads into both spruce and cedar-hemlock forest.

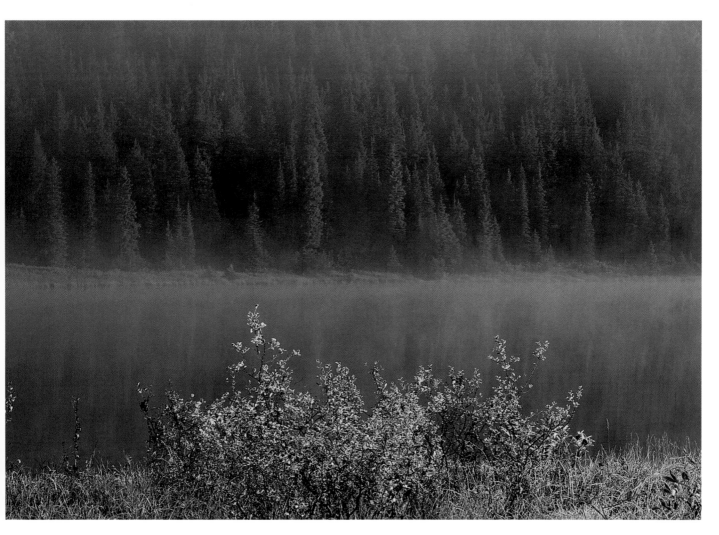

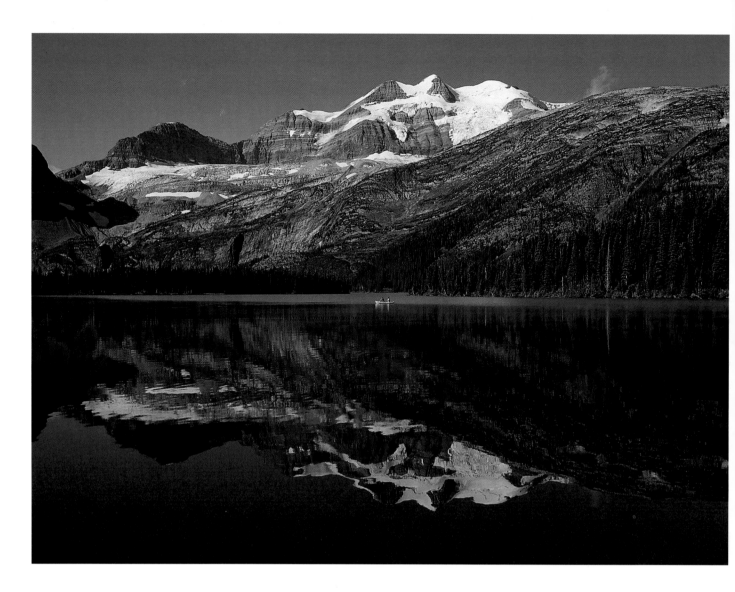

Dimsdale Lake, source of the Narraway River.

Mention the Canadian Rockies, and most of us think of our national parks. Banff was the first park to be created, and since 1885, it has attracted countless millions of visitors. The railway brought the first tourists; today, they come by road. Highways bisect Banff, Jasper, Yoho and Kootenay National Parks, east to west, north to south. Towns in the parks boast hotels, spas and fine dining. There is golf in summer and skiing in winter. Shops sell Inuit carvings, miniature totem poles and souvenir books in English, German and Japanese. Postcards offer views of mountain scenery, often with lawns and rose gardens in the foreground. This wilderness seems curiously tame. Bears loiter by the roadside and herds of elk wander among schoolyards and subdivisions.

I have always been grateful for these mountain parks: they embrace large areas of nature and allow the non-adventurous safe access to pristine landscapes. Networks of well-maintained trails lead into the back-country. My own introduction to overnight hiking was in a national park, and as a novice, I was thankful for the marked routes and established campsites.

But the time came when I resented seeing nature's secrets spelled out on signboards in neat yellow letters. I dreamed of unmarked trails, or no trails at all; of mountain ranges unroaded and unblemished; of vast lands unchanged since the earliest human visitor. Some 20 years after my first glimpse of the Rockies, I went in search of such a place, a hundred kilometres north of the northern tip of Jasper National Park.

Our float plane took off near Prince George, and for the first 150 kilometres we flew over roads, ranches and massive clearcuts. We passed low along the south flank of Mount Sir Alexander, one of the giants of the Canadian Rockies. The McGregor Valley at its base had recently been stripped of trees. Finally we left the destruction behind. We crossed the Continental Divide and entered the headwaters of the Kakwa River. It was a warm

and sunny September day, but overnight frost had left its red signature on the alpine tundra.

We circled Kakwa Lake. Just beyond the western shoreline, a 1000 metre cliff rises to an ice-crowned ridge. The place is as beautiful as Lake Louise and may share its fate. There is talk of building a highway here, a shortcut between Prince George and Edmonton. Kakwa Lake could become a major resort. Sometimes natural beauty can be loved too much.

The lake showed few signs of human presence. We saw a dirt road, a quarry, a few small structures, some tire marks on the beach. But even these disturbed us. Instead of landing here as planned, we told the pilot to fly on. We continued west down Jarvis Creek. The wooded valleys were unroaded, the lakes aquamarine, the mountains crowned with white.

We landed on Dimsdale Lake and unloaded our gear onto a tiny grassy meadow at its eastern end. The plane departed. West, across the water, stood glacier-clad Mount Petrie. A hundred metres to our right, the lake thundered over an escarpment on its way to the Arctic Ocean.

The next day we climbed to the treeline. We looked down the Narraway Valley into the foothills of Alberta. We saw no traces of humanity.

That night, by the campfire, I had a whimsical thought. If the plane did not return, how long would it take us to hike out? For the next few minutes, I examined maps and plotted a route to the nearest road. We would traverse alpine tundra to minimize time in the bush. We would avoid steep slopes. In four or five days we could probably reach the nearest road — a dirt one, and perhaps not in use.

When the plane returned three days later, I was almost disappointed.

The Narraway Valley, looking toward Alberta. Here, the foothills of the Rockies lie within British Columbia. The British Columbia portion of the Narraway covers 80,000 hectares; it is the mid-point of a 200 kilometre length of mountain wilderness that begins at the northern end of Jasper National Park. Most of this area is not protected.

The landscape shown below belongs to the Englemann Spruce-Subalpine Fir Biogeoclimatic Zone. This sub-alpine zone covers much of the British Columbia interior. Winters are long and cold. Higher elevations are characterized by open parkland, where clumps of trees are interspersed with meadow, heath and grassland.

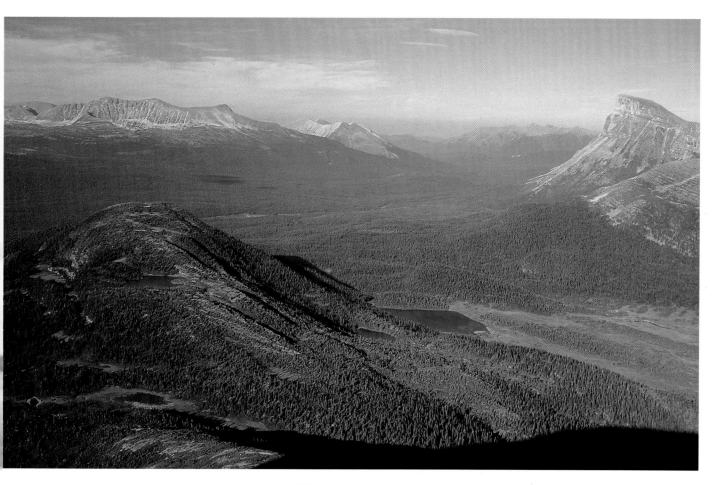

Sub-Boreal Interior

P eople often call the area "northern British Columbia," but it really occupies the geographical centre of the province. This rolling plateau, which forms the southern half of the Sub-Boreal Interior Ecoprovince, was once entirely covered with forests of spruce, pine and aspen, and resembled the landscape shown below. Today, logging and agriculture have fragmented most of the original forest.

In the northern and eastern parts of the ecoprovince, vast areas of wilderness still remain — in the Skeena and Omineca Mountains and in the central portion of the British Columbia Rockies. There, Englemann spruce and sub-alpine fir cover mountain flanks, and many of the valley floors support white and black spruce — the beginnings of the great boreal forest.

The Babine flows through a landscape typical of the Sub-Boreal Spruce Biogeoclimatic Zone. White spruce (often hybridized with Engelmann spruce) and sub-alpine fir are the dominant species, but in burned-over areas, lodgepole pine, trembling aspen and paper birch are the first trees to reappear. Although the climate is severe, this zone has a longer growing season than the boreal forest to the north.

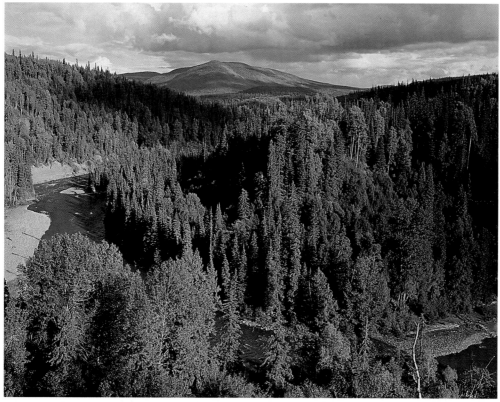

OPPOSITE: Sitka mountain ash near the Continental Divide, in the wilderness to the north of Mount Sir Alexander.

LEFT: The Babine River drains the longest natural lake in British Columbia. From its source at the centre of the province, Babine Lake stretches 150 kilometres to the northwest before narrowing into a river. It flows another 80 kilometres through placid meanders and roaring canyons before joining the Skeena. Its whitewater rafting and fishing are unsurpassed. Rich runs of salmon attract bears and help support a large population of grizzlies. Logging near the river threatens bear populations.

1810-11: A year at Stuart's Lake.

Daniel Harmon was a partner of the North West Company, and was posted for six years at Fort St. James on Stuart Lake. He kept a diary of his impressions of life at that remote fur-trading post. These are extracts from the first year.

The North Arm of Stuart Lake, near the centre of British Columbia. On the lake's east end is Fort St. James, a former fur-trading post and the oldest continuously inhabited non-Native settlement west of the Rockies. It lies near the edge of a wilderness that has changed little since Simon Fraser founded the fort in 1806. This undeveloped area includes the North Arm, the western end of Trembleur Lake, and the 23,000 hectare Tildesley Creek valley. Douglas-fir, some of them a metre thick, stand on the shores of Stuart Lake. They are isolated and at the northern limit of their range: 300 kilometres of spruce, pine and aspen separate these trees from the nearest extensive forests of Douglas-fir in the Chilcotin.

November 14. The Lake opposite the Fort is frozen over...

January 1. This being the first Day of the year our People have past it as is customary for them-Drinking & fighting. Some of the principal Indians of the place desired us to allow them to remain at the Fort to see our People drink, but as soon as they began to be intoxicated and quarrel among themselves, the Natives were apprehensive that something unpleasant might befall them also, therefore they hid themselves under beds & elsewhere, and said they thought the White People had become mad.

January 27. The Natives have burnt the Corpse of one of their Chiefs who died the beginning of this Month. One of his Nieces shortly after his death, painted her face Vermilion and in other respects arrayed herself in the gayest manner possible, which conduct her Mother observed, and upbraided her for such an unbecoming behaviour so soon after the dissolution of her Uncle, by telling her that she ought rather to paint or daub her face with black and cut off her hair, but those reproaches she took so much to heart that soon after she went into the Woods ...where she hung herself from the limb of a Tree, but fortunately for her, soon after people past that way, and saw her in that sad condition when they ran and

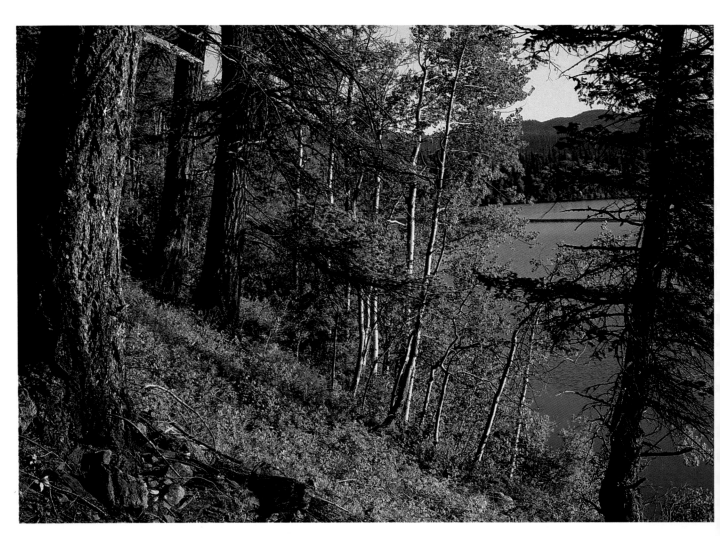

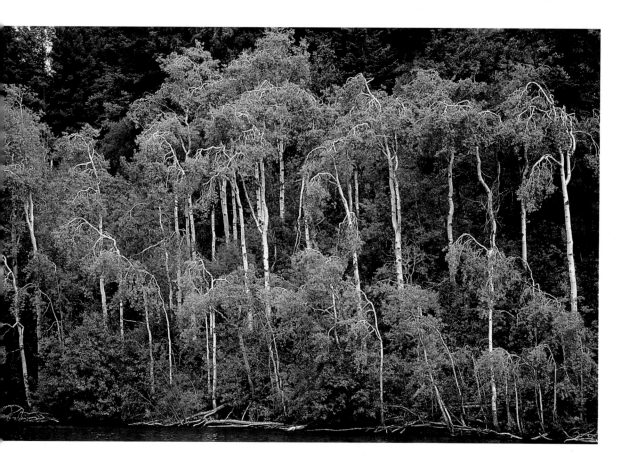

took her down, but senseless, however shortly after she recovered...

May 21. This afternoon the Ice in this Lake broke up - and Mosquetoes begin to come about and troublesome fellows they are.

August 2. Five [dried] Salmon is all the Provisions we have in the Fort & we are no less than ten persons neither can we at this Season take fish out of this Lake, and what will become of us unless the Salmon begin soon to make their appearance in the River. However we cannot believe that we shall be allowed to starve.

September 2. We now have Salmon in abundance which the Natives take in the following manner: - They make a Dam across the River and at certain places leave spaces, where they put a kind of long Basket Net ...

one end of which is made like a wire MouseTrap, & into that the Salmon enter, but when once in cannot go out ... in one of those Baskets they often will take four or five hundred Salmon...

September 17. Between nine and ten OClock this forenoon, the Sun was eclipsed for nearly a half an hour, at which circumstance the Natives were much alarmed for they looked upon it as a bad omen or as a foreboding of some evil...therefore they began crying and made a terrible Savage noise but their Priest or Magician took handfulls of Swans down and threw or rather blew it up towards the Sun and implored that luminary to accept the offering...

September 23 [Harmon records a verbal dispute with the famous Carrier chief Kwah, in which the latter expressed himself as follows:]

'You ...know how to read and write; but I do not. Do not I manage my affairs as well, as you do yours? You keep your fort in order, and make your slaves,' meaning my men, 'obey you. You send a great way off for goods, and you are rich and want for nothing. But do not I manage my affairs as well as you do yours? When did you ever hear that Quâs was in danger of starving? When it is the proper season to hunt the beaver, I kill them; and of their flesh I make feasts for my relations. ... I know the season when fish spawn, and, then send my women, with the nets which they have made, to take them. I never want for anything, and my family is always well clothed.'

October 12. For the three last days it has constantly Snowed & fell nearly two feet.

Aspen trees on the North Arm of Stuart Lake.

For many hours we travelled north from Fort St. James, along a gravel road that wound through ever steeper hills. The bottle-brush shapes of black spruce rose out of muskeg in the valley bottoms; we were entering the true boreal forest. Groves of aspen stood in golden relief against green conifers. Their small heart-shaped leaves trembled in the autumn breeze and the waning warmth of the winter-bound sun seemed to linger in the shimmering foliage.

We hiked past the last logging cuts, and finally stood overlooking Tutizzi Lake. The mountain on the opposite shore was a mosaic: above the treeline, rust-coloured tundra; below, green spruce and patches of aspen in crimson or yellow and the grey-brown hue of bare branches. Each colour demarks a single aspen clone colony. The leaves of genetically identical trees change colour and fall in unison.

During the night, a violent wind shook our tent and snowflakes mixed with flying leaves. When dawn came, the reds and yellows had vanished from the mountainside.

BELOW: Tutizzi Lake lies in a valley of the Omineca Mountains, the range west of Williston Lake and the Rocky Mountain Trench. Boreal forest lines its shores and covers the bottoms of nearby wilderness valleys. Tutizzi is reported to contain pure strains of rainbow trout, lake trout, Dolly Varden, arctic grayling and mountain whitefish — an association of species that may make the lake biologically unique. Not long ago, Tutizzi lay far beyond the industrial frontier, but logging has recently leveled vast areas of nearby forest. The timber industry continues to push forward past Tutizzi and into the pristine northern third of British Columbia.
OPPOSITE: Aspens and fireweed in the Cassiar Mountains, early September.

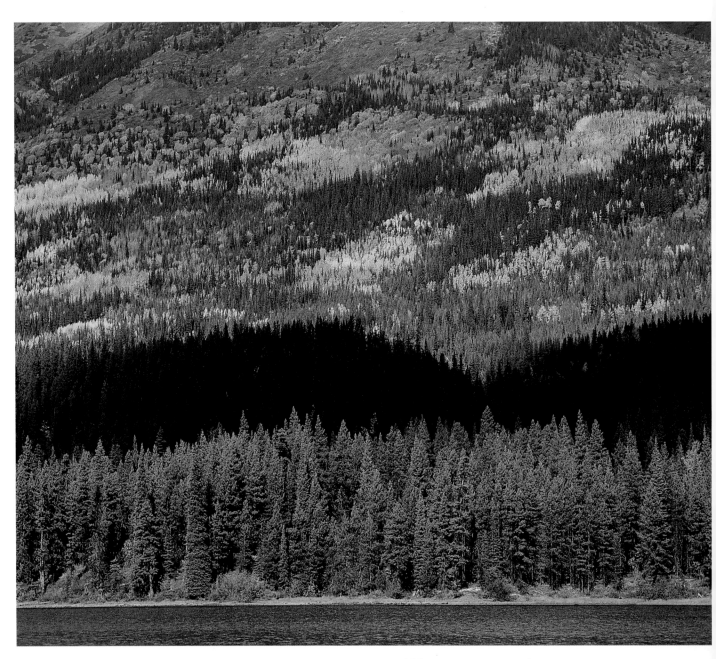

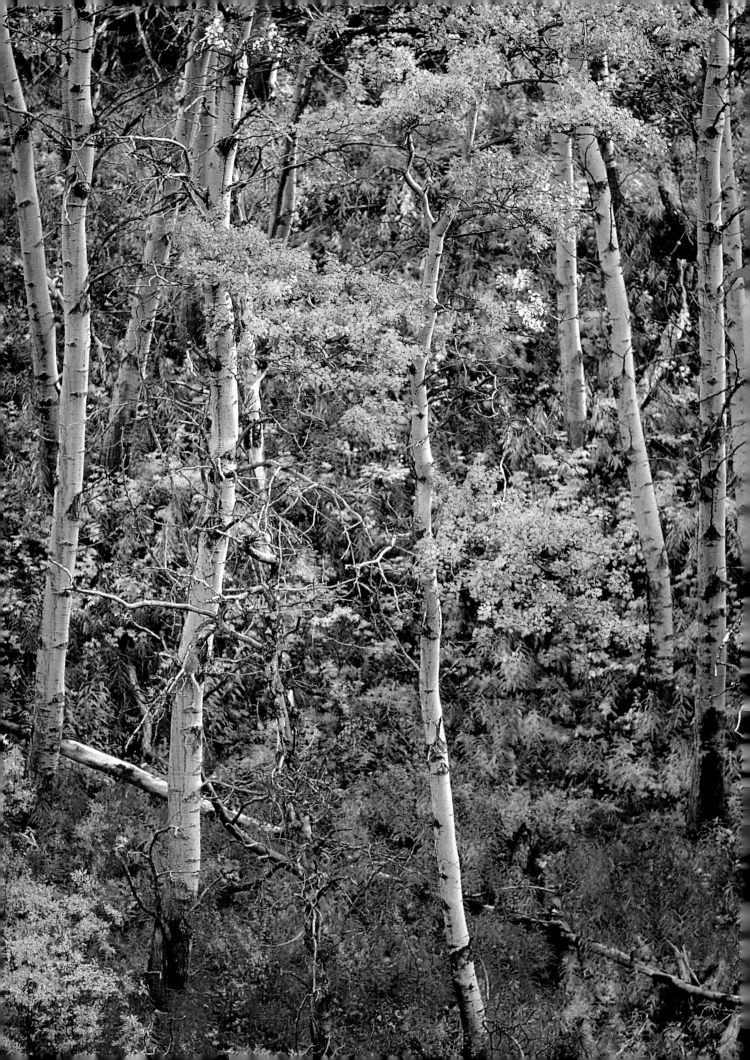

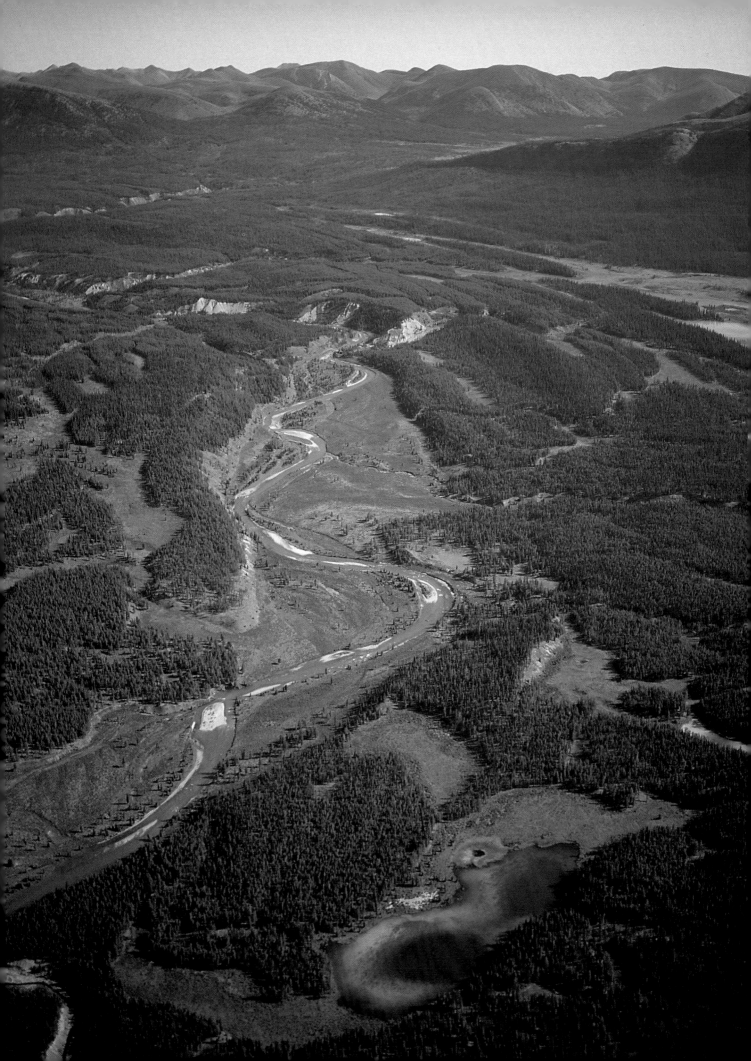

The North

Imagine a line traversing the province, beginning in the Alaskan panhandle just south of the Stikine, crossing four mountain ranges, and ending in the Rocky Mountain foothills not far from Hudson's Hope. South of this line are settlements, farms, dams and logging cuts, an ocean of modified landscape surrounding mere islands of wilderness. North of this line, wild forest stretches to the arctic tundra, interrupted only rarely by the works of mankind. This wilderness covers more than a quarter of the province.

If you want to find wilderness, look for places without roads. Only two roads cross the great northern wilderness of British Columbia. Almost everywhere else, highways bring settlers, miners, ranchers and loggers. But the north is immense and its climate severe. The trees of the boreal forest are small and grow slowly and until now, distant pulp mills have shown little interest in their fibre. The two great northern highways still traverse a largely pristine country.

Northern British Columbia is a recent frontier: there are peaks in the northern Rockies called Roosevelt and Churchill, and a range named in honour of the Battle of Britain. A flurry of map-making followed the construction of the Alaska Highway in 1942. The highway was built in haste, without a proper survey. Engineers chose the route for the 500 kilometres between Fort Nelson and Watson Lake on the advice of an aboriginal hunter. The men who pushed the highway across more than 2000 kilometres of forest and muskeg may have often been the first non-Natives to walk on this land.

In the more than 50 years since its construction, many signs of human activity have appeared along the Alaska Highway's first 400 kilometres. The road begins at Dawson Creek, and at first traverses a tamed landscape of wheat farms and cattle ranches. After crossing the Peace

LEFT: The Prophet River flows east through the foothills of the northern Rockies, at the edge of a roadless area larger than Austria.

RIGHT: Fireweed meadows above Ealue lake, on the fringe of the Spatsizi Plateau.

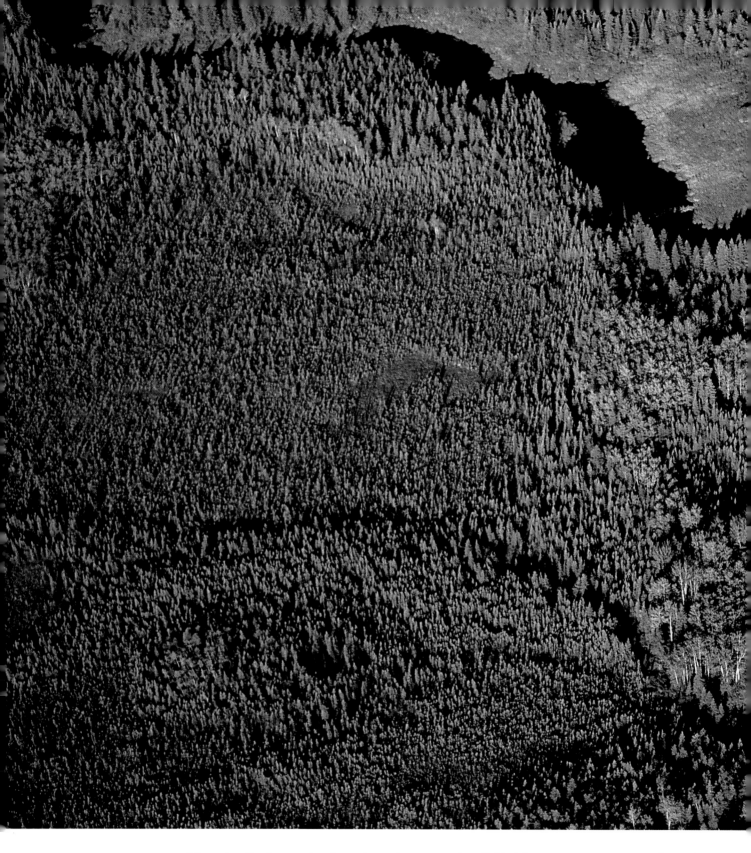

It is vast as the Amazon jungle, and stretches from Labrador to Alaska, from Lake Superior to the Beaufort Sea. North America's great boreal forest also covers parts of British Columbia. I took this photograph near Fort Nelson. It shows a landscape typical of the Taiga Plains Ecoprovince, which includes the northeast corner of British Columbia. Mature white spruce line the river. Behind them you can see stands of trembling aspen, recognizable by their white trunks — the first trees to regrow where the forest has been disturbed. Black spruce dominate the left part of the scene. These are smaller than white spruce and thrive in the acidic environment of the sphagnum bogs that cover so much of the Taiga Plains.

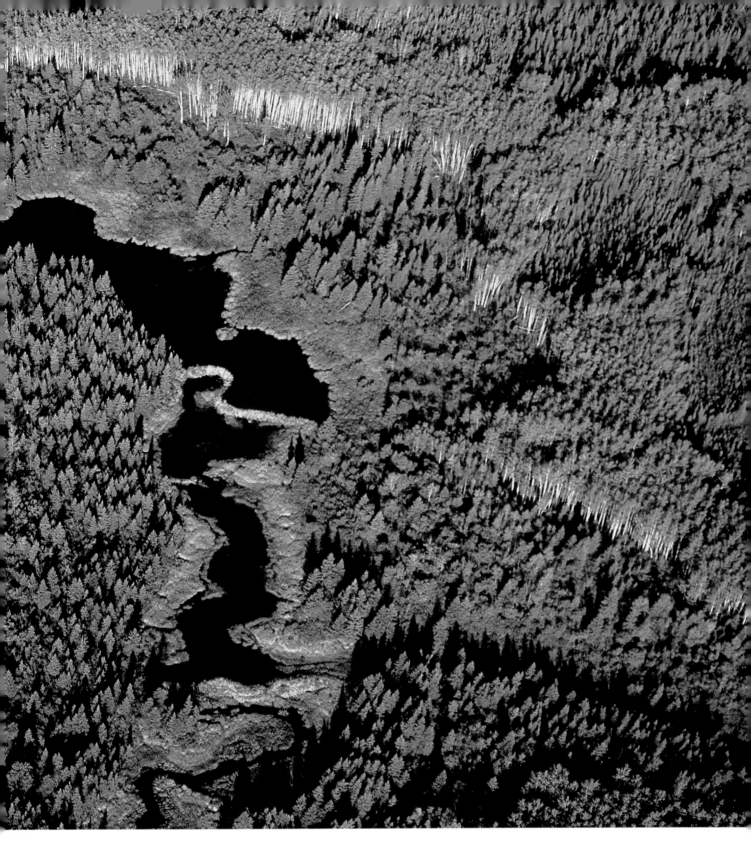

The Taiga Plains Ecoprovince is the coldest region of British Columbia. Arctic air flows unimpeded across the flat landscape and patches of permafrost lie beneath the surface. Moose are abundant, as are black bear and lynx. Beaver live here too, and the photograph shows several dams. In summer, clouds of mosquitoes fill the air. Hundreds of seismic traces criss-cross the northeast corner of British Columbia, remnants of extensive oil exploration that has left little wilderness untouched.

A single biogeoclimatic zone — Boreal White and Black Spruce — takes up the Taiga Plains Ecoprovince. This zone extends west along the Liard River, and also occurs in the valley bottoms of the northern Rockies and the Cassiar Mountains.

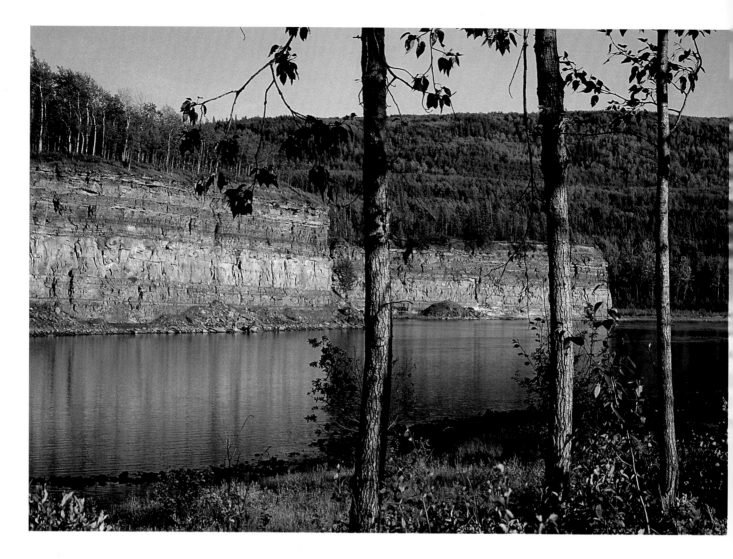

River, it continues north through the wilder country of the Rocky Mountain foothills until, just south of Fort Nelson, it enters taiga — the swampy coniferous forest that extends to the arctic treeline. A number of small roads branch from this initial section of the highway. Many lead to oil and natural gas fields.

The wilderness of the northeast corner of the province has been fragmented by petroleum exploration. Seismic lines criss-cross the landscape. Bulldozed in winter, they are arrow-straight and kilometres long. Crews lay charges along these lines and, by charting the echos of the detonations, engineers can detect petroleum deposits deep in the Earth. The seismic lines become, in effect, a

ABOVE: The Peace River downstream of the Bennett Dam. British Columbia's Peace River region falls in the Boreal Plains Ecoprovince, and the vegetation resembles large areas of Alberta. Although white and black spruce are the climax tree species, frequent fires result in a landscape dominated by aspen, poplar and lodgepole pine. In many areas trees alternate with shrubs and grasslands, forming "aspen parklands." Moose and deer are common. Many parts of the Boreal Plains Ecoprovince have been settled, and wheat farms and cattle ranches have fragmented much of the original forest. Forestry companies may clear vast areas of what remains, if government plans to exploit the boreal forest for pulp go ahead.

tight lattice of roads that allows motorized vehicles access to almost all parts of the land.

After Fort Nelson, the highway turns west, passing through the northern end of the Rocky Mountains. It enters the Boreal Mountains Ecoprovince, and from that point on, wilderness starts at the roadside.

The second of the great northern highways, the Stewart-Cassiar, was completed in the early 1980s. It begins near Terrace and cuts north along the flank of the Coast Range. Originally built to transport asbestos from Cassiar to the port of Stewart, it was extended and improved at great cost to serve as a scenic tourist route to the Yukon. Soon after its completion, massive roadside logging disfigured its southernmost 200 kilometres. At the peak of the logging, over a hundred trucks a day rolled into the tiny port of Stewart to unload whole logs for shipment to Japan. Today the chainsaws are silent and the Bell-Irving Valley is bare.

An hour or so south of the Stikine River the clearcuts end, and northbound travellers see wooded

mountains rising from the roadside. Few other places on Earth offer a day of high-speed driving through pristine forest, where even the smallest human outposts are several hours apart. We will lose this experience if logging is pushed into the Cassiar Forest District.

The population of the north is tiny. Most people who see this wilderness are travellers from the south. Those who begin their journey in late spring leave the dark behind. They sleep before dusk and awaken in the light.

I have travelled for weeks in northern British Columbia without seeing true night.

Even at noon, the sun is not high, and much of the time it skims the horizon. The country soaks in the soft golden light of a perpetual late afternoon. When autumn arrives and the fireweed, willow and aspen turn magenta and yellow, it is as if the earth were surrendering the accumulated rays of summer.

The Northern Boreal Mountains Ecoprovince reaches from Halfway River to the Tatshenshini, from the Lower Stikine River to beyond the Liard. It occupies a fifth of the province, virtually all of it wilderness. Much of it lies at higher elevations: the Stikine Plateau, the Cassiar and Omineca Mountains, and the Terminal Range of the Rockies. Boreal white and black spruce cover its valley floors, but the majority of the ecoprovince's surface area falls within the Spruce-Willow-Birch Biogeoclimatic Zone. This is a sub-alpine zone, characterized at its lower limits by open forests of white spruce and subalpine fir. Higher on the slopes, deciduous shrubs predominate, particularly scrub birch and a number of species of dwarf willow collectively known as "buck brush." The scene below from the northern Rockies typifies the zone.

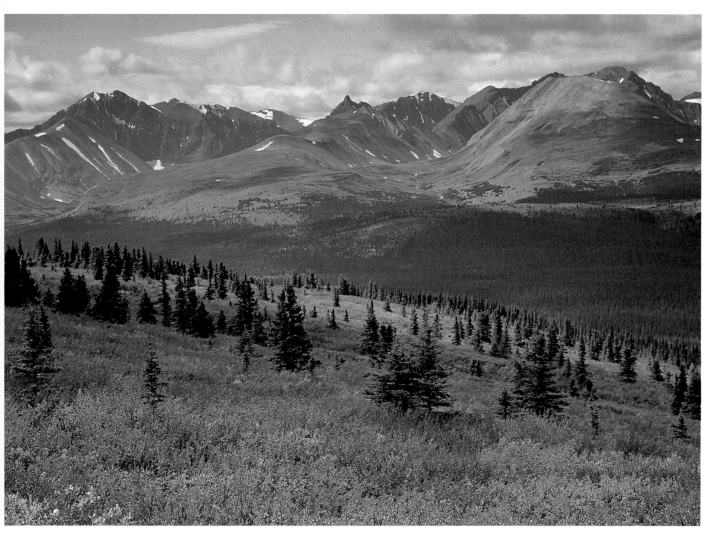

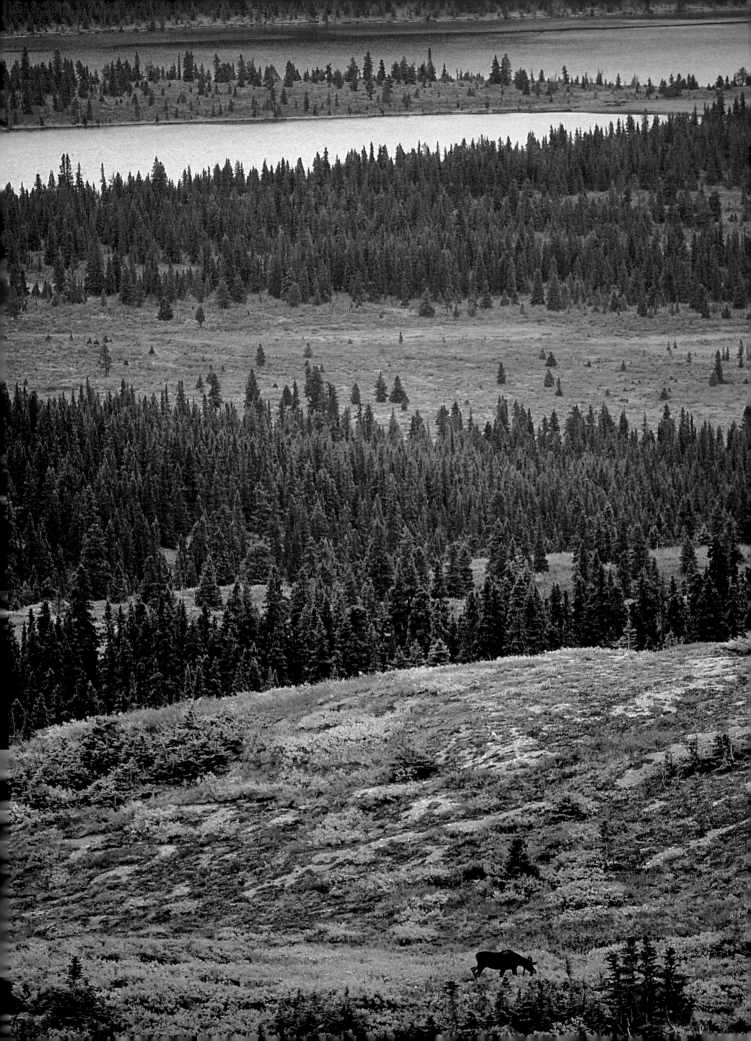

Northern Rockies

I watched the ancient yellow Beaver fly into the distance. It had once belonged to the U.S. army, and someone had rivetted patches over bullet holes in its fuselage. Now, a bush pilot owned it, one of a handful who regularly flies into these parts. Urs was born in Switzerland, and he had brought me to a wilderness twice the size of his native country.

After taking off from a lake near Fort Nelson we had flown over a forested plain striped with seismic lines. In half an hour, we had reached a large river meandering eastward through the foothills. Beyond it, I saw no further signs of oil exploration. "The Prophet River," said Urs. "I haven't taken anyone past here for a while." Fifty kilometres further southwest we descended toward a cluster of aquamarine lakes. Hills rolled away to the east. To the west rose mountains and icefields.

Few sensations feel more profound than the sound of a floatplane fading over a wild lake. It is the moment when technology yields to silence. I rested on the moss and listened to wavelets against the shore. The August morning was warm and cloudless, I had 15 kilos of food, the nearest person might have been a hundred kilometres away, and for six more days I had not a single obligation.

I followed a narrow beach, then crossed a bog that moose had marked in a thousand places. I climbed east through white spruce, thick trunks supporting squat cones of foliage. Moss covered the forest floor, and understorey willow grew waist-high. Trails turned up everywhere, an erratic network carved into the land by generations of hooves.

OPPOSITE: Cranswick Lake.

BELOW: Redfern Lake. Rising out of the desert of New Mexico, the Rocky Mountains stretch northwest for 3000 kilometres. They end in British Columbia, just south of the Yukon border, and their last 300 kilometres lie in wilderness. Here, mountains and foothills cover a pristine area larger than Vancouver Island. The valley bottoms harbour lakes, wetlands and spruce forests. Above rise brushlands, tundra, glaciers and eternal snow. The Gataga, Muskwa and Prophet drainages provide pasture for some of the province's largest concentrations of caribou, moose and elk. The Sikanni Chief Valley is home to British Columbia's only wild herds of bison. More roadless nature stretches west across the Rocky Mountain Trench to the Cassiar Mountains and the headwaters of the Stikine.

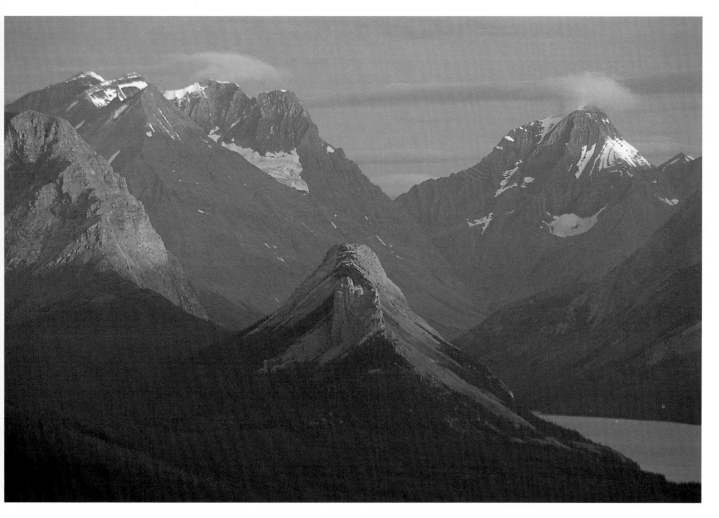

The spruce thinned, and I reached the ridgetop at sunset. Trimble Lake lay in dusk among the eastern foothills, and to the west, the waters of Redfern Lake reflected the pink of nearby peaks. I made camp under the stars.

In the morning I returned to the lake. Hoofprints were everywhere, and in the distance I heard the lonely bellow of a cow moose. But I had yet to see any animals. I tried to imagine myself in their place. I would avoid dry ridgetops and follow streams into alpine valleys and lush summer pastures. I filled a pack with 40 kilos of cameras

The Alpine Tundra Biogeoclimatic Zone is the vegetation zone that exists above the treeline. In southern parts of British Columbia, it begins at around 2000 metres; near the Yukon border, it occurs as low as 1500. Harsh winters, persistent snow cover and short, cool growing seasons allow only shrubs, herbs, mosses and lichens to survive. The character of alpine tundra varies significantly according to latitude and rainfall. The alpine meadows of dwarf willow typical of the northern Rockies (shown below) are quite different from the fields of fireweed found above the treeline further west (see the photo on page 103) or the wildflower meadows that cover upper mountain slopes in the wetter areas of the south (page 82). Owing to its recreational appeal and general lack of commercial value, alpine tundra is better represented in our park system than any other biogeoclimatic zone.

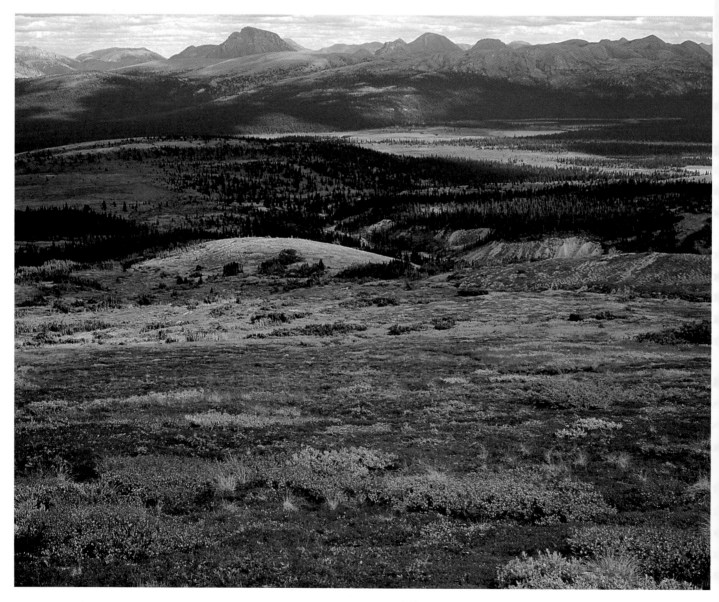

A young caribou near the headwaters of the Prophet River. Some scientists believe that the foothills of the northern Rockies were the site of a dry corridor between the two great ice sheets that once covered most of Canada. The ancestors of the first inhabitants of South America may have passed through this land. It remains home to Athabaskan peoples, who may have descended from some of the earliest nomadic hunters of the western hemisphere.

and food, and struck out west toward the mountains.

The northern foothills support some of the densest populations of wild ungulates in British Columbia. The animals here are truly wild, not like the half-tame creatures in national parks. The area attracts hunters, and caribou, moose, elk and wolves are killed regularly.

I was still in forest when I saw a full-antlered caribou 50 metres ahead. We stood and stared into each other's eyes. I had lost the advantage of stealth, and knew that I could not photograph him. I continued forward and the bull caribou lept off the trail, vanishing among swaying branches and snapping twigs.

I emerged from the forest onto a broad ridgetop. A kilometre to the south was an avalanche chute, still filled with a triangle of white from the previous winter. On it were two dark flecks. They were a pair of resting caribou, one standing, the other lying on the snow.

I found the pasture where the moose browsed in a high pass between two valleys, watered by a tiny creek. I crawled behind some bushes on the downwind side. One of the bulls hung close to a cow and her yearling calf. The cow lunged at him. She lowed and bellowed in what seemed to be ambivalent passion, then lunged again. She allowed him close enough to nuzzle only once. Between flirtations, the animals browsed. I wrestled with my heavy lens and clung to plants to keep myself from sliding off the hill. Hours passed. I had expected these creatures to lead me on a journey somewhere, but they were like sheep or horses, content to remain where the grass was lush. The scene was almost bucolic.

As I was leaving the pass, I met a young caribou. I stopped and stepped backwards. The animal advanced, as if following me. I was blocking its only route into the meadow and it seemed unwilling to forego a meal on my account. I moved uphill out of its path, hoping to frame it against the valley background. The caribou trotted into my photographic composition, then stopped and turned to look at me, wavering between hunger, fear and curiosity.

A cold wind sprang up, and I began to walk back to my tent. As the sky grew dim, only the ground exuded light and warmth, its carpet of dwarf willows unfolding in a mosaic of pale green, yellow and scarlet. In the distance were the same two caribou. Now both were lying on the snow.

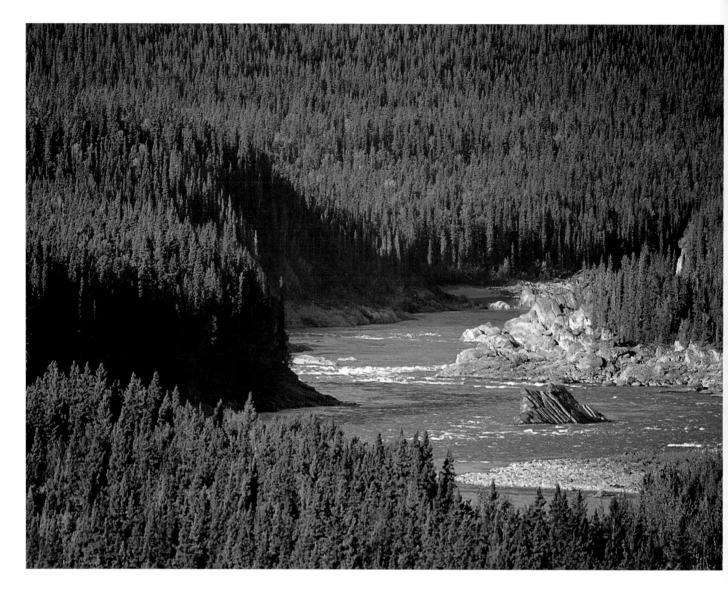

Imagine, if you can, the Fraser River during the first half of the 19th century. No city stood at its mouth. Rainforest flanked its lower course. Inland, it formed a wild canyon that cut through a dry landscape. The population along its banks was small and mostly indigenous. Its tributaries drained wild valleys and remote plateaus. Imagine mountain heights to ocean tide, mighty and pristine.

Such a river exists today. It is called the Stikine.

Few places on Earth are lonelier now than they were a hundred years ago. The lower part of the Stikine is one of them. It was once a major route into the interior of the province. Passenger steamers plied the 240 kilometres between the seacoast and the village of Glenora. Today, the lower Stikine sees only a boat or two a day.

John Muir travelled up the Stikine on one of those early passenger steamers. In his book *Travels in Alaska*, published posthumously in 1915, the celebrated American naturalist described the river in the following terms:

"It is about three hundred and fifty miles long... It first pursues a westerly course through grassy plains darkened here and there with groves of spruce and pine; then, curving southward and receiving numerous tributaries from the north, it enters the Coast Range, and sweeps across it through a magnificent cañon three thousand to five thousand feet deep, and more than a hundred miles long. The majestic cliffs and mountains forming the cañon

ABOVE: The Liard River, just east of Fireside on the Alaska Highway. The Liard and its tributaries drain the northeast corner of British Columbia, about a sixth of the province's area. The river flows through a vast lowland covered in boreal spruce. As forestry companies move further north, this pristine area is threatened with logging. No one knows how long it takes for forests such as these to recover after clearcutting. At this latitude, a conifer only 20 centimetres in diameter may be older than a century.

OPPOSITE: The Grand Canyon of the Stikine, just east of Telegraph Creek.

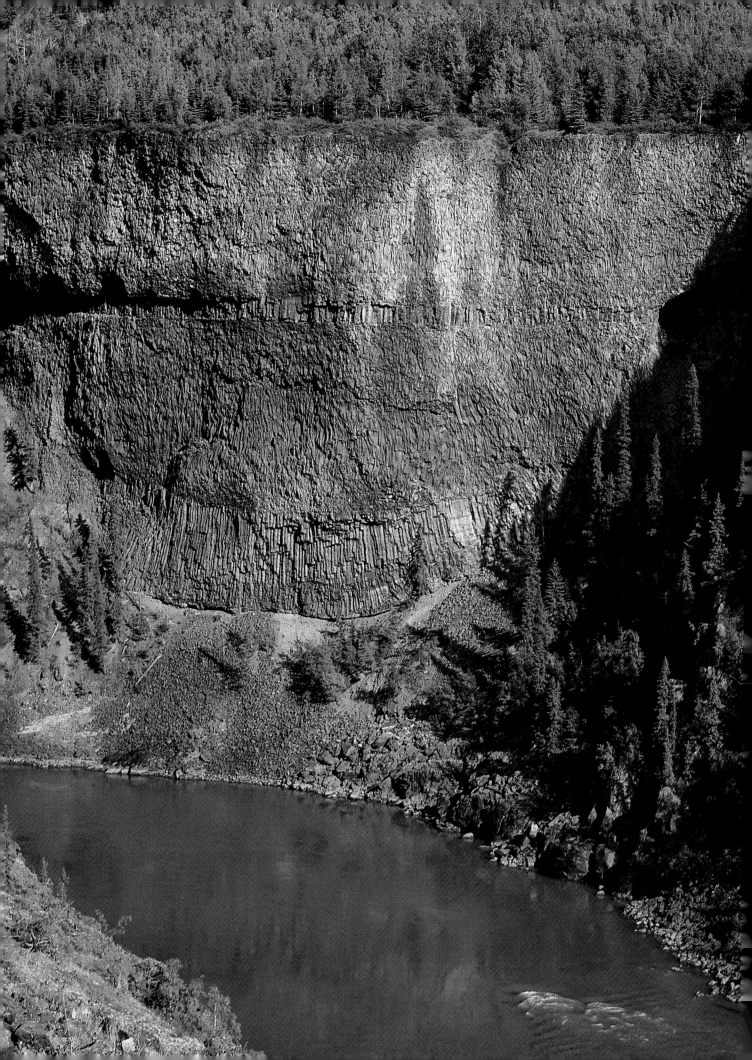

Aspen parkland near Telegraph Creek, in a rainshadow that covers part of the mid-Stikine.

BELOW: Near Ealue Lake, at the head of the Iskut, the Stikine's largest tributary. The Ministry of Forests plans to increase the level of logging in the Cassiar Forest District — one proposal called for a 10-fold increase in the rate of cut. Only the valley bottoms — some three percent of the total area — have commercially valuable trees. Logging in this mountainous region would fragment vast tracts of wilderness in exchange for a minimal amount of timber.

walls display endless variety of form and sculpture, and are wonderfully adorned and enlivened with glaciers and waterfalls, while throughout almost its whole extent the floor is a flowery landscape garden, like Yosemite."

Muir was particularly interested in the glaciers. He visited several of them, and spent days exploring the Great Glacier. As was his custom, he set out alone, equipped with nothing more than "biscuits, dried salmon, a little sugar and tea, a blanket, and a piece of light sheeting for shelter..."

When the keeper of the steamer station asked him when he would return, he replied: " 'Oh, any time. ... I shall see as much as possible of the glacier, and I know not how long it will hold me.'

" 'Well, but when will I come to look for you, if anything happens? Where are you going to try to go? Years ago Russian officers from Sitka went up the glacier from here and none ever returned. It's a mighty dangerous glacier, all full of damn deep holes and cracks. You've no idea what ticklish deceiving traps are scattered over it.'

" 'Yes, I have,' I said. 'I have seen glaciers before, though none so big as this one. Do not look for me until I make my appearance on the river-bank. Never mind. I am used to caring for myself.' "

After crossing the moraine and circling over the glacier itself, Muir came to a "lake about two hundred yards wide and two miles long ... a miniature Arctic Ocean, its ice-cliffs played upon by whispering, rippling wavelets and its small berg floes drifting in its currents or with the wind, or stranded here and there along its rocky moraine shore." It was the largest of several such lakes. In the century since Muir's visit in the late 1880s, the glacier has receded, and today there is a single vast melt lake.

Muir explored the surrounding "dripping jungles," the "smell of the washed ground and vegetation [making] every breath a pleasure." He exulted in the mosses "so cheerily green," and in the "wet berries, Nature's precious jewelry."

"In the gardens and forests of this wonderful moraine," he wrote, "one might spend a whole joyful life."

BELOW, AND FOLLOWING PAGE: The Great Glacier of the Stikine.

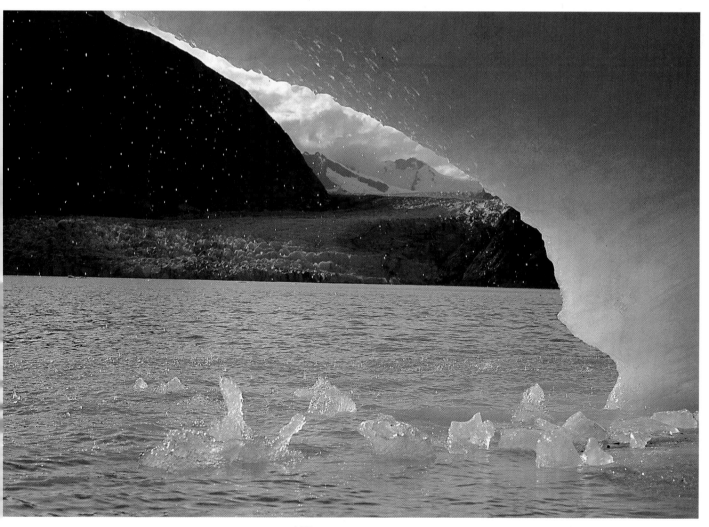

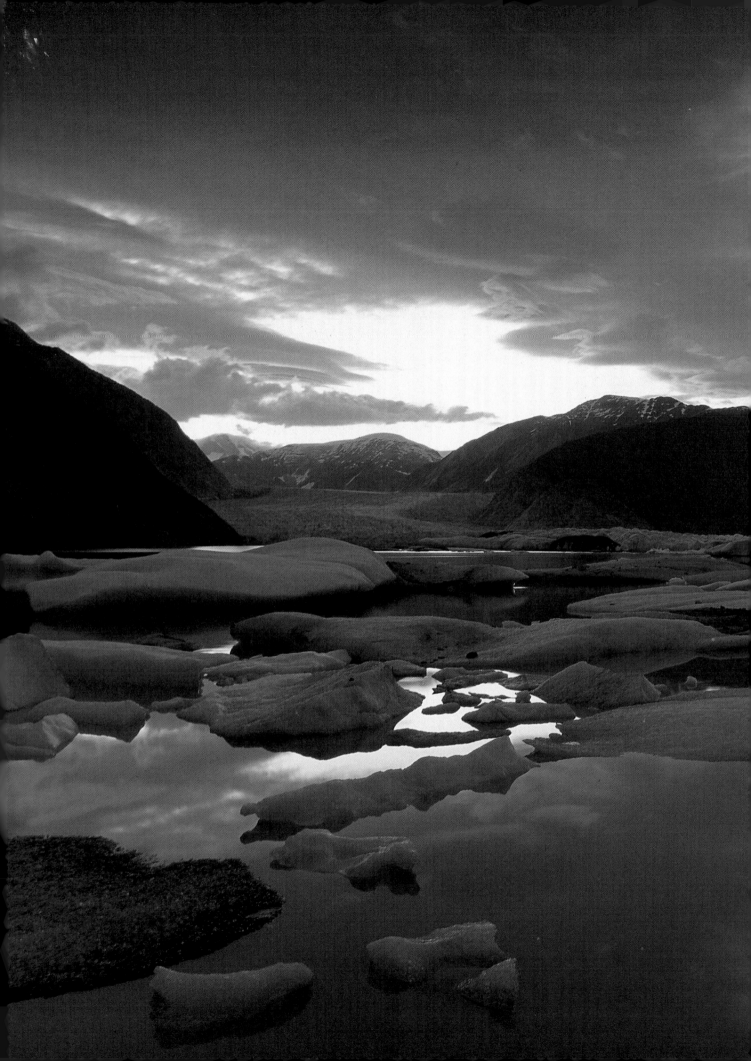

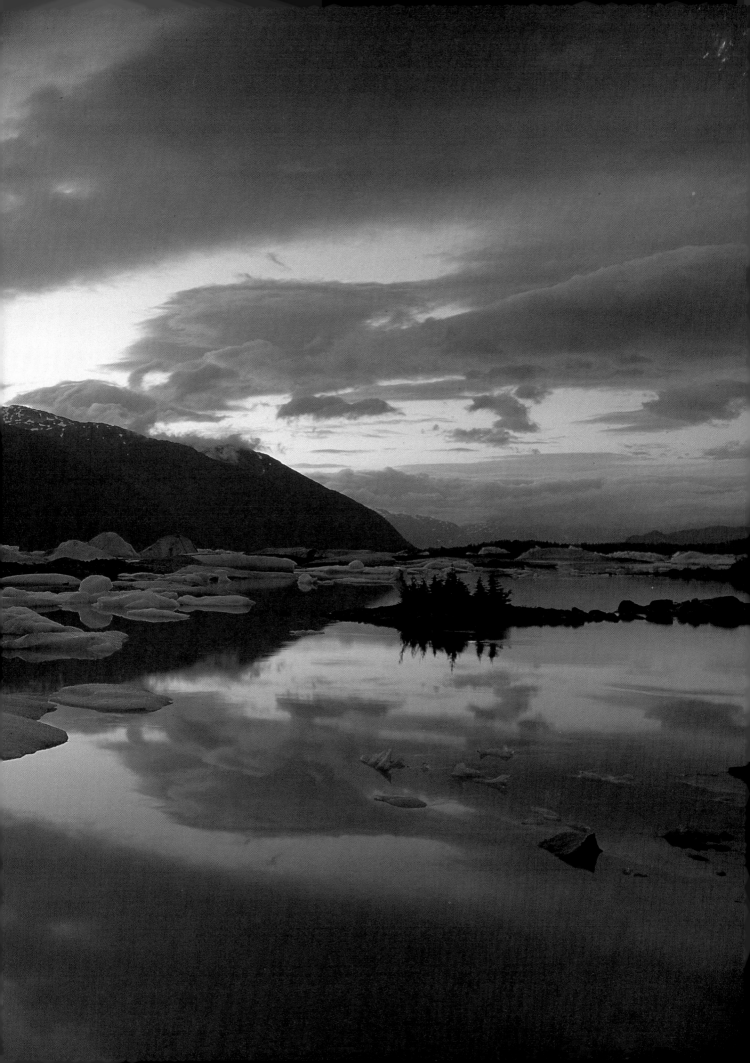

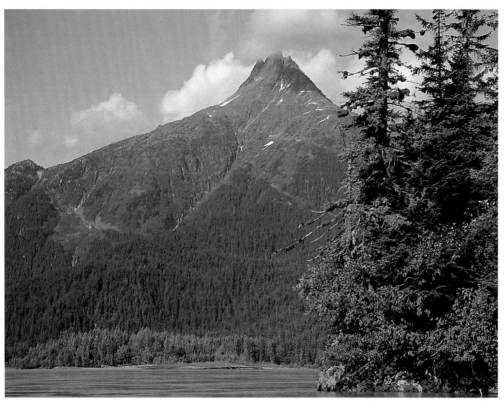

LEFT AND BELOW: The Eagle Crag rises above forests of Sitka spruce in the vicinity of the Great Glacier. Flowing for most of its length through boreal woodlands, the Stikine enters coastal rainforest just east of the Alaska border. Between Telegraph Creek and the sea, a distance of some 200 kilometres, the river is navigable by small boat. Few other wilderness rivers are as friendly to recreational users. Mining operations in the Iskut, a major tributary, threaten to bring development into the main valley.

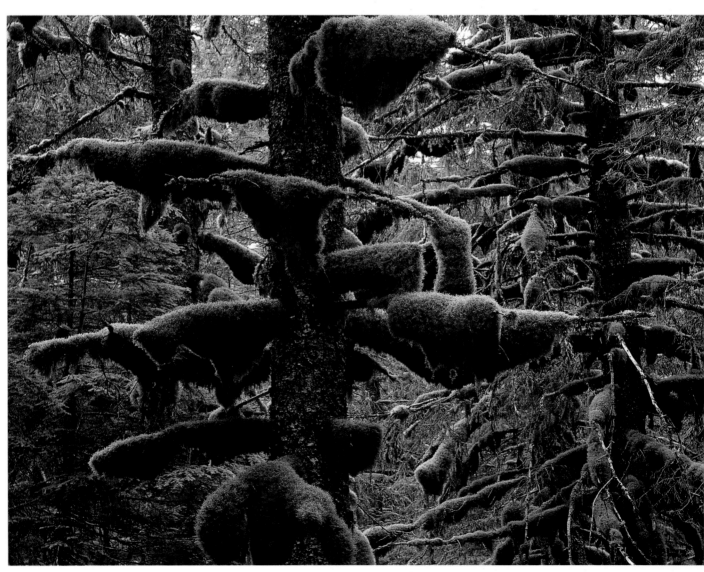

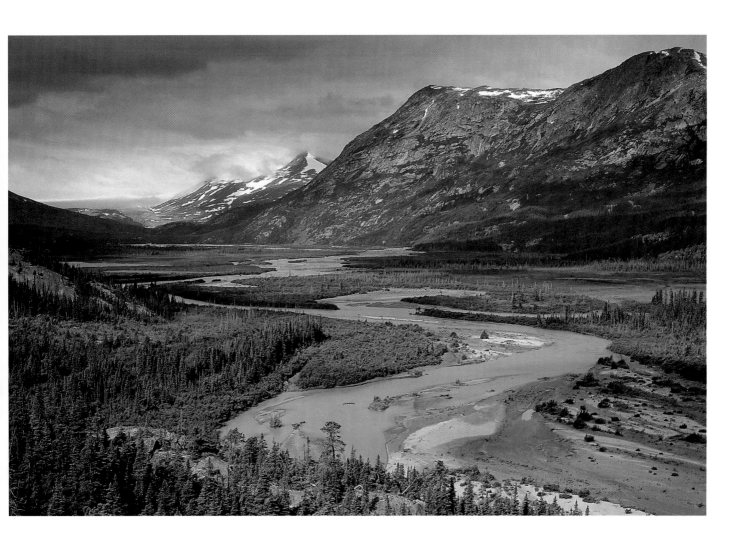

Tagish Lake, with its multiple arms, forms a network of waterways with some 400 kilometres of shoreline. Atlin Lake, the province's largest natural body of water, drains into Tagish from the east through a navigable river four kilometres long. Together, Tagish and Atlin constitute one of the province's most extensive networks of connected lakes. Most of their collective shoreline lies in wilderness.

I wanted to reach the source of Tagish Lake's remotest arm. I began my journey in the village of Atlin, a former mining town that retains its turn-of-the-century charm. On the opposite side of the lake, and visible from town, is a so-called "rock glacier." It moves with glacial slowness, but contains no ice. It is a colossal pile of scree subsiding stone by stone, pushed downward by the weight of new rocks peeling from a frost-cracked cliff.

The outlet of Atlin lake lies a few kilometres to the north. Atlin River was an easy descent, but when I returned against the current five days later, I would need every ounce of power in the motor. I entered Graham Inlet. A dense forest of conifers grew on its flat southern side.

Gentle mountains rose to the north, meadows alternating with spruce and aspen all the way to the summits. Clusters of scarlet soapberries lined the shore.

On Taku Arm I passed the sagging ruins of a mine. Fifty-year-old aspens stood in the doorway of the building that had housed the ore-crushing machinery.

I went ashore a second time and walked on a thick carpet of yellow-green lichen that crunched under my feet. Jagged summits and hanging icefields loomed over the forest of lodgepole pine.

When I neared the end of the arm, a glacier-cooled ocean wind buffeted my boat. I landed on sand that bore the marks of wolf, moose and bear, and supported clumps of pink-petalled willowherb. The stream that fed the arm was too shallow for my boat, but too swift and deep for wading, and impenetrable thickets of alder guarded the banks. I could only climb a cliff and follow its meanderings with my eyes. I could see its source visible on the horizon, one of the grey-blue tongues of the Juneau icefield.

The estuary of Swanson River at the end of Taku Arm, Tagish Lake. Tagish straddles the British Columbia-Yukon border. The view looks west, toward the glacier-covered Boundary Ranges of the Alaskan panhandle. Over the ice lies Skagway, starting point of the "Trail of '98" to the Klondike goldfields.

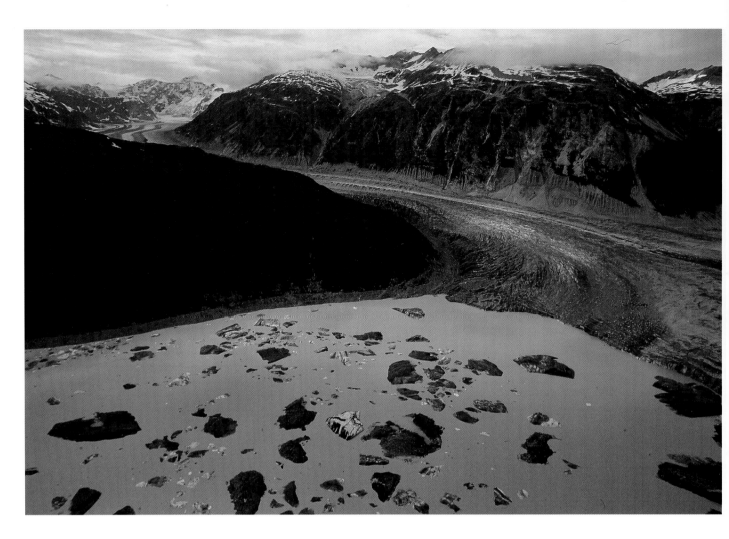

ABOVE: Melbern Glacier and its melt lake, near the confluence of the Tatshenshini and Alsek rivers.

Wedged between the Alaskan panhandle and the Yukon border, the northwest corner of British Columbia forms a triangle with an area of some 10,000 square kilometres. Few places in the province are more remote. From its heart springs a river that churns northward through a canyon, crosses into the Yukon, bends west and south, and passes through another set of rapids before re-entering British Columbia. The Tatshenshini is sometimes swift, sometimes deep and slow, often broad and separated into a score of streams. As you raft down it, the mountains along its course grow taller with every passing day.

On a raft trip lasting 10 days, the glaciers begin on the sixth. Half a dozen of them, evenly spaced, descend the northern slopes of the Fairweather Ranges. The Tatshenshini then joins the Alsek River, enters Alaska, and turns south, describing a half-circle with a six kilometre radius. One point in this bend offers a panorama of 18 glaciers.

The east shore of Alsek Lake is a wall of ice kilometres long. Chunks of glacier the size of buildings split from its edge and plunge into the water. Many of these icebergs gather at the entrance to the lake where they slowly melt. Some become top-heavy, and when they somersault they can swamp a boat.

We camped on the west shore. Long into the twilight of the sub-arctic night we listened to the rumbling and crackling of a billion tons of ice grinding across bedrock — the sound that half our continent made as glaciers scoured its surface.

OPPOSITE, ABOVE: Beds of broad-leaved willowherb along the Alsek River, just east of the Alaska border.

OPPOSITE, BELOW: Fireweed meadows in the lower Tatshenshini valley. A deciduous rainforest of cottonwood, alder and devil's club surrounds these meadows. The provincial government granted protection to the Tatshenshini wilderness — an area of almost one million hectares — in 1993. It adjoins parks in the Yukon and Alaska and together they form the world's largest international protected area — some 8.5 million hectares.

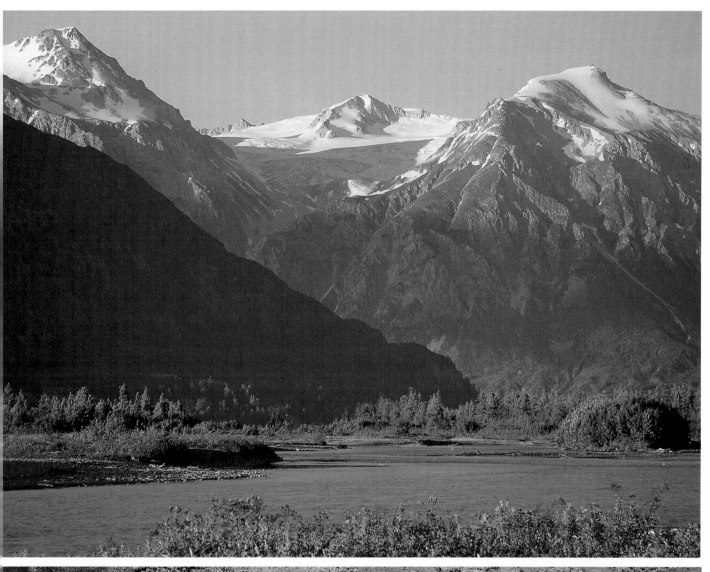

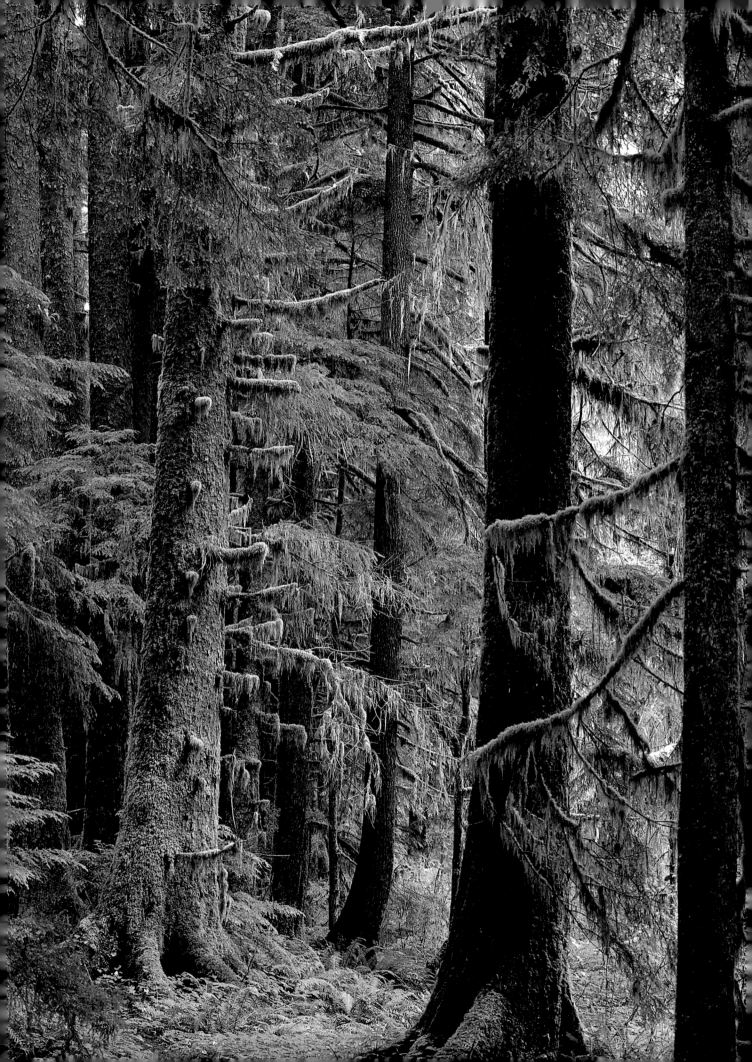

Epilogue

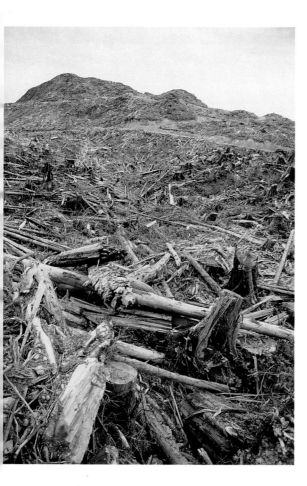

Between 1991 and 1995, the government of British Columbia made a series of highly publicized announcements. It proclaimed the creation of scores of new parks, and stated its intention of increasing the area of protected wilderness to some 12 percent of the province's land base.

In 1995 it made a different kind of announcement, this time quietly and almost unnoticed. In the first six months of that year, it renewed more than half of the province's "Tree Farm" licences. The renewals covered some 40,000 square kilometres — an area as large as Switzerland — and breathed 25 years

FAR LEFT: Carmanah Valley. Old-growth forests such as this are among the most biologically diverse ecosystems on the continent. Yet the logging industry has long insisted that these forests are "overmature," "decadent," "museums of rotting cellulose" — and that clearcutting is necessary to ensure ecological health. LEFT: Clearcut a few kilometres north of Carmanah. BELOW: An 8000 hectare clearcut along the Matthew River, Cariboo Mountains. This high elevation site, cleared some 10 years before I took the photo, shows few signs of growing a new forest.

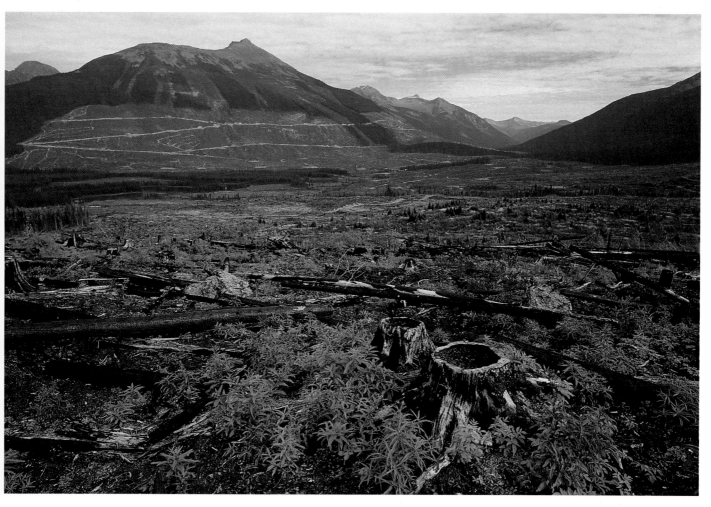

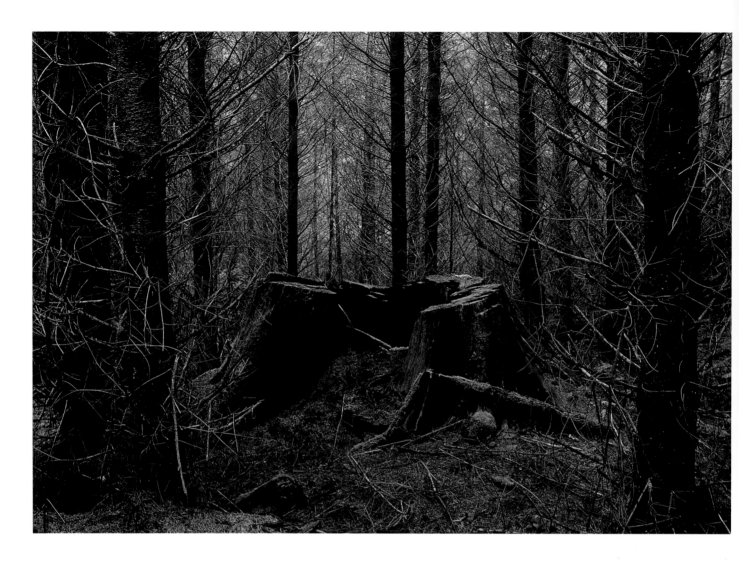

A typical second-growth forest on Vancouver Island. Little more than mushrooms grow in the deep shade of this thicket. Left undisturbed for 150 years, this plantation would begin to resemble an old-growth forest, with trees of varying ages and a flourishing understorey. But these trees are to be felled before they are 80 years old. The wood will be of inferior quality. Unlike old-growth timber, most juvenile wood is high in lignin, filled with knots, and prone to warping. Although the best softwood in the world still comes from British Columbia, current forestry policy calls for the rapid liquidation of most of the remaining fine-grained ancient trees. Unless there is a change in policy, in 20 years British Columbia's wood industry will be producing little more than cheap fibre for pulp or particle board.

of new life into a system of forest management that grants monopoly control over vast tracts of land to a handful of large corporations.

A small number of companies dominates British Columbia's wood industry. In 1995, 10 corporations held exclusive rights to half of all forests allocated for cutting. They enjoy a system of land tenure that eliminates competition and guarantees a cheap supply of timber. The price they pay for wood — the "stumpage" — is set well below market levels.

The low cost of British Columbia timber enables companies to resell unfinished wood in the world market for handsome profits. Corporations have little incentive to add value to exports through secondary manufacturing. British Columbia exports large quantities of rough-cut, semi-processed lumber, of cants (squared logs) and of wood pulp, but relatively few pre-fabricated houses, window frames, furniture, musical instruments, wooden boats or specialty papers.

Over the years, logging corporations have pushed for an ever-larger share of timber. Governments have listened to their demands. In 1961, forestry companies took 32 million cubic metres of wood from British Columbia's forests. In 1991, the figure stood at 74 million cubic metres. Yet according to the government's own figures, the sustainable rate of cut is only 59 million cubic metres per year. The real sustainable cut is undoubtedly much lower: the official one comes from highly unreliable timber inventories and optimistic estimates of the rate of forest regrowth.

British Columbia's logging industry presents a paradox. More than 50 percent of all timber ever cut in the

province has been extracted since 1972. Yet during recent decades the number of jobs in the forest industry has fallen dramatically. While the total number of people working in the province increased from 1.27 million in 1981 to 1.51 million in 1992, during this same period employment in the forest industry declined from 111,000 to 86,600. In many mill towns, employment has dropped by 50 percent or more.

Very little of this job loss has been caused by the creation of new parks. Almost all of it has been the result of mechanization. Feller-buncher machines replace lumberjacks; automated production lines make thousands of millworkers redundant. In 1950, 28 truckloads of timber created direct employment for 2.3 people. By 1986, that same volume of wood could not keep one person working. In 1961, every 1000 cubic metres of timber meant two jobs. By 1991, it meant only 0.88. The United States has three to four times more jobs per unit volume of wood than British Columbia. Our province produces one half of all Canadian timber, yet accounts for only 28 percent of the nation's forestry sector jobs.

The forest industry is in crisis. In many areas, it has already depleted the accessible timber. In others, the demise of the last commercially valuable old-growth forests is only a few years away. Most second-growth forests still need decades to mature to harvestable age. Employment in forestry, already falling because of mechanization, threatens to collapse as the industry liquidates the last ancient woodlands. Clearcut logging continues to transform the landscape into an industrial wasteland.

We need vigorous reforms. We should abolish the tenure system, and all companies, large or small, should purchase their wood on the free market. The Ministry of Forests should become a responsible steward and immediately reduce the allowable annual cut to sustainable levels. Clearcutting should be replaced by methods of selective logging that respect the integrity of old-growth forests. The new *Forest Practices Act*, passed in 1994, does not address these fundamental issues.

These necessary reforms would result in a large reduction in the timber harvest, but employment need not suffer as a result. Selective logging, for example, is very labour intensive; so is selective thinning of immature stands, a salutary operation much neglected now. The government should use tax incentives and other means to encourage secondary manufacturing.

A courageous government could rescue the forest and the industry with it. It would face short-term economic and social disruption, and collision with international corporations unhappy at losing their windfall profits. If it acted now, it could avert sure disaster in 15 or 20 years, when unrestrained logging will have exhausted all accessible old-growth forest. The longer we wait, the fewer options we leave ourselves.

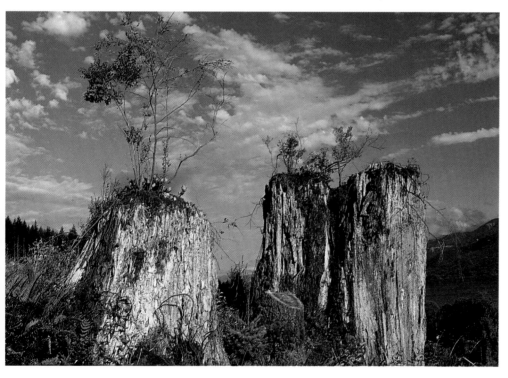

"Forests Forever" on the shores of Cowichan Lake. The large stumps are from an ancient forest cut down almost a century ago. The small stumps are from the second-growth forest that replaced it, judged sufficiently "mature" to be felled. Current forestry policy precludes the growth of large trees on logged-over lands. Industrial forestry sees plantations of young, even-aged trees as the forests of the future.

Biogeoclimatic Zones of British Columbia

British Columbia's 14 biogeoclimatic zones are areas of broadly homogeneous climate and vegetation. To a large extent, these zones correlate with altitude. The numbers in the key refer to pages where you will find photos of typical landscapes in each zone. Captions explaining the zones can be found on pages indicated in **bold.**

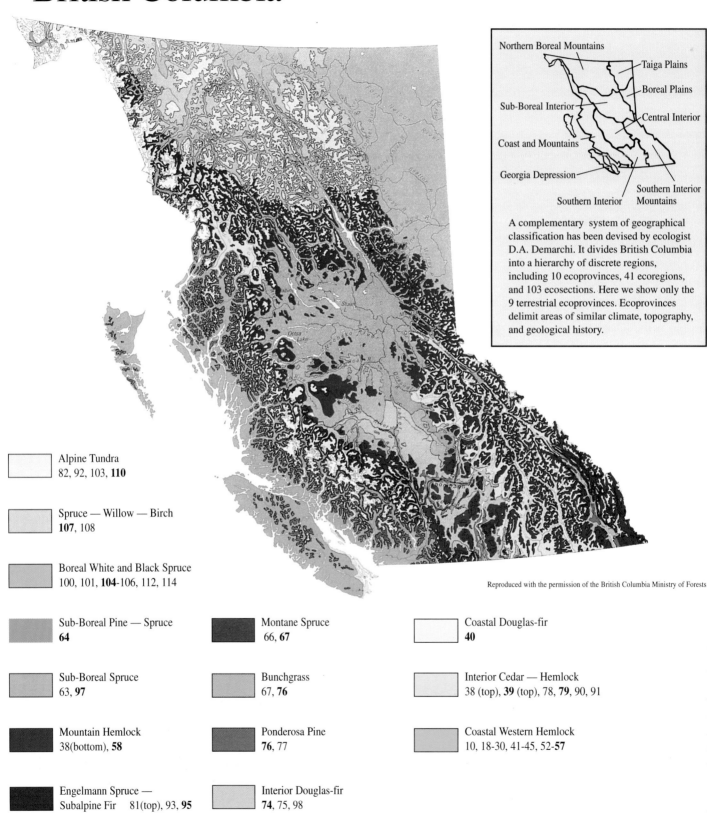

Northern Boreal Mountains

Taiga Plains

Boreal Plains

Sub-Boreal Interior

Central Interior

Coast and Mountains

Georgia Depression

Southern Interior Mountains

Southern Interior

A complementary system of geographical classification has been devised by ecologist D.A. Demarchi. It divides British Columbia into a hierarchy of discrete regions, including 10 ecoprovinces, 41 ecoregions, and 103 ecosections. Here we show only the 9 terrestrial ecoprovinces. Ecoprovinces delimit areas of similar climate, topography, and geological history.

Reproduced with the permission of the British Columbia Ministry of Forests

Alpine Tundra
82, 92, 103, **110**

Spruce — Willow — Birch
107, 108

Boreal White and Black Spruce
100, 101, **104**-106, 112, 114

Sub-Boreal Pine — Spruce
64

Sub-Boreal Spruce
63, **97**

Mountain Hemlock
38(bottom), **58**

Engelmann Spruce —
Subalpine Fir 81(top), 93, **95**

Montane Spruce
66, **67**

Bunchgrass
67, **76**

Ponderosa Pine
76, 77

Interior Douglas-fir
74, 75, 98

Coastal Douglas-fir
40

Interior Cedar — Hemlock
38 (top), **39** (top), 78, **79**, 90, 91

Coastal Western Hemlock
10, 18-30, 41-45, 52-**57**

Roadless Areas of British Columbia

Wilderness is found where there are no roads. This map shows those areas of British Columbia that were still roadless in 1989.

Most of the biological diversity of British Columbia is found at lower altitudes, as is the greater part of the province's fertile land and commercially valuable forest. The most precious and the most threatened of our wilderness areas lie at low elevations.

Often areas of lowland wilderness have survived only because they are unproductive. Many of the larger wild areas of Haida Gwaii, Vancouver Island and the mainland coast continue to exist only because they are covered in commercially worthless bog forest.

A number of high elevation wilderness areas are threatened as well. The forest industry is increasingly desperate for new sources of fibre, and in many regions logging is occurring ever closer to the treeline.

Green shows the islands, shorelines and valley bottoms that harbour the largest remaining tracts of low elevation old-growth forest. It indicates roadless areas that fall in any of the nine low elevation biogeoclimatic zones, including Boreal White and Black Spruce, Sub-Boreal Pine — Spruce, Sub-Boreal Spruce, Interior Douglas-fir, Interior Cedar — Hemlock, and Coastal Western Hemlock. No wilderness remains in the other low elevation zones.

Yellow shows wilderness at higher elevations — mountains, ice fields, alpine meadows and forests of stunted or slow growing trees. It indicates those roadless areas that fall within any of the five high elevation biogeoclimatic zones: Montane Spruce, Engelmann Spruce — Subalpine Fir, Mountain Hemlock, Spruce — Willow — Birch, and Alpine Tundra.

This map is based on information from two principal sources: a map of roadless areas of British Columbia compiled in 1989 by the British Columbia Forest Service, and the Biogeoclimatic Zone map that appears on the facing page. It has been somewhat refined on the basis of information from other sources. Coloured areas indicate tracts of land that have undergone little or no modification, that cover more than 1000 hectares and lie at least one kilometre from a 4-wheel drive road.

1-125 The numbers on the map are page numbers, and serve to locate the photographs.

The Nemaia Valley, Chilcotin region.

Acknowledgements

During the course of this six year project, I have received the help and support of many people. It would be impossible to thank them all. Many offered me some kindness during my travels — information on a wild place, a helping hand with my boat, a car ride at the end of the trail, a place to stay for the night. To the guide-outfitters who assisted me, the pilots who flew me, the other wilderness travellers with whom I shared a meal by the campfire — I thank you all, for you have contributed in one way or another to the success of this book.

I would like to thank the following people by name, roughly in the order in which they became involved in my life or in this project: Paul George, for being the first to appreciate and publish my photographs; Adriane Carr, Joe Foy, Mark Waring, Ken Lay and the other environmentalists without whose efforts my work would have been pointless; Grant Kennedy, for believing in this book early on, and Shane Kennedy, who, as my publisher, often had more faith in this project than I had myself, and showed unfailing support and patience; Wade Davis, for his constructive critiques of my writing; my brother David, for volunteering his services as a pilot for aerial reconnaissance and photography; Doug Radies and Ocean Hellman, for practical information and the inspiration of their example; Kevin Scott, for his help in the field, and for making available the resources of B.C. Wild; and all the other people and organizations from whom I have received advice or assistance over the years, including Rick Careless, John Clark, Grant Copeland, Allen and Leslie Gottesfeld, Lighthawk, Lisa Kofod, Andy Mutang, Tom Pater, Terry Vold, Clinton Webb.

Special thanks are due to Dennis Demarchi, who reviewed the entire manuscript for scientific accuracy; to Ben Parfitt, for reviewing the epilogue; and to Glenn Rollans and Lynn Zwicky, whose thorough edit of the manuscript contributed so much to the smoothness of the final text.

I would like to thank Michele Johnson and Volker Bodegom for their assistance with the maps, Wei Yew for the graphic design concept, and Nancy Foulds, Jennifer Keane and Bruce Keith for their work on the final edit and proof. I am grateful to Dave Vasicek for his outstanding work on the colour separations, and to all the others at Pièce de Résistance Ltée who worked nights and weekends in the effort to meet an almost impossible deadline. A special thanks goes to Jean Poulin, whose efficiency, enthusiasm and good humour played such an important role in the design and production of this book.